'Photography has always been an excellent pretext for being wherever I was. In North Korea I wasn't supposed to be there, but I was.'

Philippe Chancel

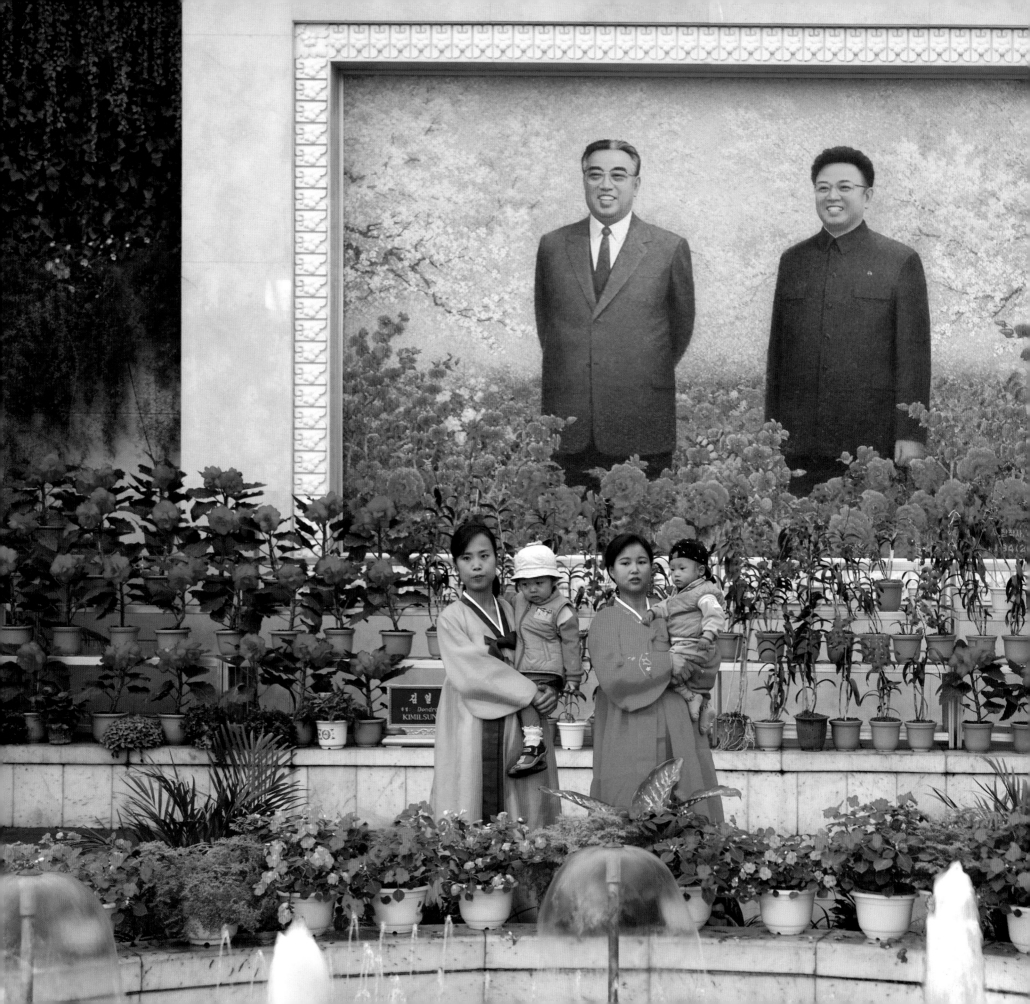

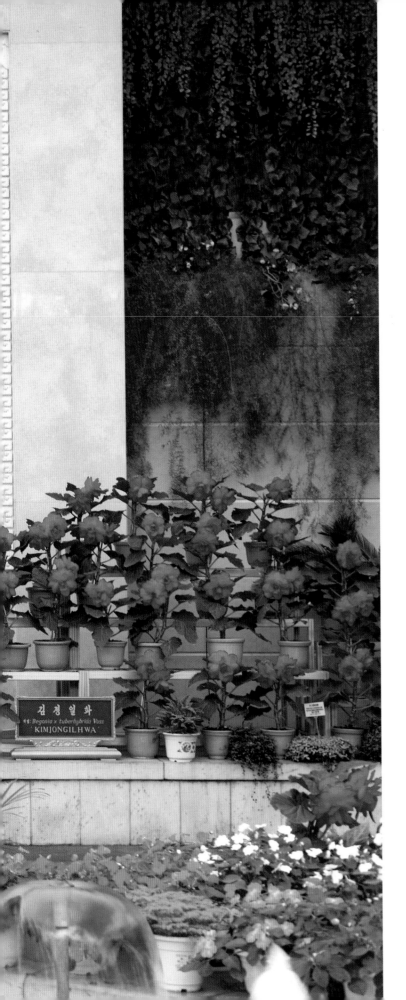

NORTH KOREA
philippe chancel

texts by michel poivert
& jonathan fenby

with 129 color photographs

Thames & Hudson

Frontispiece: Festival in Pyongyang to celebrate the two national flowers, Kimilsungia and Kimjongilia, hybrid cultivars of orchid and begonia respectively

013322097

APPEARANCES

MICHEL POIVERT

Impenetrable places arouse two opposing but interdependent feelings in us: their inaccessibility contains the promise of the extraordinary, but also the fear of something that has remained a mystery for far too long; whatever tales we may have heard before experiencing such places for ourselves, the two feelings coexist until they become confused. Producing a photographic work in North Korea, as Philippe Chancel has done, is no exception to this rule. This country, whose reputation for isolationism, totalitarianism, poverty and the cult of personality is so familiar, makes us conscious of just how little we really know.

Precedents set by the countries of the former Eastern Bloc, having flung open their doors to visitors, are instructive. Long regarded by reporters as politically alien, these countries now reveal to attentive travellers the traces of their ambiguity: although democratized, they have not yet broken away from the cult of the appearance of normality. No one shows us images of this, however, for the simple reason that such an intangible reality defies all attempts at description.

North Korea, at least until the general onward movement of history sweeps away the present state, is the only country in which it is still possible to conduct a kind of archaeological, aesthetic inquiry into the façade of normality in its most spectacular form. Later, when globalization takes over – here, like everywhere else – we will no longer know exactly

what it is we have been dealing with. The rituals and the religious monuments will take on the aura of a huge film set abandoned post production, like the replica of the Angkor Temple at the International Colonial Exhibition in Paris in 1931, which was passed on to Hollywood once the festival was over. For the moment, the ghostly nature of these structures is still imbued with the terror that the North Korean regime imposes on its people. The things that these photographs depict are not yet completely relics.

Chancel obtained permission to compile his book in the vast expanses of an open-air museum which devotedly preserves all the forms of an ideology that still dares to speak its name. These images look through time as well as space. Everything we see here reflects the pomp of a kind of regime we had thought to be long since dead and buried, but this reflection is no mirage. If it sets North Korea even further apart from what we had imagined, by placing it in a world of make-believe, at the same time the mere possibility of such images makes it all seem worryingly immediate. It is therefore all the more to the credit of this artistic venture that it makes us think about power and how it is represented, when we may have thought that there was no longer anything new to be said about the 'aestheticization of politics'.

The first issue that must be addressed is the question of genre. What we have here is not an investigative report, or a traveller's tale charting a personal quest. Nor is it one of those humanist 'portraits' – a photographic postscript to history, such as Henri Cartier-Bresson's photographs of the Russians and the Chinese. Although it is quite explicitly a photographer's book, it does not form part of the modern drift towards the genre of historical

photography that feeds on the ambivalence between the fine arts and news media – that apparent dialectic which has engulfed one branch of contemporary photography.

The approach is aesthetic, and there is no need to load it with anti-totalitarian rhetoric. Here it is only the visible forms of totalitarianism that are contrasted with what for an artist is the experience of today's imagery. Chancel's photographs do not seek originality through surprise, and they avoid wonderment and fear, substituting in their stead an extravagant form of beauty and fascination to the very point at which we know that there can be no question of either breathing new life into this regime or putting it on trial. To avoid being ideological when faced with an ideology requires a very real balancing act that entails both detachment and judgment: the photographer has to 'win' on the playing field of the picture against an 'opponent' who explicitly draws on the authority of the image.

In the October 1967 issue of the journal *Internationale Situationniste*, there is a photograph, a badly printed vignette of a Chinese ceremony in honour of Mao: the stadium is filled with people arranged in a perfect rosette, and the stand is bursting with an immaculate configuration of bit players whose costumes from a distance form images in praise of 'The Great Leader'. The caption gets straight to the point: 'Portrait of alienation'. With such images, Guy Debord and his team revealed a primitive form of the showbiz society – a highly concentrated spectacle in which representations took the place of every possible experience, in a monstrous split between humanity and the real world. This recollection is enlightening in so far as there is no need for an image to be artistically created in order for it to denounce alienation. On the contrary, the triviality of a newspaper photo and the impact of a caption are all that is necessary.

Chancel's work, in its restrained sophistication, though confronted with similar themes to those of 1960s China, does not involve the same kind of political motivation; it is more concerned with conveying a reflexive experience, which turns the perfect aesthetic order of power in upon itself in order to show us what is most familiar to us. It is through his style that Chancel holds this exotic carnival of social realism at a distance and at the same time presents it with an absence of emotional expression that enables him to steer clear of political imagery. What, then, did he set out to observe? Not the poverty which the guise of a reporter would have allowed him to record – by photographing a market, for instance – but a world of formalities, in which attitudes and images, buildings and sculptures, town planning and showpieces are enshrined in the endless ritual of the photogenic. On this stage of wonders, however, one is struck by the clinical atmosphere, the severity of forms, the rigidity of postures, the mathematics of polychromy. And yet strangest of all is a kind of grace that lies at the very centre of these images but does not originate from the visual potency of the scenes and sights recorded. Instead we witness humanity rising visibly to the surface through the softness of bodies and attitudes, seemingly rejecting all these enduring images of authority in its own heart of hearts.

What formal opposition can there be to the unceasing kitsch of these scenes? How can one avoid falling into the ironic raptures to which the Martin Parrs of this world have accustomed us? Perhaps in the first instance by selecting and regularizing the light. Chancel's book works on the principle of a light that remains insensible to what it illuminates. We see skies that are always grey but bright, expressionless but powerful, sending out a light that is totally indifferent to the hundreds of scenes below. It is as if the climate

were taking entirely upon itself the bleakness of the human condition. This is a place where the sky never changes, like a face devoid of expression, and where the light creates no drama, weaves no magic, and draws no shapes upon the earth – a light produced by an absent sun. Chancel creates distance and detachment with this climate, and forges a visible link between light and humanity in scenes that are silent and yet express a certain kind of beauty, the only possible resistance against the aesthetic heresy of the settings. And then we come to the last man – the man we are given to gaze upon at the very end of the book, who in this photograph has eliminated every trace of the oppressive environment. He is steering his bicycle, looking into the distance, taking no notice of the medal pinned to his jacket – a tiny relic of the monuments on which he has turned his back.

The photographs taken in museums and similar institutions are the most disturbing of all – not because of a setting that stresses the petrifaction of a whole society, but because, when all is said and done, this theatricalization of culture is not altogether unfamiliar to us. Animals fossilized in their glass cages, the paraphernalia of battle fetishized in the name of history...these museum displays, like Russian dolls, seem to insistently repeat over and over again that there are lessons to be learned from history.

We are familiar with the work of artists such as Candida Höfer in German museums, showing didactic spaces that are just as impressive and mysterious, with objects or animals scattered around in glass cases as part of 'installations' in which educational value and tourist appeal are brought together in a world of spectacle. The similarity to contemporary German photography is not restricted to museums, for one cannot help thinking also of

Thomas Struth's work in Japan as a striking contrast in the way social spaces may be handled in two totally dissimilar countries. While Struth studies humanity in an urban chaos that oozes vitality (also examined in his portraits), Chancel goes in search of spaces that have been stripped of all emotional expression (not so very different in form from those constructed by Thomas Demand) – thus producing a work that is socially defined by ideology in so far as ideology both manifests itself in and is a formative influence on those spaces.

In this context, if we may stay for a moment with the Düsseldorf artists, we should look at the comparison that might be drawn between Chancel's book and the success enjoyed for many years by the work of Andreas Gursky. The monumentality of the architecture and images that Gursky turns into a metonym with his immense formats might be seen as the exact opposite of the concrete stage sets erected by the 'great leaders' of North Korea and their Stalinist predecessors.

Yet, even if it would have been unthinkable for Chancel to move such Stalinist settings onto the walls of contemporary art museums – the book is the most suitable format for this – nevertheless one might justifiably ask whether advanced capitalism, through its art, has not actually provided the world with a response of equal scale to these North Korean scenes, which are on the face of it so seemingly out of touch with the present. It is quite disturbing to note that with the reversal of perspectives there is some kind of parallel between the spectacle of democracy and the spectacle of dictatorship, which becomes all the more evident when art reveals this perverse link. This indeed is the impression that Chancel declares he was constantly aware of – a strange feeling that political aestheticization, which defines a totalitarian society, should also seem familiar to us through our

museums of contemporary art! Within this game of analogies Chancel's pictures seem to pose the question: what can have happened to us that our conscience is so troubled by this confrontation?

The rhetoric of modern photography is founded on the mundane and on detachment from every 'subject' in the classic or journalistic sense of the word – whether the aim is to affirm the autonomy of the image or to fulfil a critical intent. The various forms of reportage have long since distanced themselves from this approach, which is so closely akin to that of contemporary art, not only because they favour the anecdotal (the news item), but also because they are totally dependent on the stylistic devices and dynamics of expression of the 'author'.

The empathy of the reporter and the vaguely heroic mythology that has somehow attached itself to him do not fit with the intellectual nature of the documentary approach. On the other hand, the aestheticization of photojournalism, characterized by the new iconography of the scoop, with its claims to 'great art', has for some years tended to exceed the bounds of corporatism and information use and become a cultural object in itself. All the same, this often reduces the question of the 'subject' to a matter of categories of current affairs.

With Chancel's book, subjects are treated within the framework of an aesthetic experience. It must be understood that this does not mean subscribing to a repertoire of abstract forms, reduced to motifs and shapes, or yielding to the temptation of treating the present simply as a current event. In fact, there is a duality in this work, and indeed in some

of the individual images: on the one hand, we have the immediate and informative approach to size and distance, carefully thought out in terms of visual space; on the other, we have the details, the angles, the glancing contact with people, bodies, gestures. Herein lies the reflective quality of Chancel's work: without ever allowing himself to be over-whelmed, he shows the aesthetics of neo-Stalinist pomp and circumstance, and at the same time approaches the human body to reshape it on an individual scale in all its ele-gance, softness and sensuality.

These changes of scale, however, take place with an unremitting neutrality. The contradictions are delicately shaded in, with no searching for clues or evidence of alien-ation; they are established over the course of the book, accentuated perhaps by the allegorical figure of the traveller. This book is a journey, with its narrative aspects, its moments, episodes and its highlights (e.g. the celebrations of the 60th anniversary of the foundation of the Korean Workers' Party), but the author-traveller never makes an appear-ance; it is not his impressions that the images are translating, and all the energy of representation goes into putting the power of his gaze back into the viewed space. And so one cannot talk of the so-called 'withdrawal of expression' typical of the documentary style; here the subject resists neutralization because of the curiosity it arouses (the journey remains an exploration) and because of the all-pervasive fascination that it engenders (with an almost vertiginous perspective such as you might find in an artist's sketch). Chancel is not laying this spectacular regime out flat; he captures and sometimes almost playfully accentuates the things that actually work, but the balance of his compositions and the sobriety of the light imbue them with an aura of contemplation. One might say that he

breathes warmth and humanity into them. And then the people arrive, at chosen moments of the journey-cum-stay, like allegories of liberty: a group or a single passer-by, in stark contrast to all the stiff poses of the officials, the ceremonies of commemoration, the gaudy celebrations which seem to be swallowed up in their own artifice.

The question remains open, and the discussion will no doubt continue for many years to come within our culture: what are the ethics of the aestheticization of horror? Susan Sontag considered this a key question, and applies it, for instance, to war photography, which she places in the great tradition of the iconography of martyrdom. In her book *Regarding the Pain of Others*, the American critic mocks those who reject emotion and compassion, attack the 'inauthenticity of the beautiful', and would rather 'speak of reality becoming a spectacle'. On the threshold of the twenty-first century, Sontag defended the criteria for appreciating reality against the posture of 'derealizing' the world, and set the record straight on the subject of images.

What is the ethical dimension in Chancel's photographs? The question is particularly apt when there is a subject in which the inauthenticity of the beautiful takes the form of a façade of normality. For deep down, even where there are no tears or visible wounds, horror is never far away, scarcely concealed by the theatricality of the poses and props. It is a cold horror, a silent pain, and it does not need the chaos of bodies to make the spectator feel it.

These are not pictures that aestheticize battle or the charnel house; they are monuments and mausoleums on display. What better way to capture their arrogance than by compiling a visual record of them? What better way of conveying their menace than by

showing their tendency to become tourist attractions (since is not the future destined to be a geopolitical entertainment)? What better way of approaching this reality, which has constructed its own sham realities, than by making these indistinguishable from postmodernism?

This Korea is, however, very real, and the sufferings that it hides are on just as vast a scale as the decorative spectacles that it stages. It is the accumulation, the quantitative persistence of the pictures in the book that manages to reveal this reality, and gradually the spectator is worn down – initially seduced, then astonished, then attentive, but swiftly overwhelmed. It is just the beginning, for the book goes on relentlessly, almost serially, repeating its central themes ad nauseam: in an anti-compassionate manner, the pain of others seems to pass through one reality and spill over directly into our own.

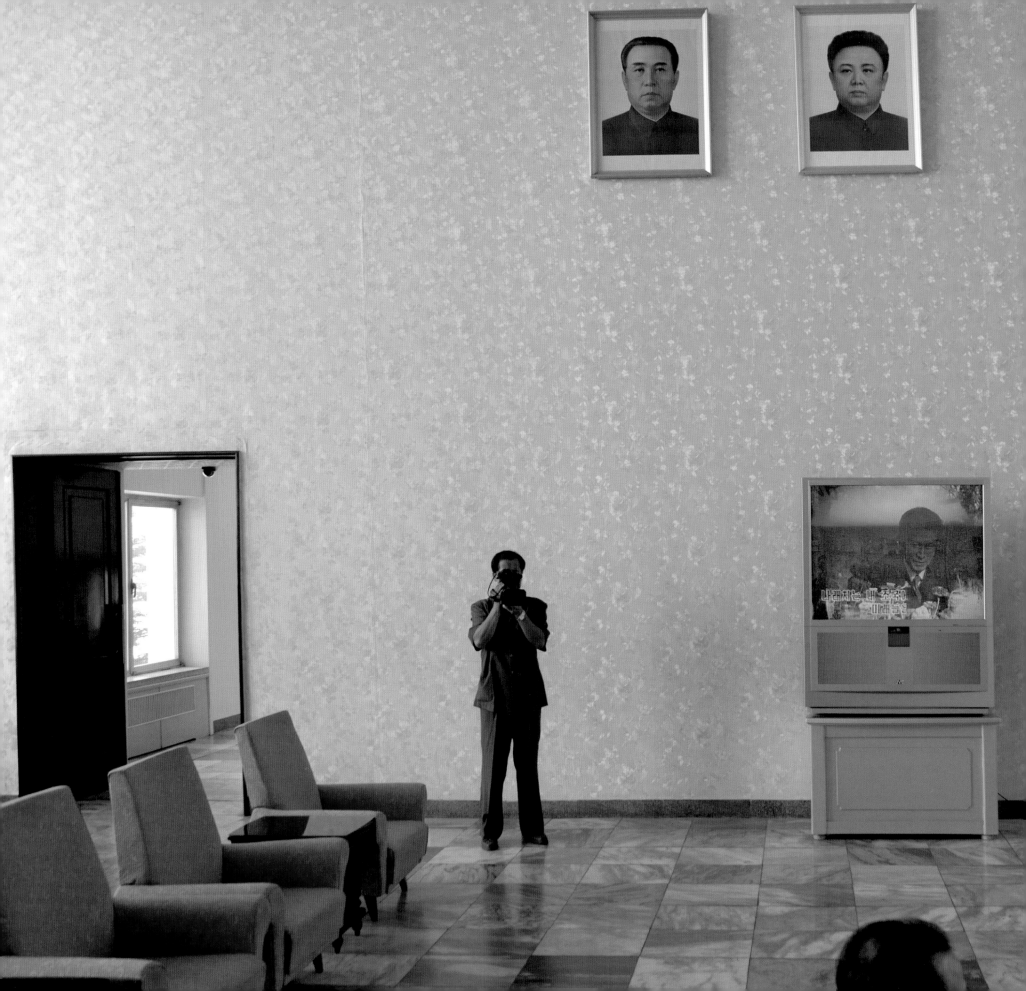

VIP lounge, Pyongyang Airport 17

A COUNTRY APART

—JONATHAN FENBY

North Korea is, to extend Winston Churchill's phrase about Bolshevik Russia, an enigma wrapped in mystery enveloped in nuclear-tipped uncertainty. For more than half a century, it has been a nation apart, a self-proclaimed workers' paradise that bears more resemblance to a giant Gulag, ruled since the defeat of the Japanese occupiers in 1945 by father and son autocrats. A decade and a half after the fall of the Berlin Wall, the Democratic People's Republic of Korea (DPRK) is the last remnant of the Cold War, divided from the southern half of the country by a highly fortified frontier left over from the Korean War.

It is also the only state where the President is a dead man. The epitome of a rogue state, its two rulers – Kim Il-sung and his successor Kim Jong-il – have expanded the cult of personality to unprecedented lengths. Giant effigies of the Great Leader and the Dear Leader, as father and son are respectively known, stare out over the capital of Pyongyang and other cities. Massed ranks of people in stadiums flip cards to form huge pictures of their heads. The boundless abilities of the Kims are even demonstrated by a golf scorecard which records the father as potting nothing but holes-in-one when he picked up a club. Though he died in 1994, the post of President has been assigned to the elder Kim for eternity.

The regime proclaims a creed of *Juche* – self-reliance. In practice, this means grinding repression and extreme privation. For its size, North Korea has one of the biggest

armies in the world, as militarism permeates national life, with endless warnings of imminent attacks from foreign enemies. However, despite *Juche* and its rejection of the rest of the world, the often bleak country depends on foreign aid for food. An international pariah, it has been accused of everything from assassination, kidnapping and backing terrorism to drug-trafficking, illicit arms sales, money laundering, counterfeiting $100 bills and acting as the protector for Taiwanese gangs that manufacture up to forty billion fake Western cigarettes a year on its territory. The regime's international defenders are few and far between. Some commentators see its behaviour as so abhorrent that they call for international action to hold Pyongyang to account.

North Korea might be a simply tragic, vicious oddity on the world stage of the twenty-first century were it not for its nuclear ambitions, the subject of on-off talks involving the United States, China, Japan, Russia and South Korea. Its moves to gain a nuclear capability in the early 1990s led to confrontation with the Clinton administration which threatened to turn into war before the Kim regime agreed to freeze its programme in return for the United States lifting sanctions and helping to construct nuclear reactors for peaceful use. One part of the programme was, indeed, halted; but Pyongyang then started another – slower – course of development. For its part, the United States did not lift sanctions. This stand-off opened the door to the clash under the Bush administration. While talk of a major American air strike then faded, Pyongyang was reported to be back on its original path, which would enable it to manufacture a substantial number of weapons.

Nobody outside the charmed leadership circle in the North knows whether Pyongyang is a real and present danger to world peace or just a braggart enjoying its high

profile on the international stage. That uncertainty breeds fear that the country is the nightmare of our age, an outlaw dictatorship acting without rhyme or reason, ready to supply terrorists and rogue regimes with nuclear weapons, irrational by accepted global standards and indifferent to the sufferings of its people. Or are Kim and those around him much more savvy, carefully measuring just how far they can go, using their outlaw status to maximum effect, aided in their grip on power by the international boycott that prevents foreign influences reaching the people? This more benign view notes that, for all the rhetoric, there has been no attack across the demilitarized zone between North and South since the end of fighting in the Korean War in 1953 – though there has still been no formal peace agreement. On this calculation, Pyongyang may make provocative moves, but will limit them in scale so as not to provoke the South and its American ally into all-out conflict. The trouble is that Pyongyang's ignorance of how far it could go might set in motion a pattern of events that would make Washington feel it had to act to maintain the security umbrella it has provided for non-Communist East Asia since 1945.

The will o' the wisp nature of such speculation is very much in line with the general degree of ignorance about this country of twenty-three million people and 47,399 square miles jutting out from the eastern end of the European-Asian landmass. Despite a series of recent books, most knowledge is based on evidence from defectors and satellite intelligence. To start with, nobody knows how firmly in control the regime is or whether, as some think, it would only take a nudge to topple Kim.

Some things are clear, however, and mirror the country's strange history. Under its dynasty, stretching back to 1392, Korea cultivated a separate identity designed to protect it

from Japan across the sea and the Manchus to the north. Outsiders were not welcome. Three Dutch sailors shipwrecked on the coast in the seventeenth century were not allowed to leave. They were well-treated, and two died fighting for the dynasty; but the court was not going to allow them to take information about the kingdom to the rest of the world. A pattern of control that persists to this day was set long ago.

Still, Christian missionaries made their way to the country. The mid-nineteenth-century king saw their teachings as dangerous, and nine French missionaries were killed, leading a French fleet to sail to exact reprisals. At the same time, in 1866, an American schooner, the *General Sherman*, made an unauthorized entry into Korean waters on a trading mission – an illegal activity. Ordered to leave, the ship fired into a crowd on the shore. Royal boats attacked her, and her mainly Asian crew was killed. A month later, the French fleet arrived, drove back the Koreans and plundered, but it was unable to establish a permanent presence and sailed away.

Isolation was proclaimed as royal policy to safeguard the Confucian-based Korean way of life. 'Not to fight back against foreign attacks is to invite more attacks,' the court proclaimed. When Washington dispatched a naval expedition in 1871, the Koreans emerged victorious. To an American envoy sent in to propose a treaty, the Koreans replied: 'We have been living 4,000 years without any treaty with you, and we can't see why we shouldn't continue to live as we do.' It might have been Kim Jong-il speaking.

Isolation was not always complete, however. Just as Kim accepts Beijing as his big brother across the border, so the Korean monarchs submitted to the general overlordship of the Qing Empire in China so long as it did not interfere with the way their country was

ruled. China was content with this state of affairs, but the more assertive Japanese saw Korea as a tempting target and, at the end of the nineteenth century, backed sword-wielding assassins who stormed the royal palace and killed the ruling queen. The declining power of the Chinese Empire then left the way open for Tokyo to turn Korea into a colony, an oppression that lasted until 1945.

The Allied victory divided the country under Soviet and American occupation forces. Attempts to forge national unity got nowhere as political groups vied with one another across the spectrum from far right to Communists. In 1948, separate governments were set up – the Communist one in the North headed by Kim, who had emerged as a major resistance figure against the Japanese. Each government called itself the legitimate administration of the whole nation, and Kim was set on asserting his claim.

On 25 June 1950, the northern army invaded the South, driving on Seoul before the United States threw in forces under a United Nations mandate. With China pouring in men from the north, the war bogged down into a bloody three-year stalemate that killed an estimated three million people, half of them Korean civilians, and caused widespread devastation. The truce called in 1953, establishing the demilitarized zone that cuts the country in two, persists to this day.

Thanks to aid from Moscow, Beijing and Eastern Europe, North Korea recovered from the destruction of war faster than the South, but Kim then declared *Juche* – in part to avoid having to choose sides in the Sino-Soviet split. The result was to make the country ever more isolated, and to hold it back economically, while the South began its rise to become a major economic power and install democracy.

In the 1990s, Seoul sought to improve relations with a 'sunshine policy', which produced the first summit meeting between leaders of the two parts of Korea in 2000, but has foundered on the rocks of the nuclear dispute. However, aid to the North has reaped few returns for the donors, while hopes that Pyongyang would encourage economic progress through market-orientated reforms have been undermined by the regime's stop-go approach and general impoverishment.

Not only have the rulers in Pyongyang isolated their country from the world, in line with Korea's old nickname of the 'Hermit Kingdom', but they have also cut their people off from their own country, and from one another. Denunciations are encouraged, as the regime demands complete obedience. Ceaseless propaganda tells the population that they owe everything to the genius of the rulers. Even if life is indisputably grim, brainwashing on a national scale convinces many of them that it is even worse elsewhere, and that their nation's invincible forces under Kim's inspirational leadership would win any war they undertook.

Secrecy is such that walls along main railway tracks cut off the view of the countryside. Bloody purges are levelled at anybody suspected of independent thinking. Whole families are punished for the transgression – real or imagined – of one member. According to a survivor of the North Korean Gulag, Kang Chol-Hwan in his harrowing *The Aquariums of Pyongyang*, violence between ordinary citizens is common; 'the law is far,' one saying has it, 'the fist is close'.

Beneath the veneer of socialism, the black market and money rule in a country that has lived with shortages for decades. It is in this context that Kim Jong-il held lavish parties and spent $200 million on a mausoleum to the honour of his father.

At the centre of the North Korean web sits the mysterious figure of the squat, heavily bespectacled Great Leader, a keen filmmaker whose family is the subject of constant rumours of factionalism and wild behaviour. Around the Head of State ebbs the central question of what motivates the regime he heads, and whether sixty years of 'Kim Il-sungism' can change a people beyond recognition. It may be that no state in modern times has ever been so totally the creature of its rulers, with a whole generation brought up knowing nothing except what it is told day after day through omnipresent slogans. The bellicose language and the nuclear capability make Pyongyang a uniquely threatening presence on the world stage, and also a uniquely unfathomable one, bereft of the means of telling truth from falsehood on anything beyond personal experience. Yet, if the present is puzzling, the future may be even more so as the world plays blindfold poker with a regime beyond its ken.

Further Reading

Jasper Becker, *Rogue State: Kim Jong-il and the Looming Threat of North Korea* (Oxford & New York: Oxford University Press, 2005)

Kang Chol-Hwan & Pierre Rigoulot, *The Aquariums of Pyongyang: Ten Years in a North Korean Gulag* (London: Atlantic Books, 2006)

Paul French, *North Korea: The Paranoid Peninsula* (London: ZED Books, 2005)

Bradley Martin, *Under the Loving Care of the Fatherly Leader: North Korea and the Kim Dynasty* (New York: Thomas Dunne Books, 2004)

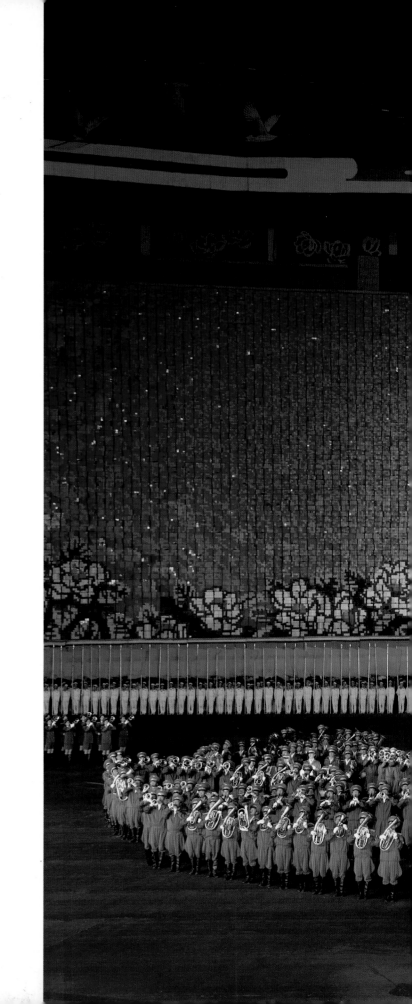

26 Arirang Festival to celebrate the 90th birthday of the late Kim Il-sung,
 'the smiling sun of the Korean people', May Day Stadium, Pyongyang

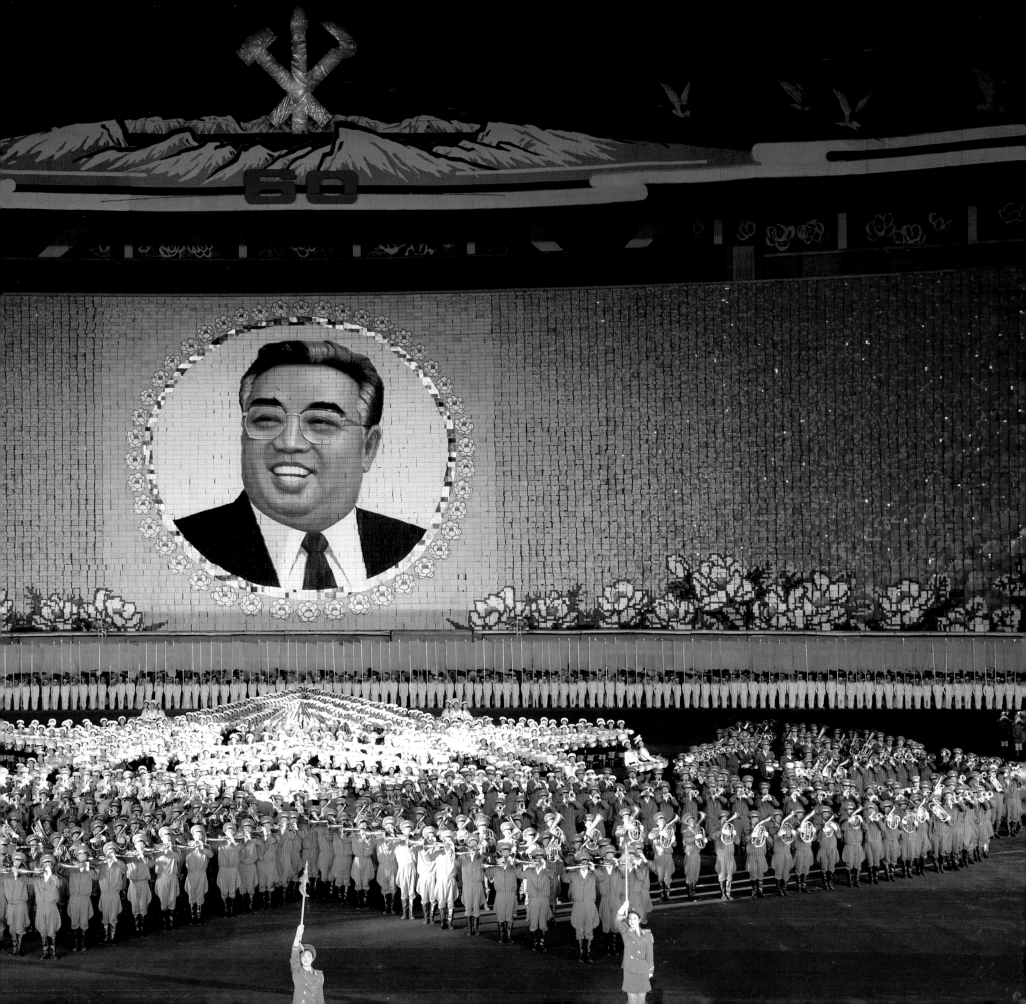

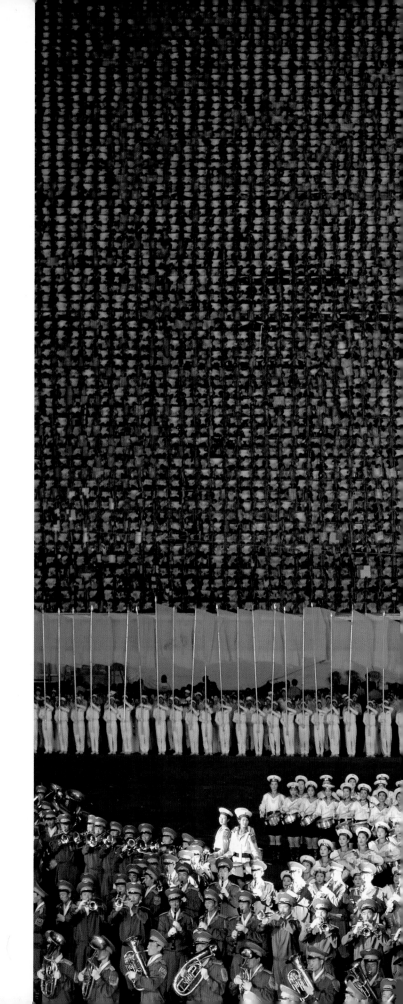

28 30,000 primary and secondary school pupils put on a show

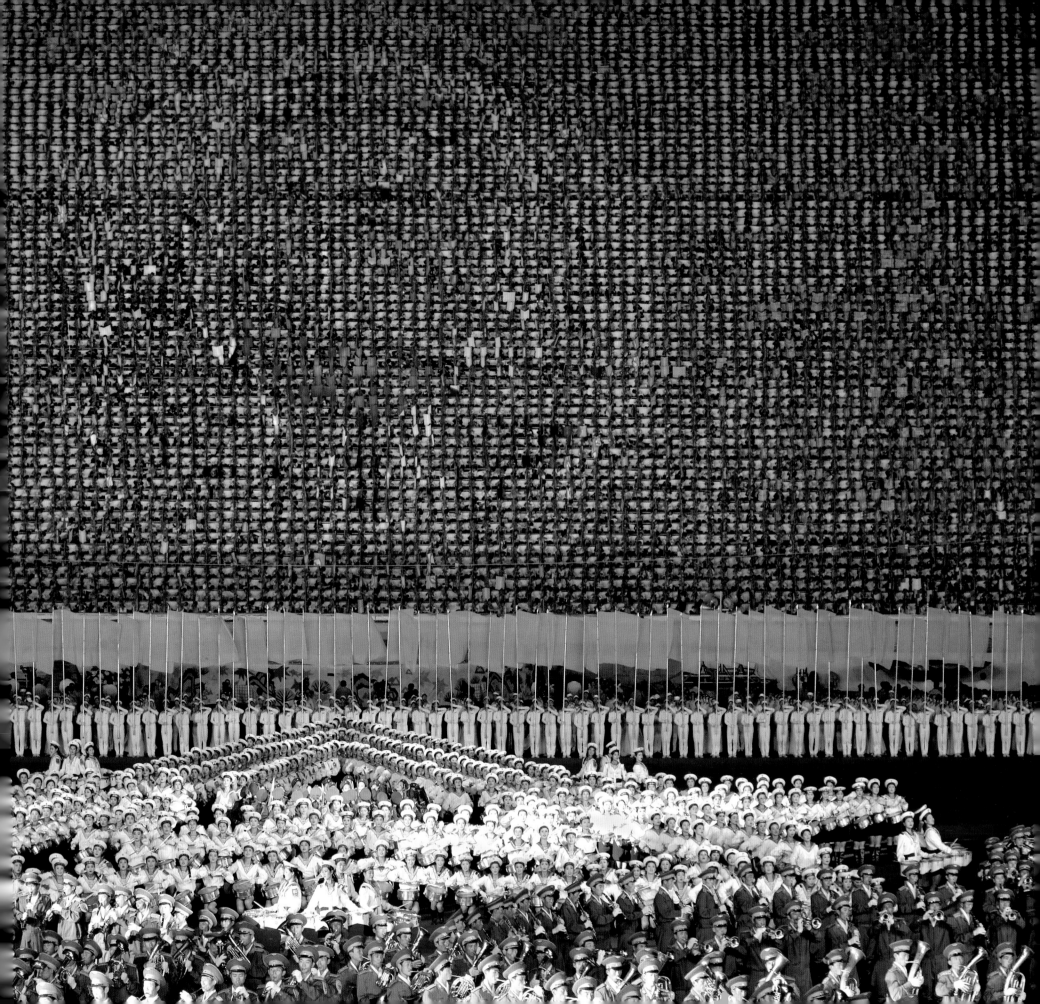

30 Air Koryo flight attendant, Pyongyang

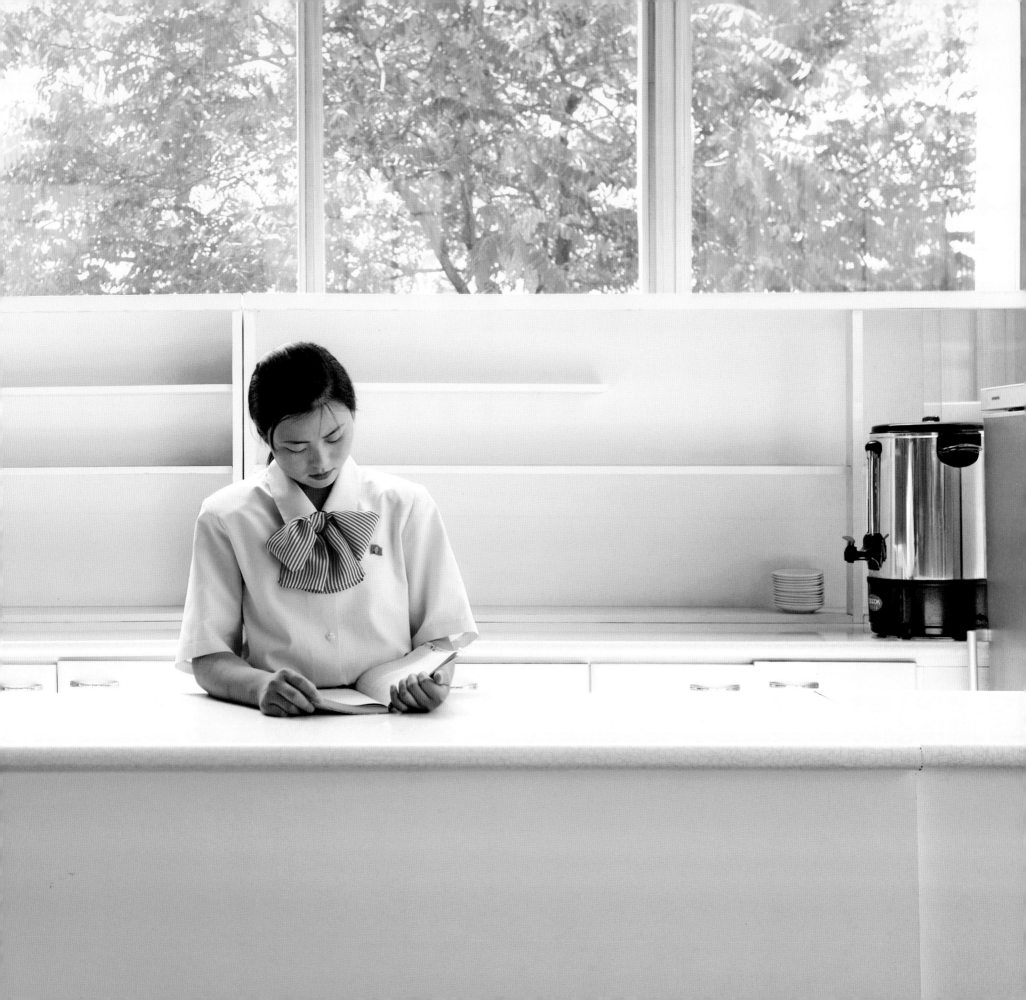

32 Meeting room, Pyongyang Hotel

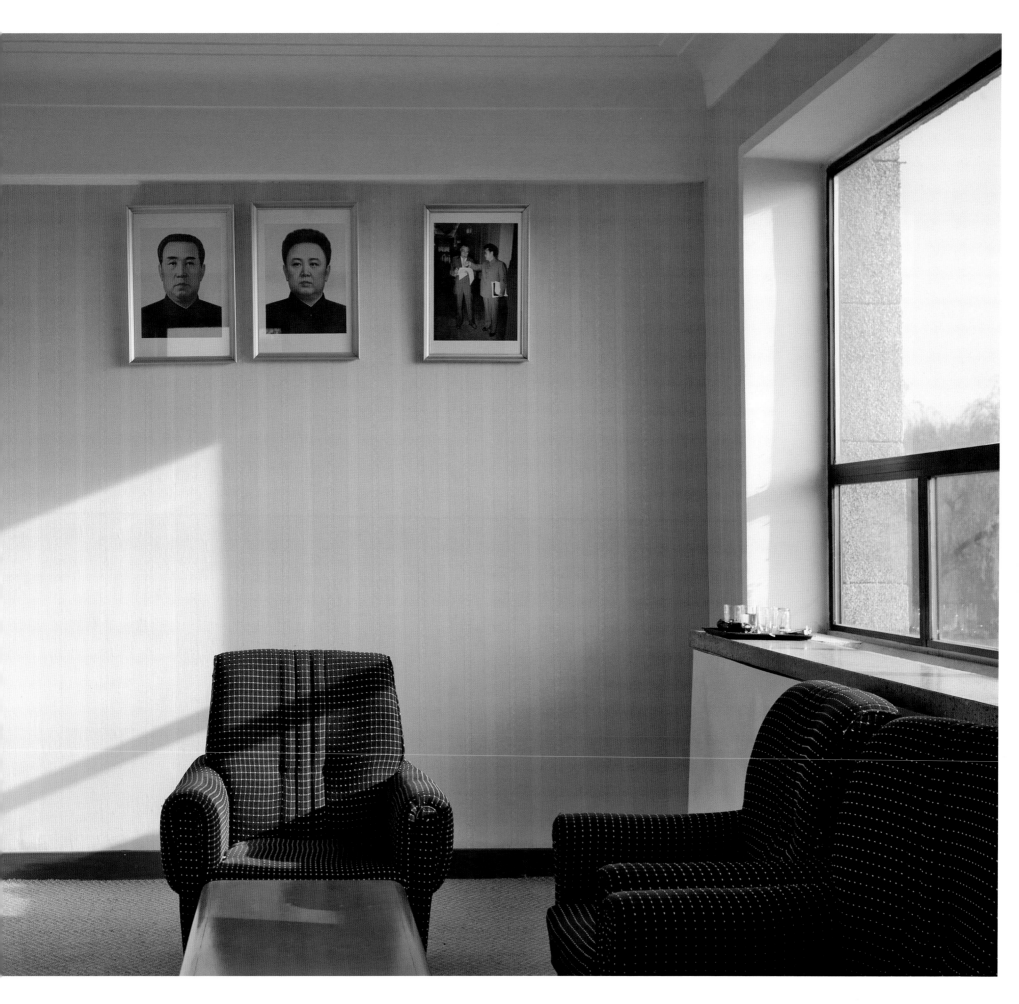

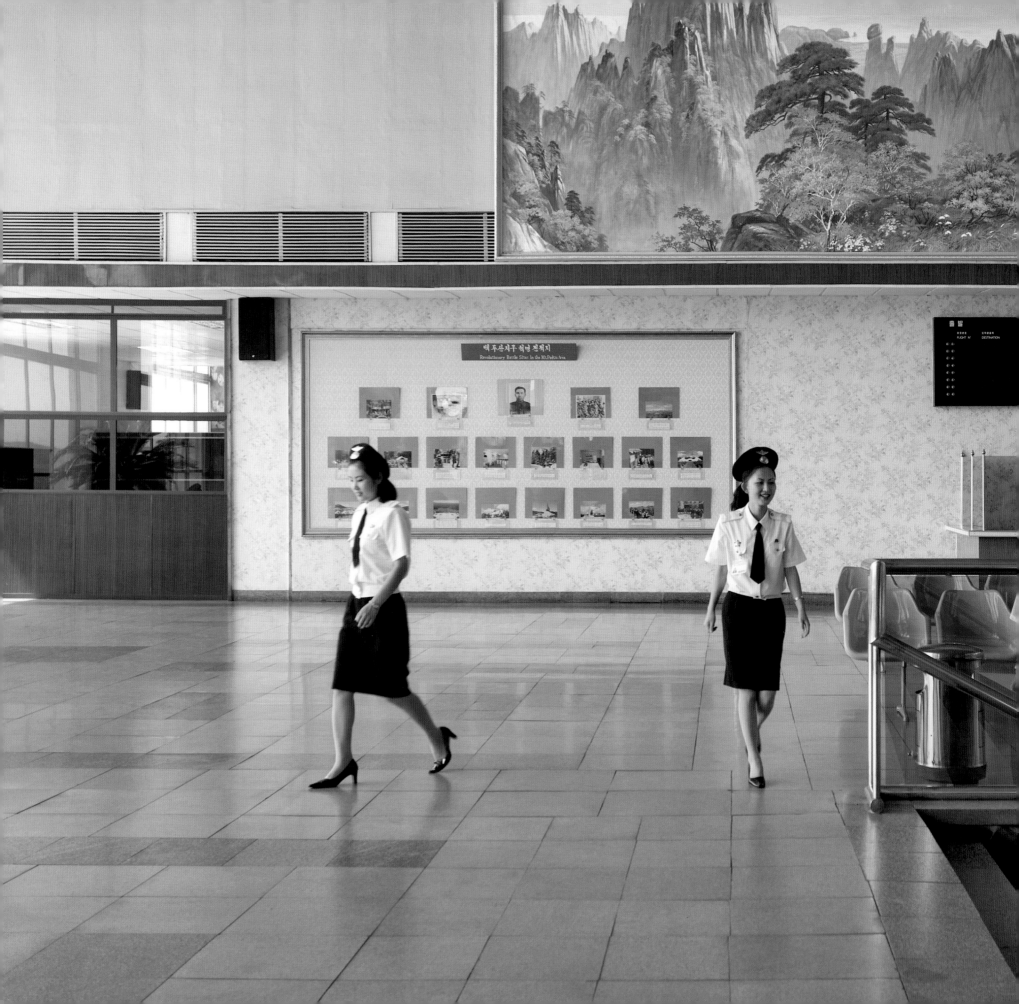

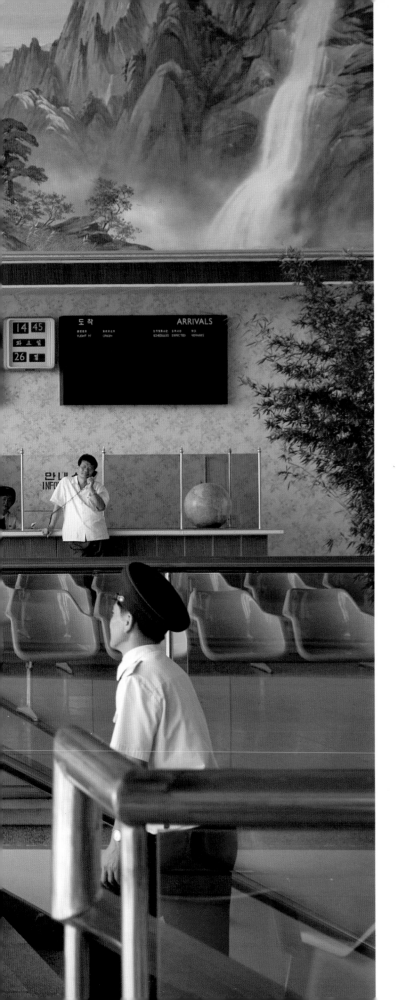

Arrivals hall, Pyongyang Airport · 35

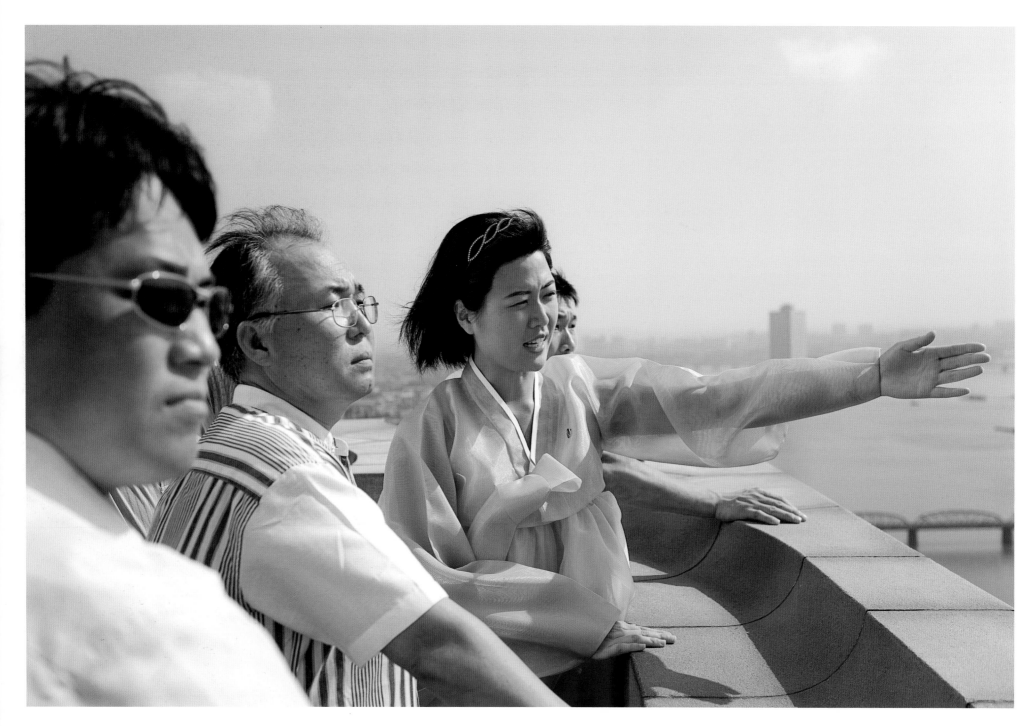

Looking out over Pyongyang from the top of the Juche Tower

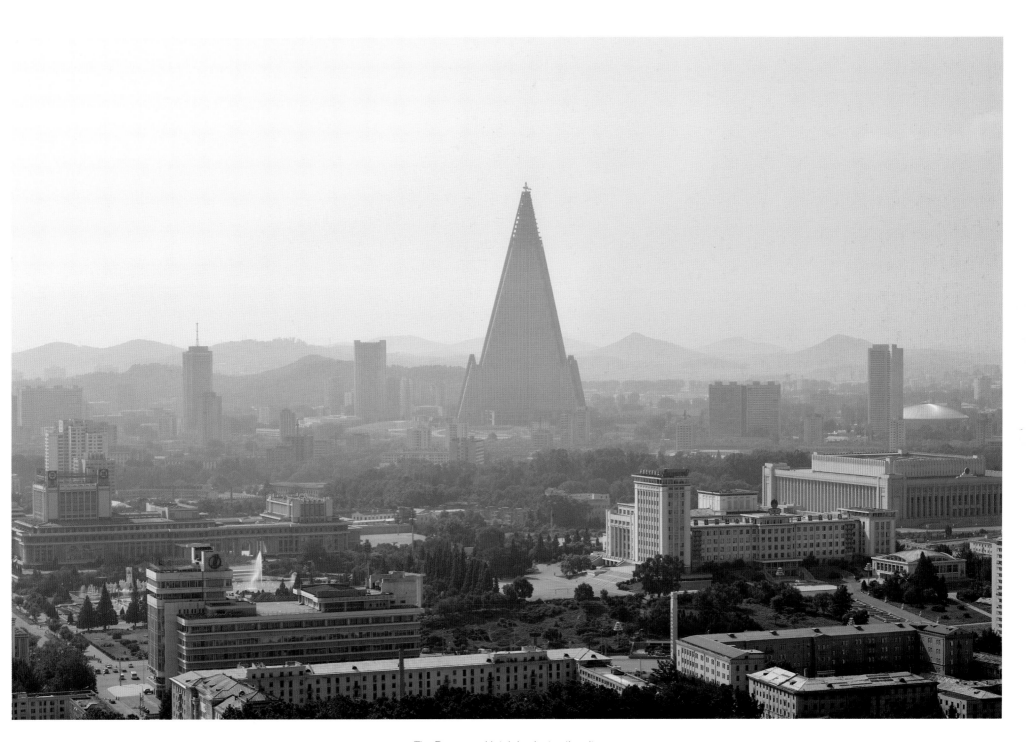

The Ryugyong Hotel dominates the city

38 Monument to the Party Foundation, Pyongyang. Political slogans adorn the rotunda ('Long live the Korean Workers' Party, which has coordinated and led the Korean people in all their victories') and the buildings behind ('One hundred victories – One hundred battles').

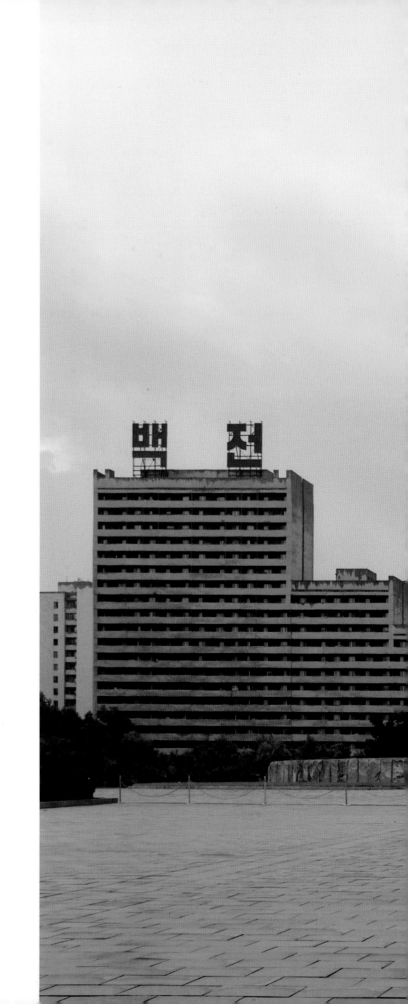

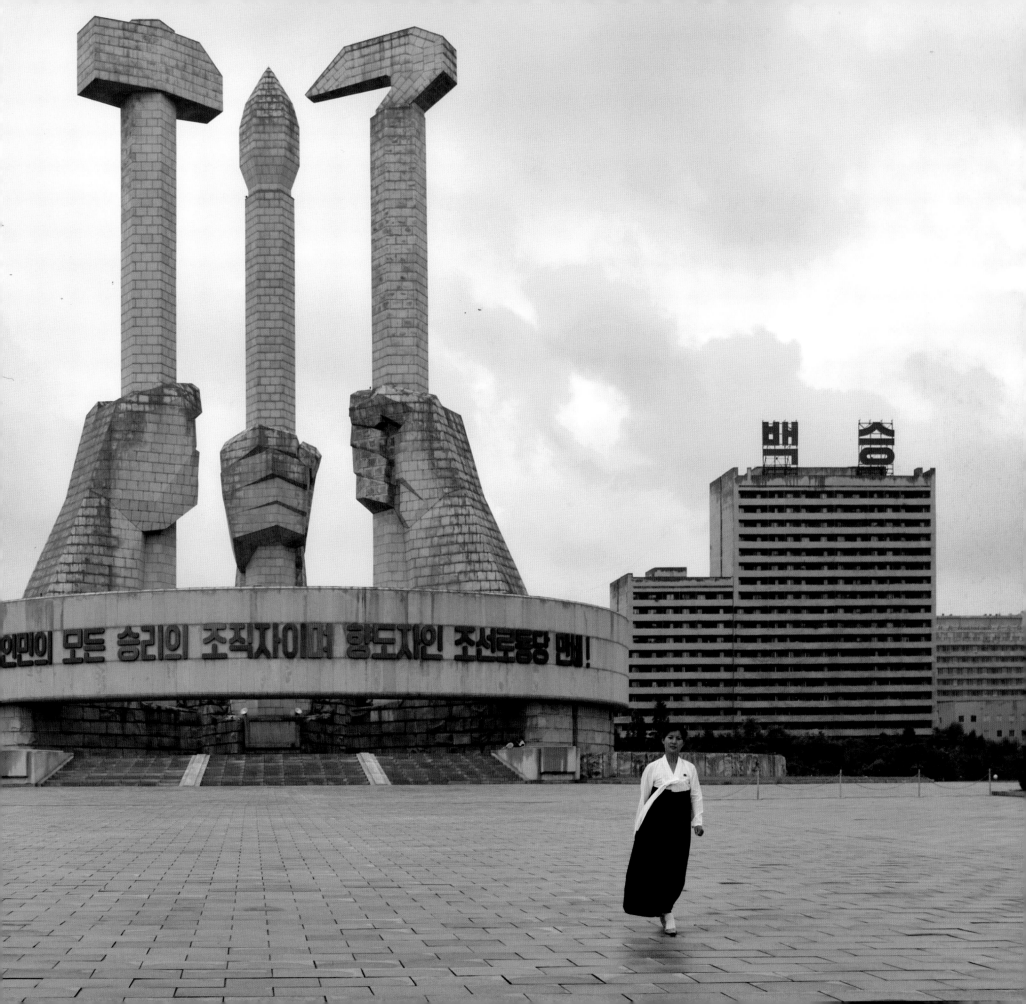

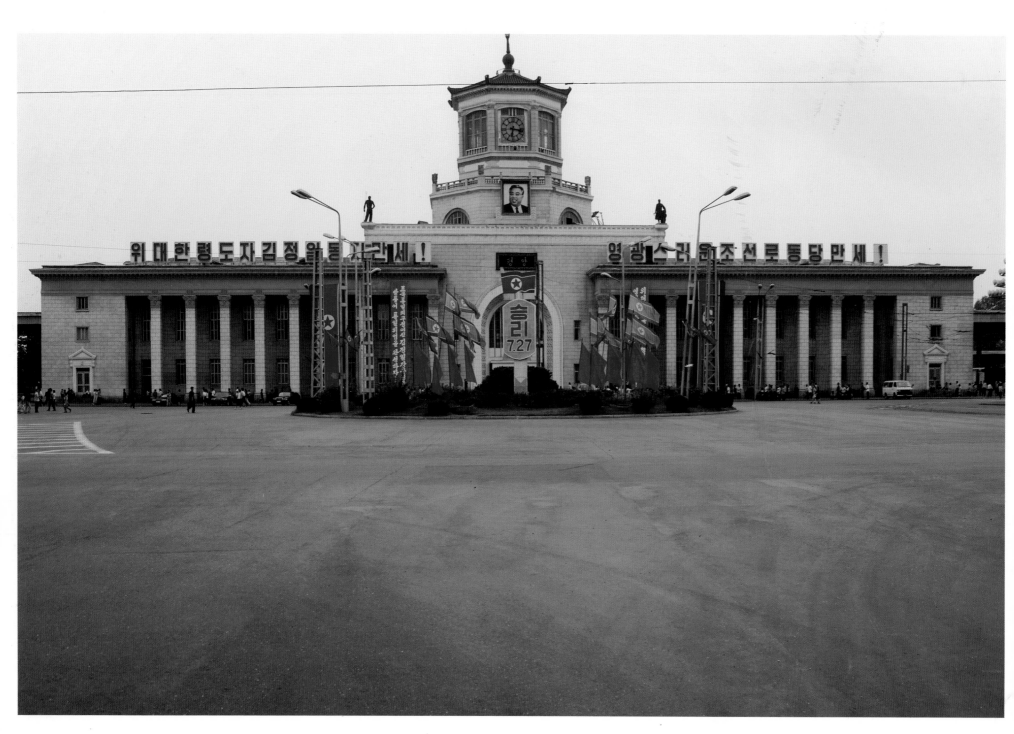

Pyongyang Station: 'Long live our comrade Kim Jong-il, the Dear Leader. Long live the glorious Korean Workers' Party.'

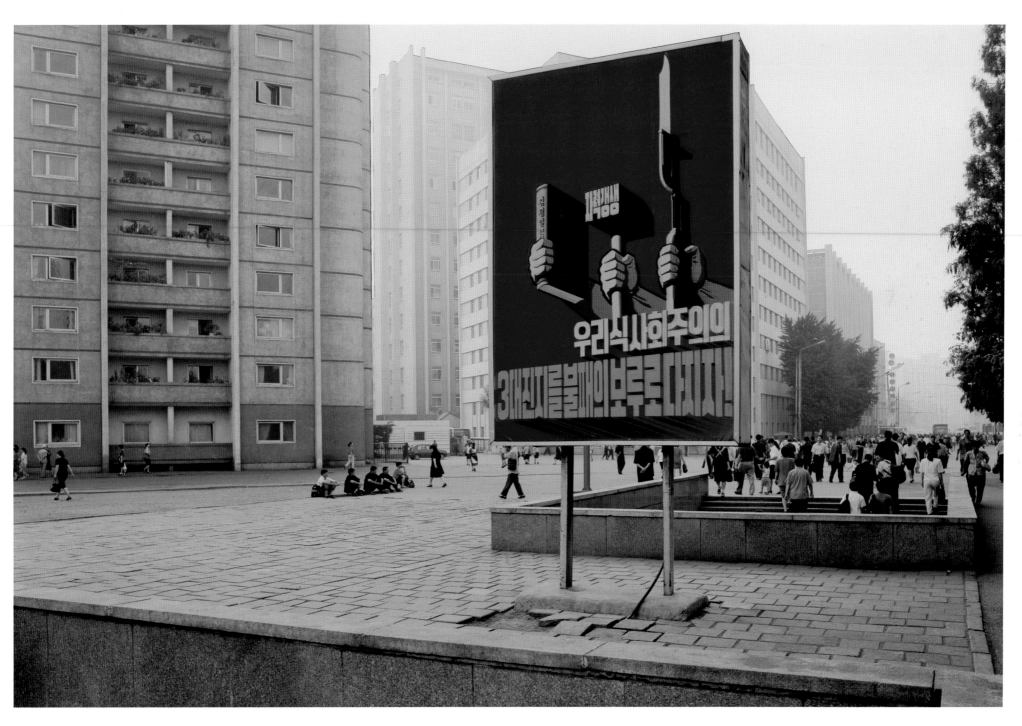

The hammer ('confidence in oneself') reinforces the slogan below: 'We strengthen the three foundations of our socialism like an invincible fortress'

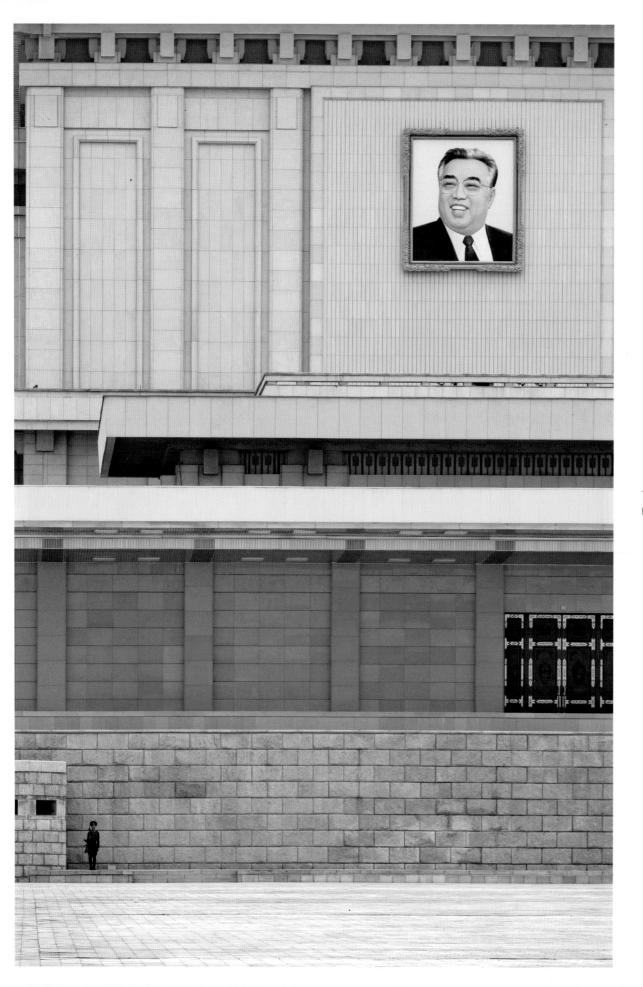

The Kumsusan Memorial Palace: Kim Il-sung's former home has been transformed into his mausoleum

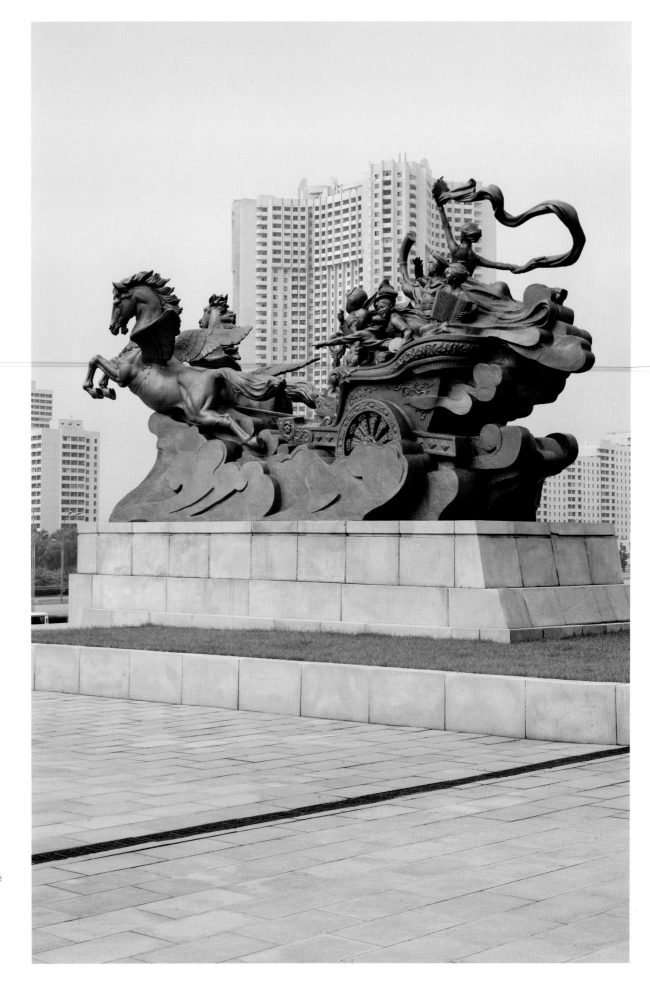

Bronze sculpture at the Children's Palace

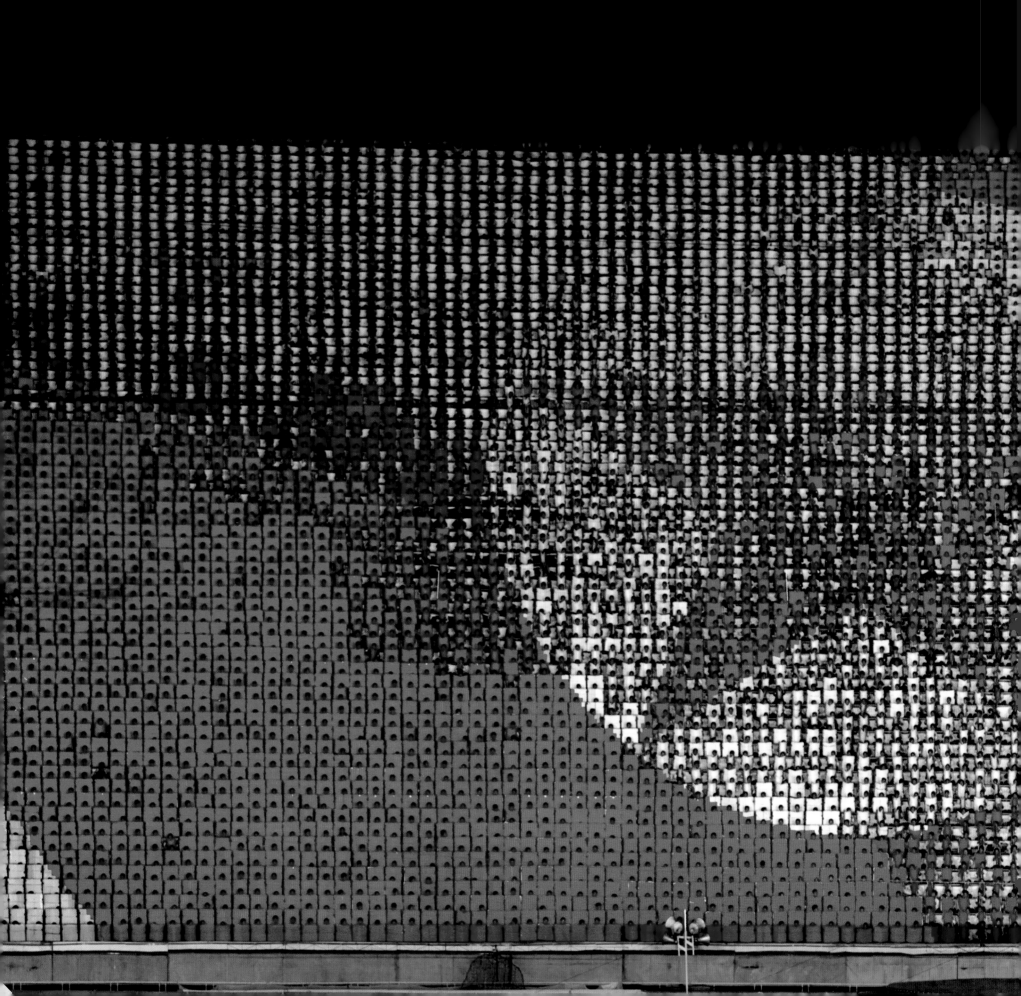

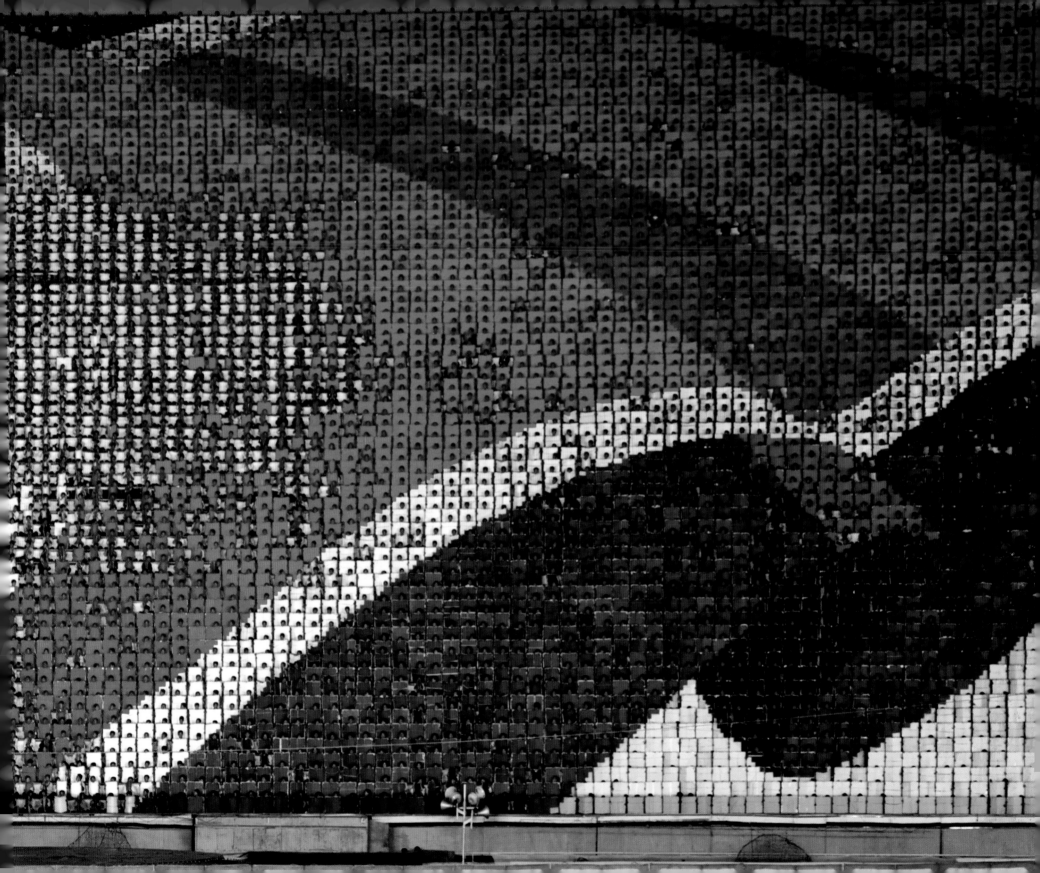

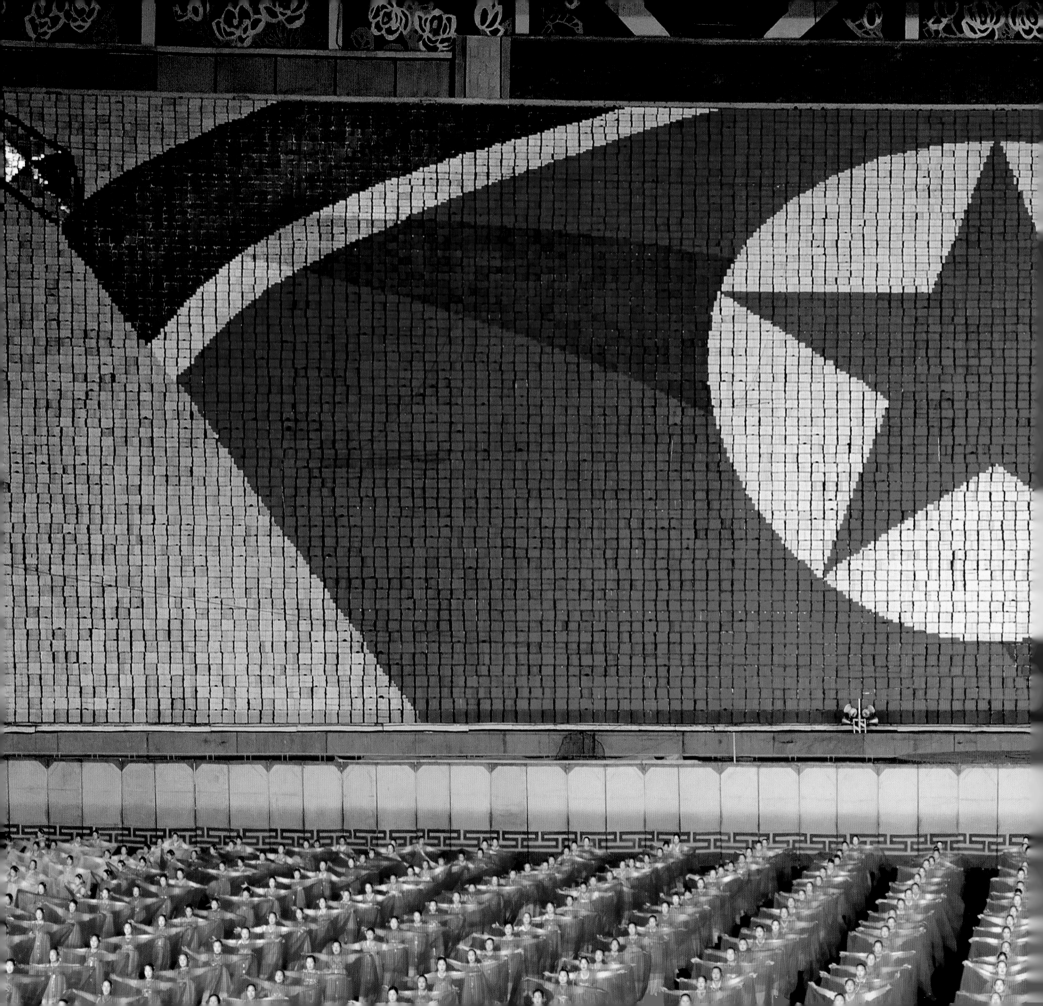

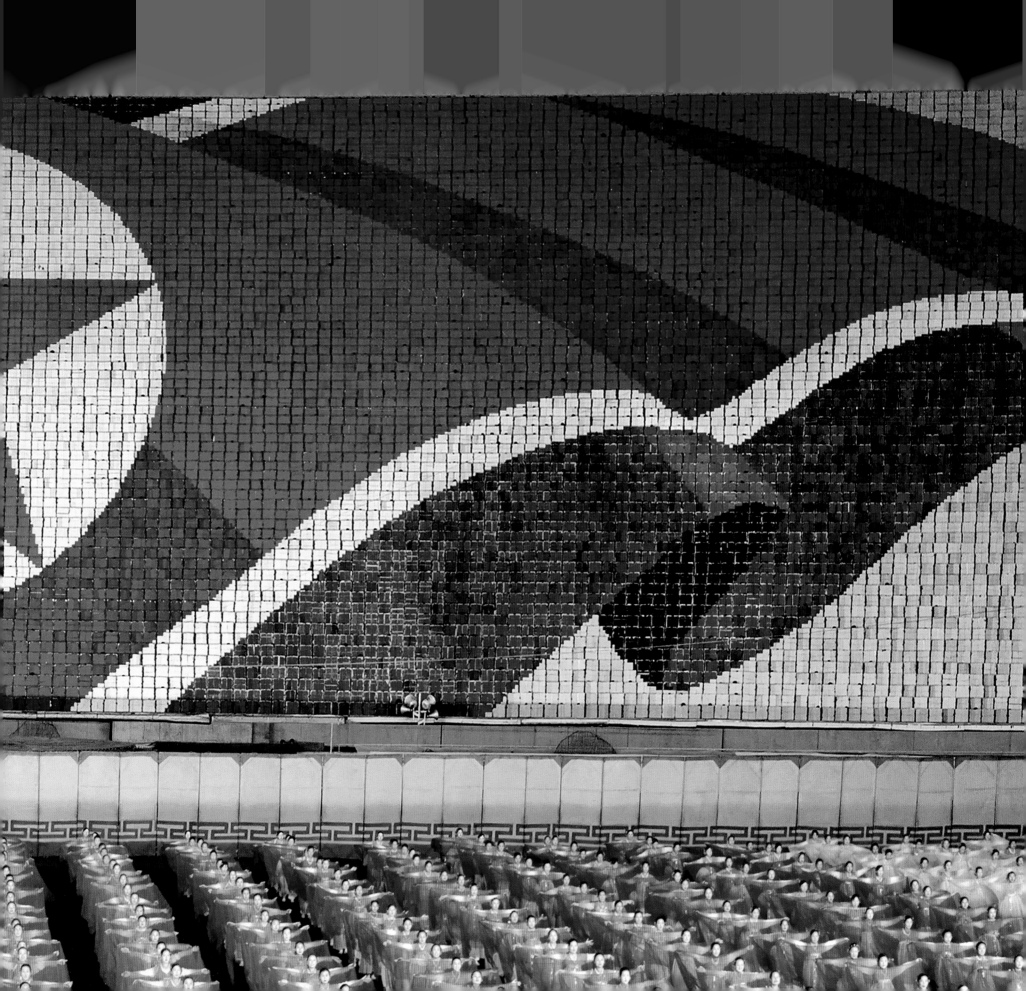

Preceding pages: Flags fluttering in the wind, Arirang Festival

48 The room where the Armistice between North and South was signed in 1953, Panmunjom

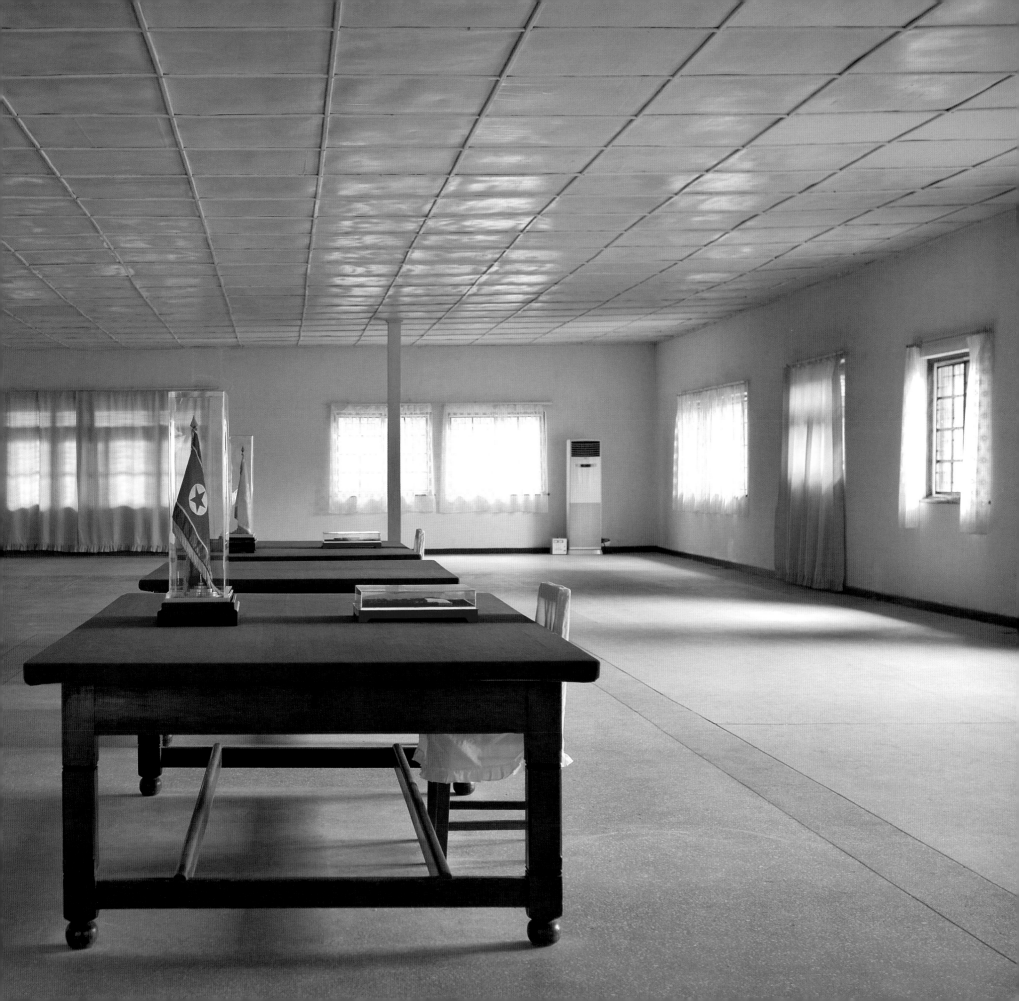

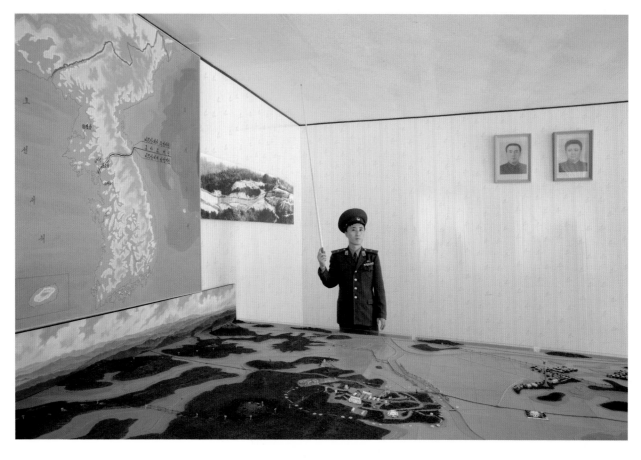

The map room, Panmunjom

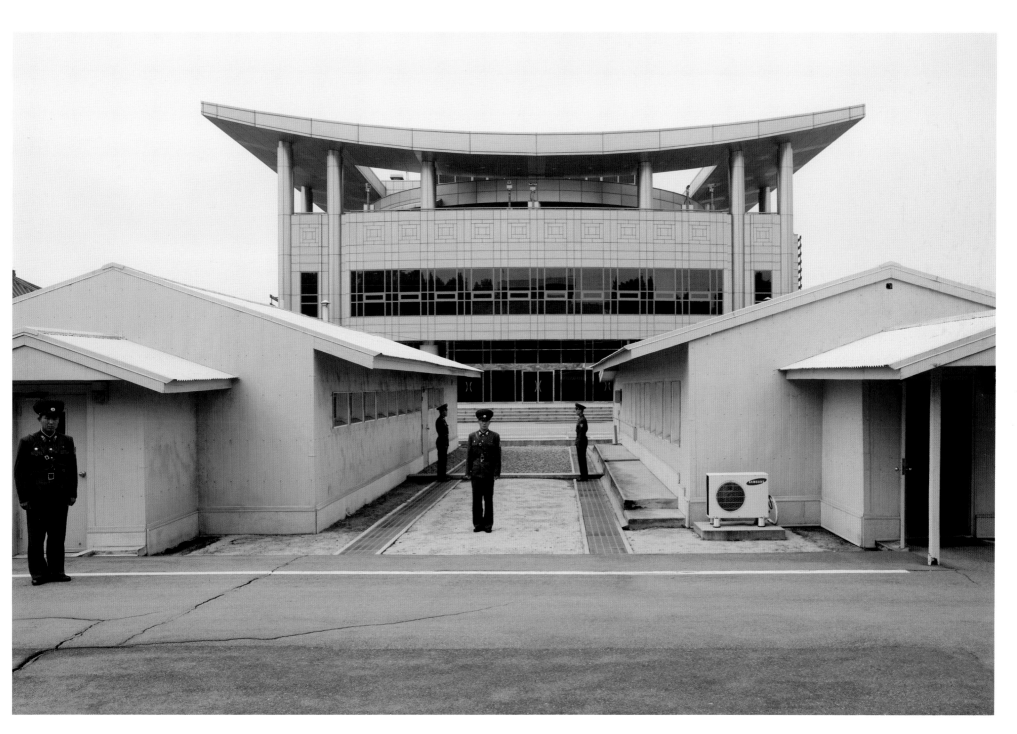

The Military Demarcation Line at Panmunjom marks the border between North and South

52 The location of the Six-Party Talks on North Korea's nuclear programme, Panmunjom

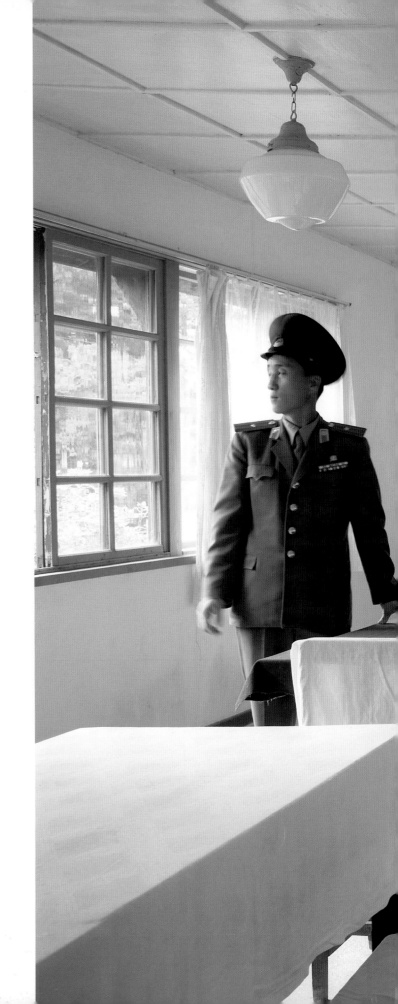

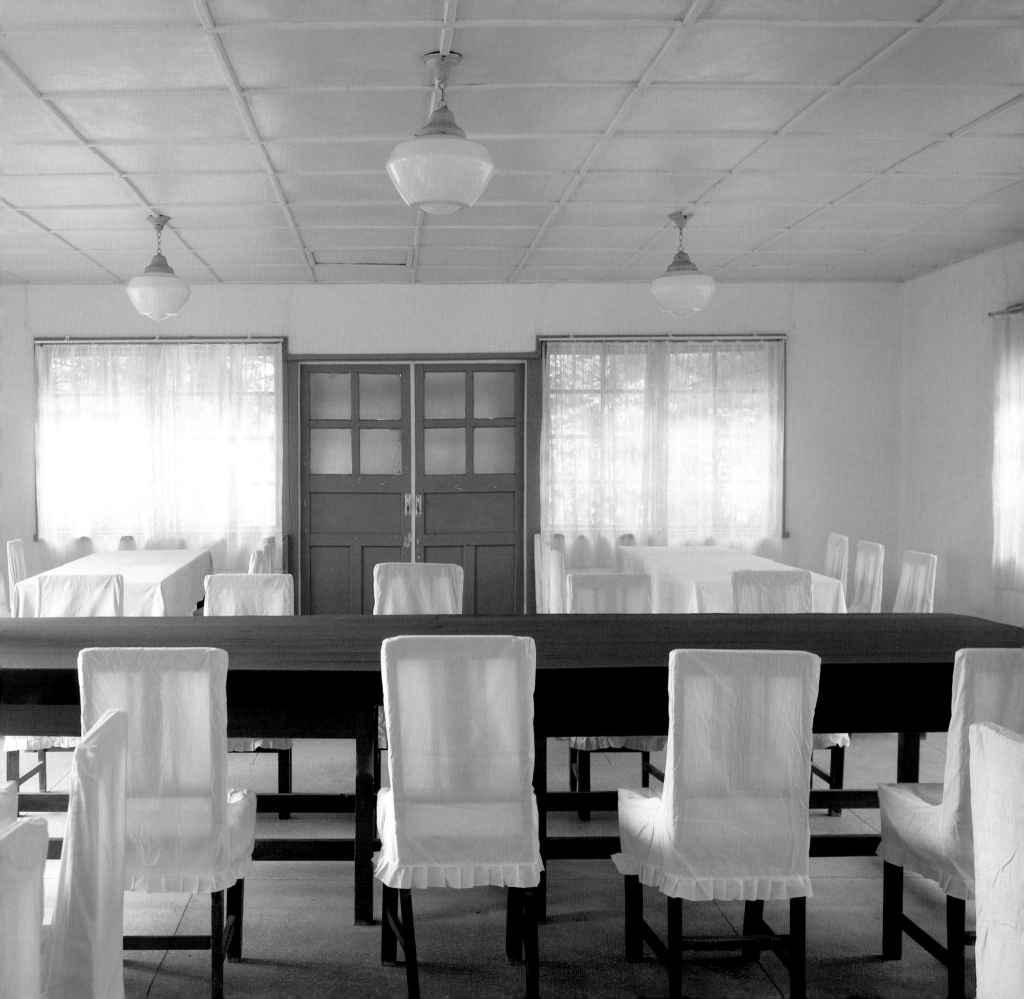

54 Kim Il-sung's pistol

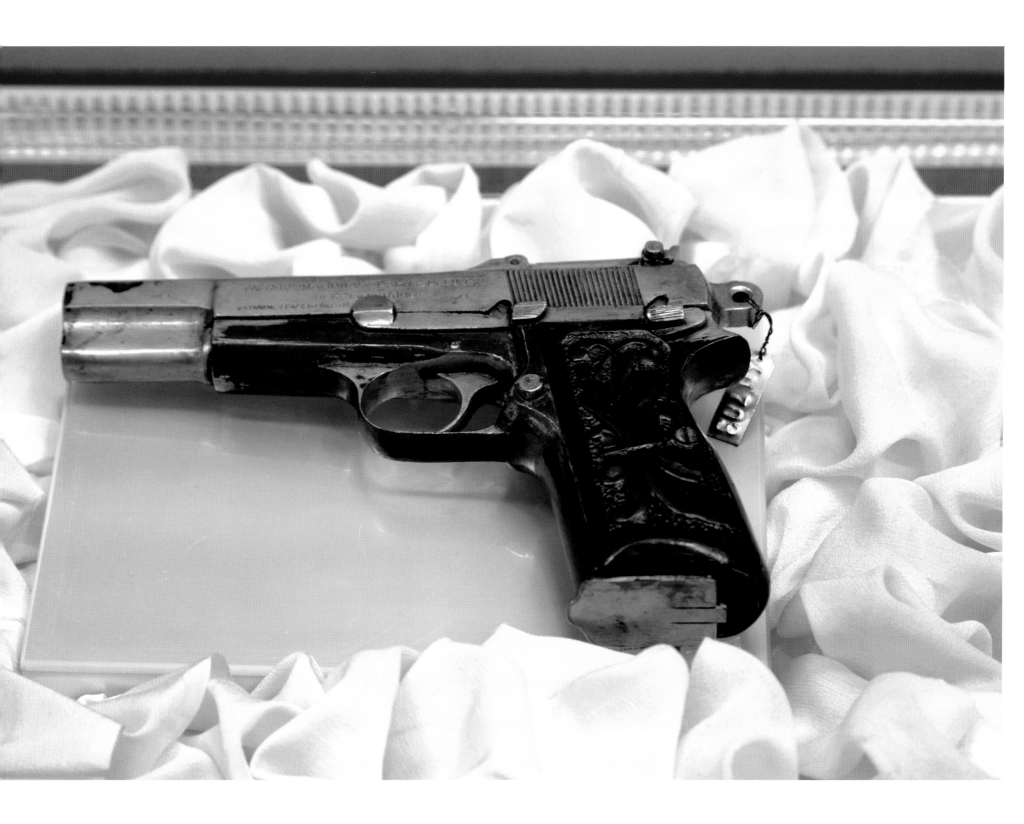

56 National liberation from Japanese occupation, celebrated at the Arirang Festival.
 Kim Il-sung is said to have used his father's two pistols in the conflict.

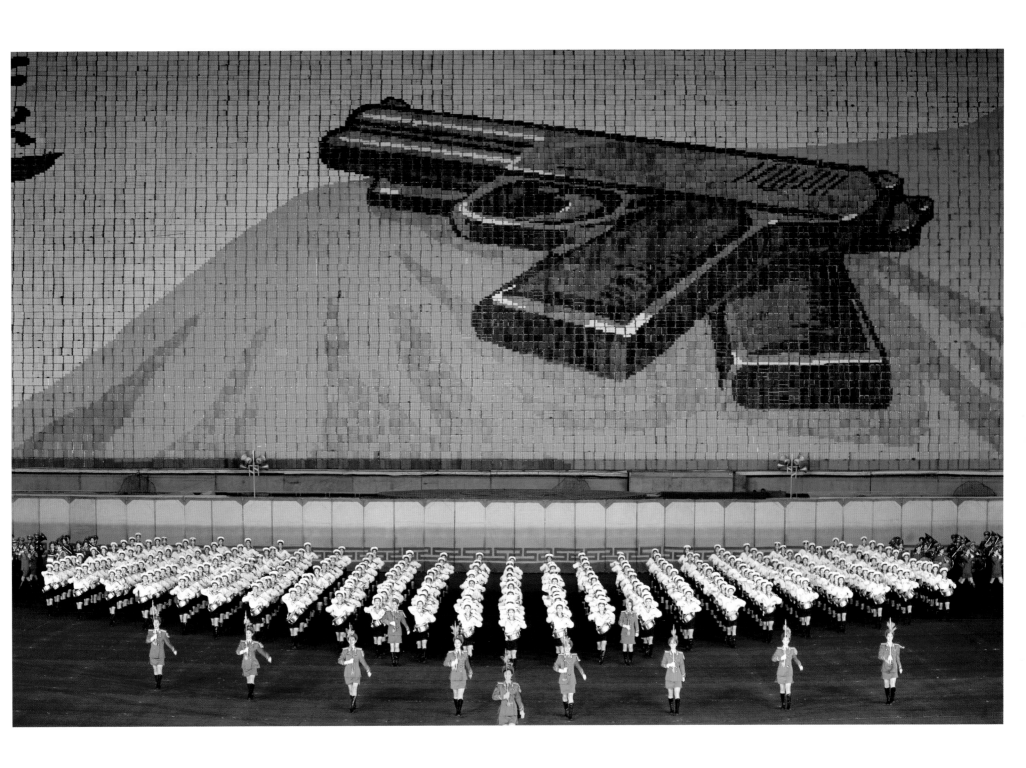

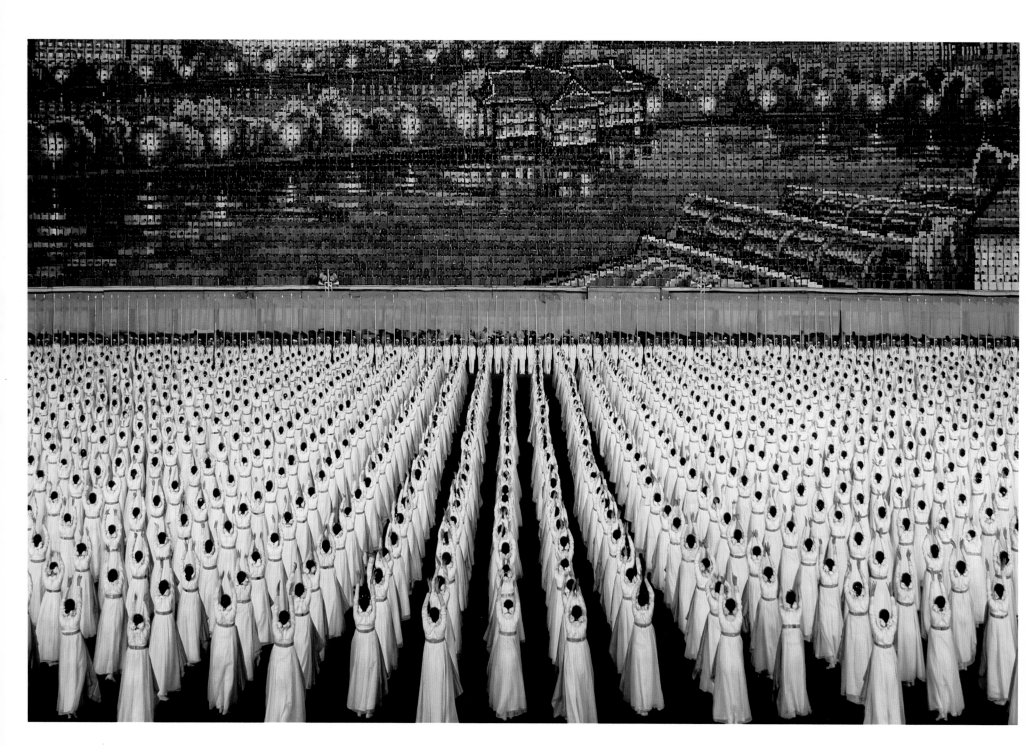

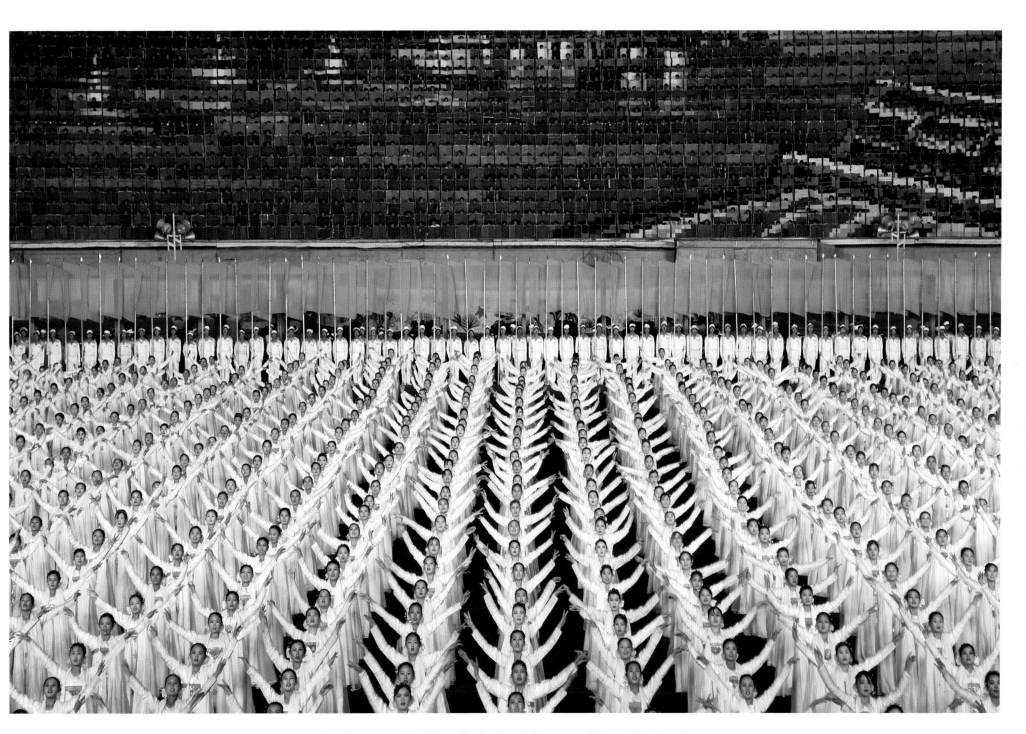

A performance at the Arirang Festival symbolizing 'moonlight on North Korea'

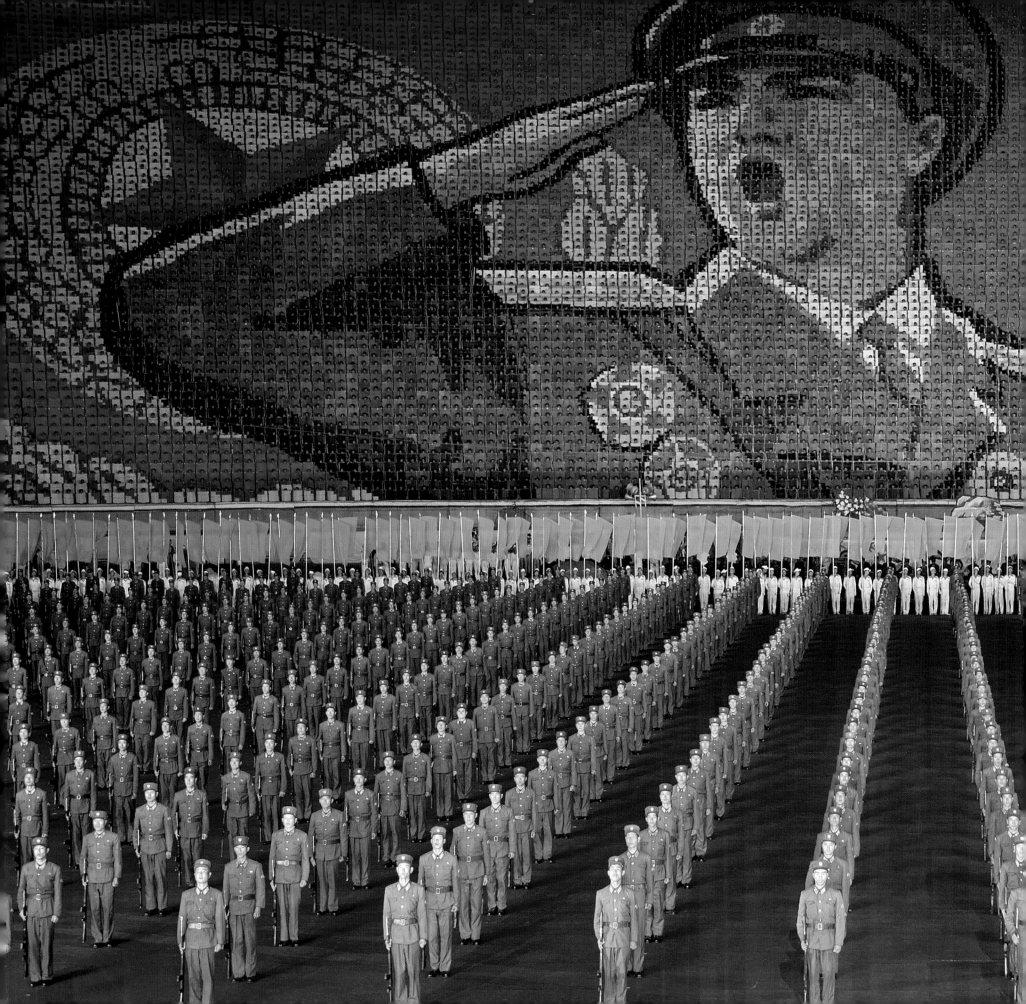

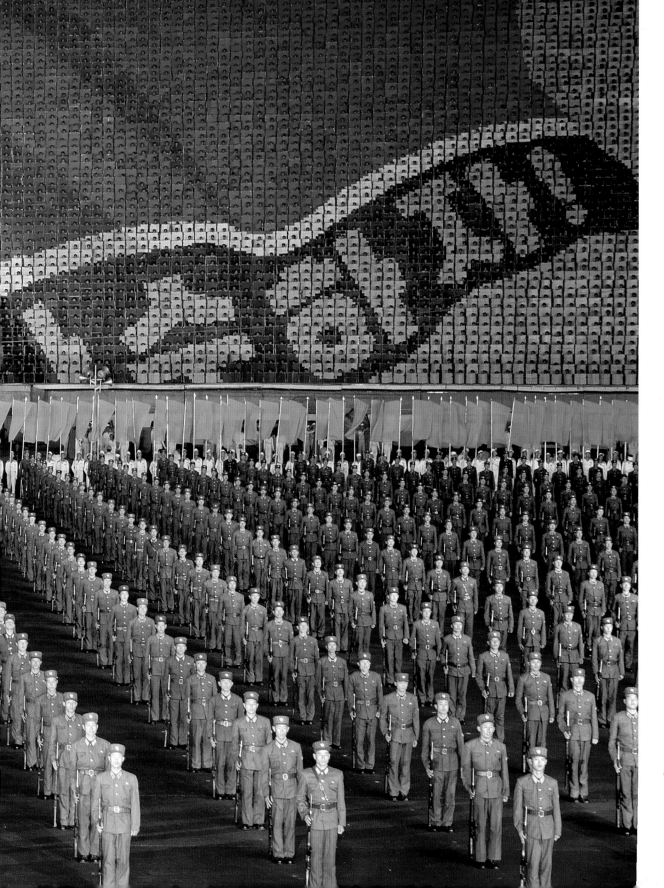

'Songun Politics', symbolizing the supremacy of the army 61

Overleaf: 'The great eternal power'

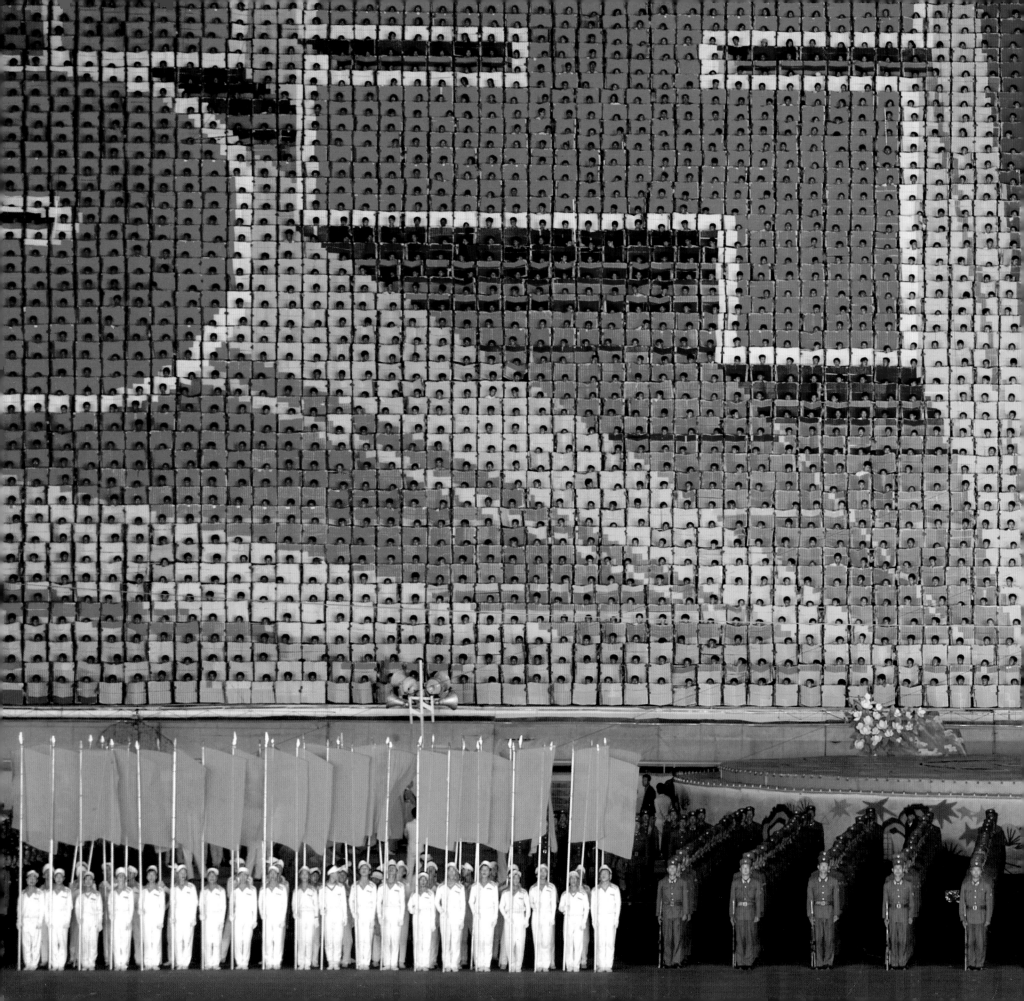

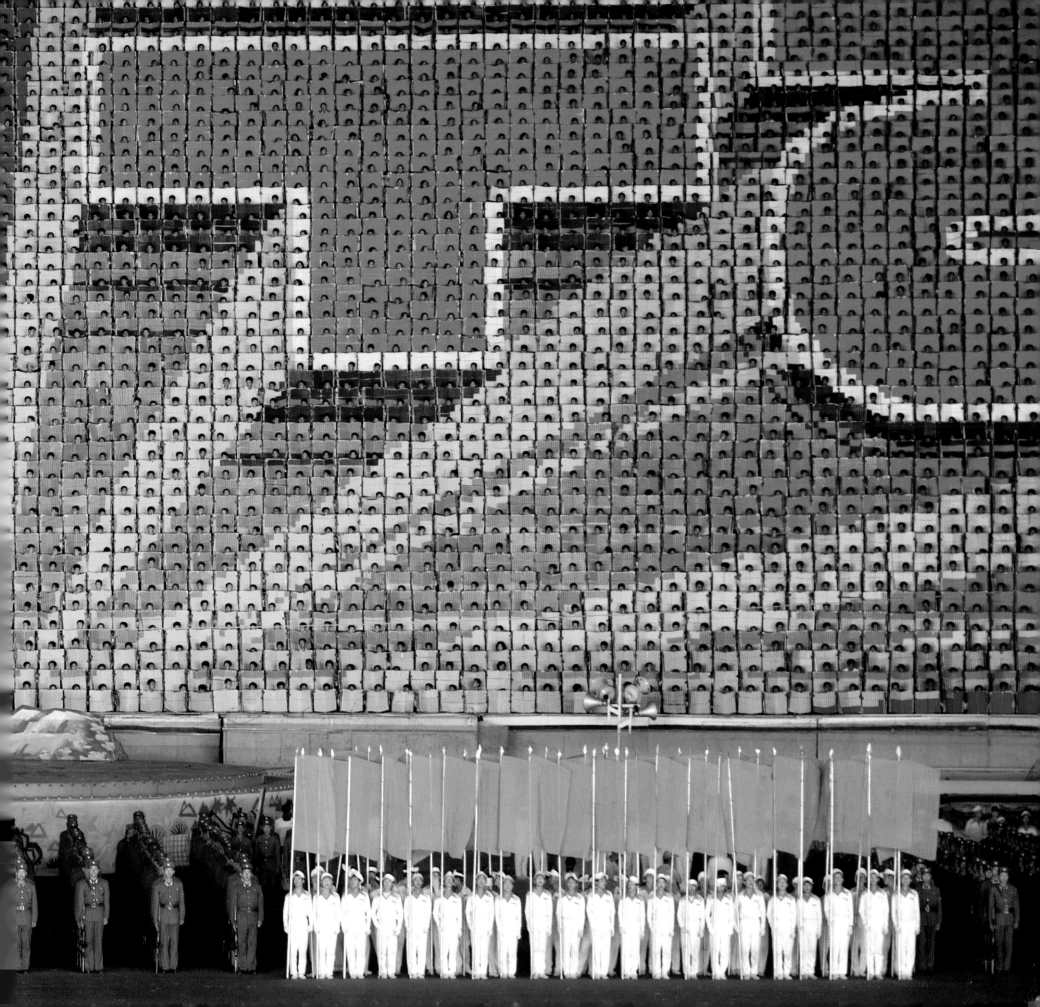

64 Pyongyang prepares to celebrate the 60th anniversary of the Korean Workers' Party,
10 October 2005

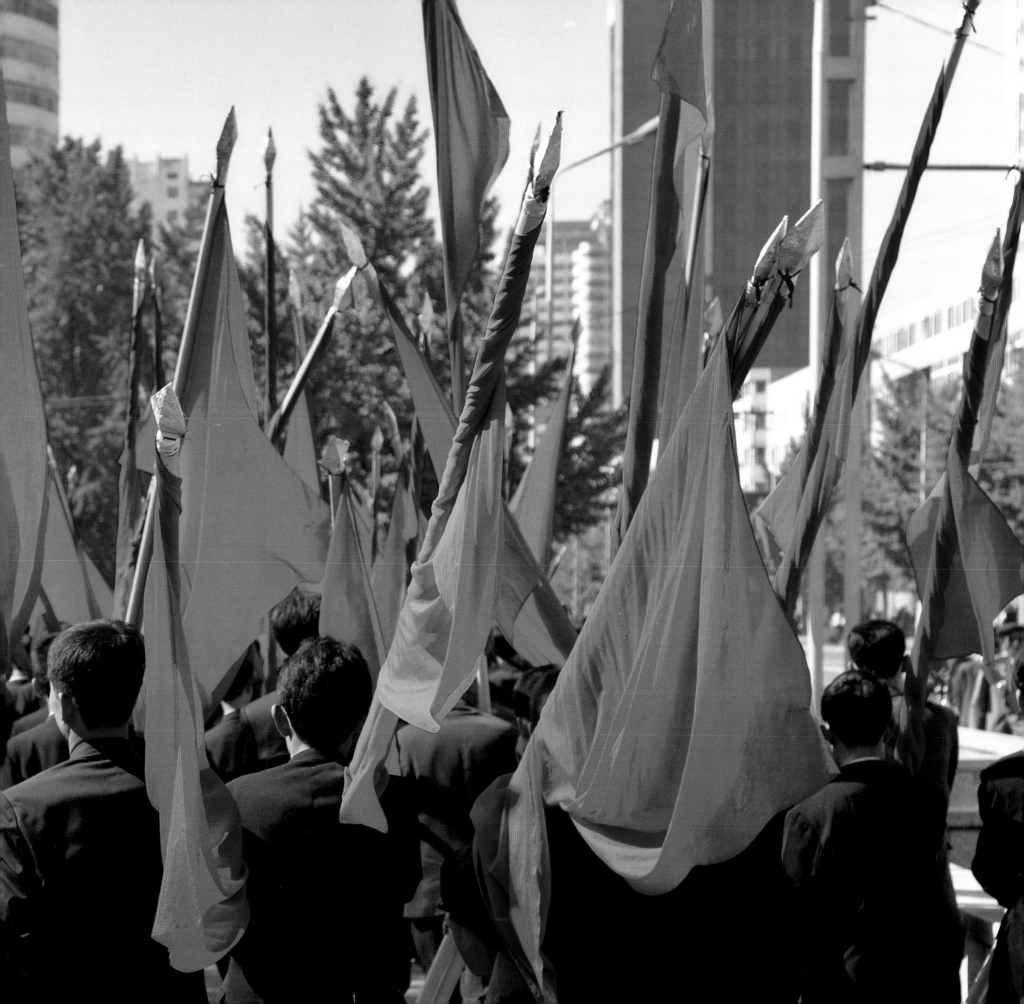

66 Soldiers pay homage at the Revolutionary Martyrs' Cemetery, Pyongyang

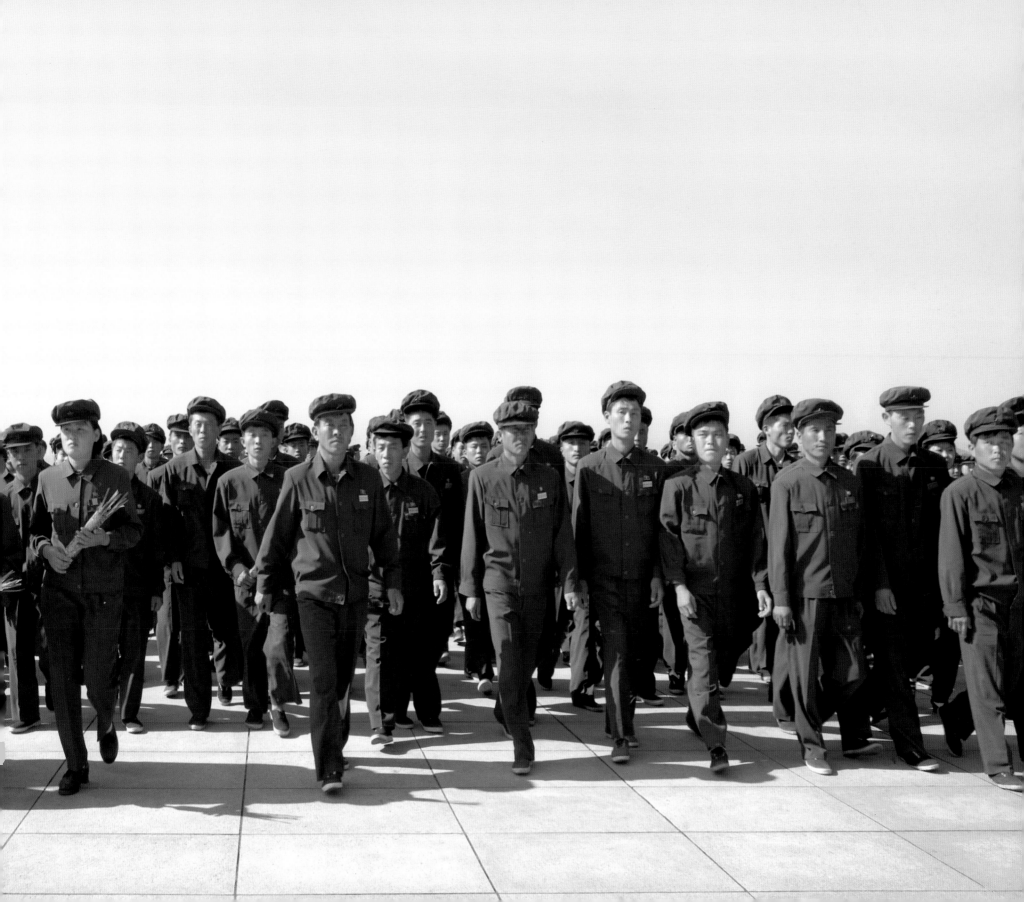

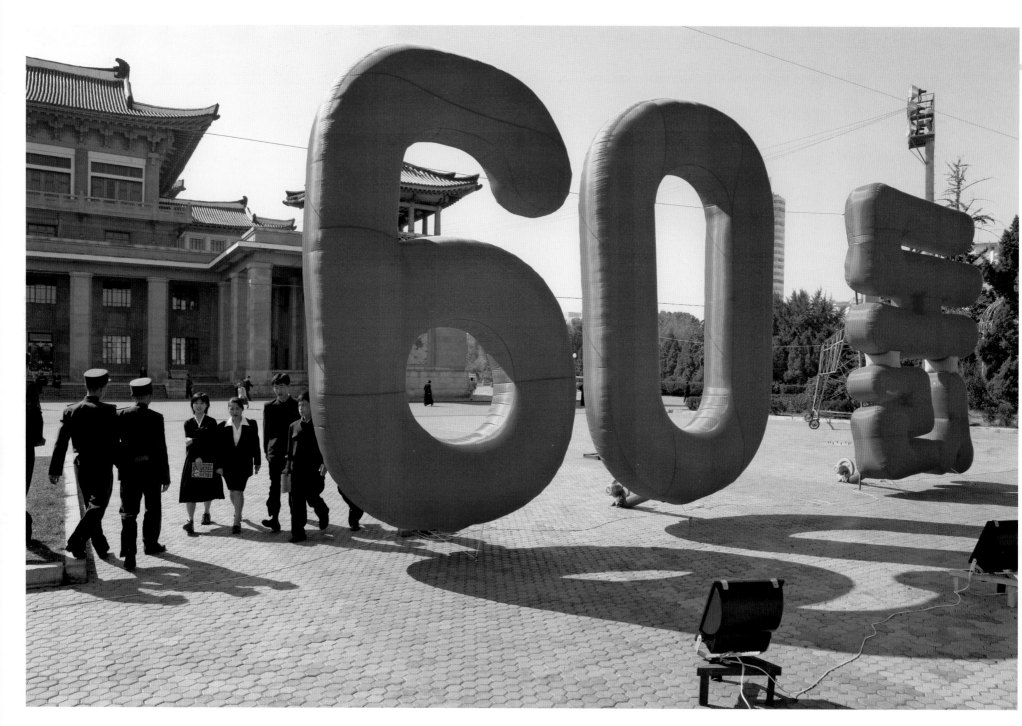

Decorations for the 60th anniversary

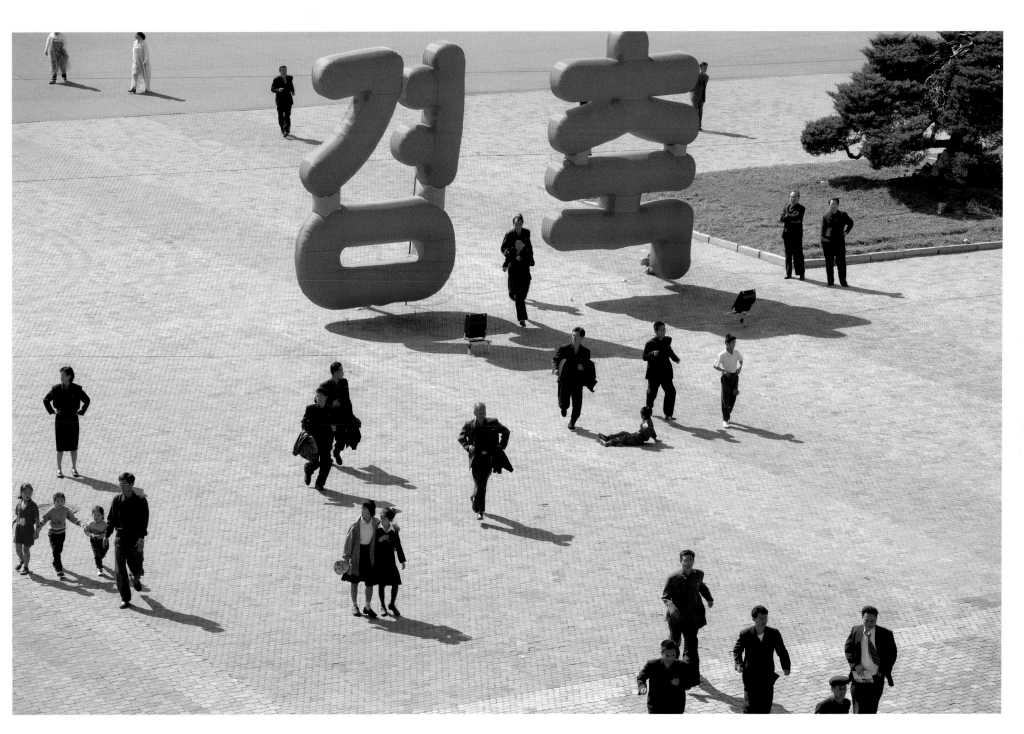

On the way to the anniversary celebrations

70 Kim Il-sung Square, before the celebrations begin

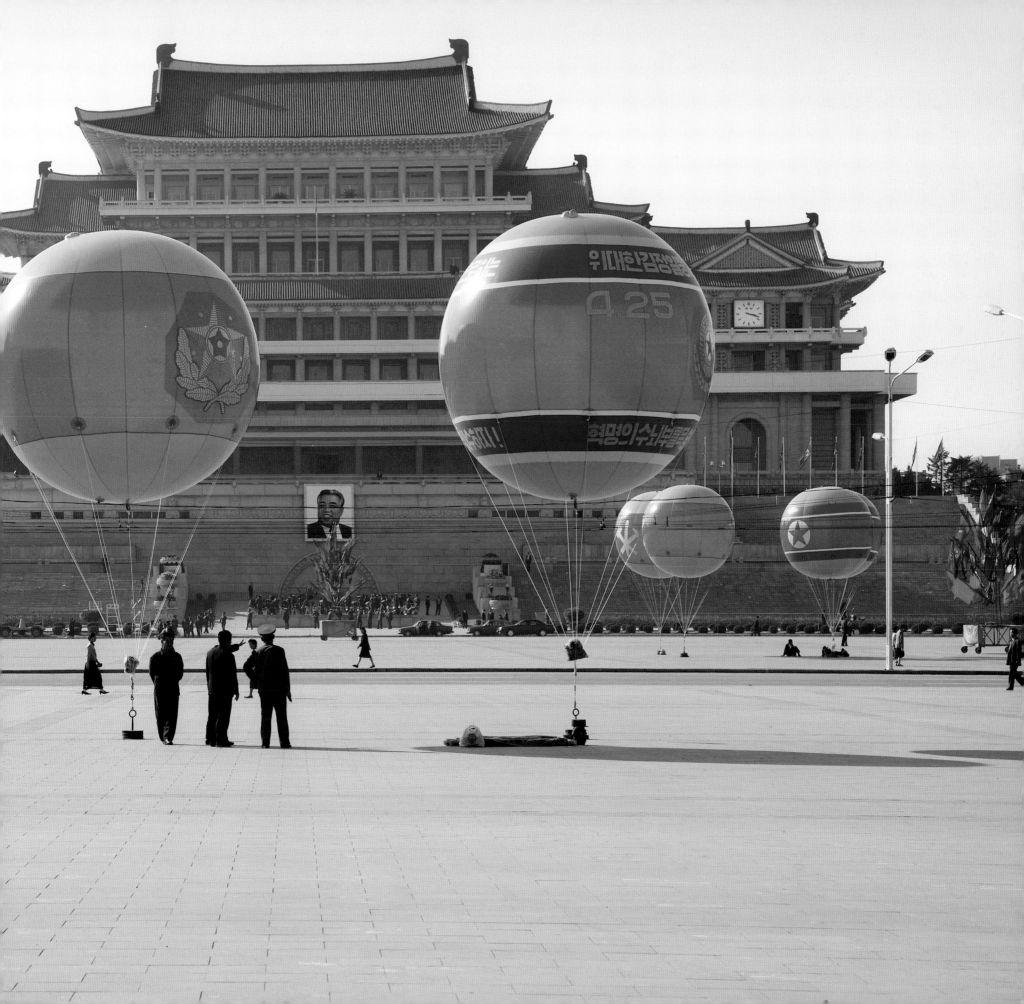

72 Posing for the camera in Kim Il-sung Square

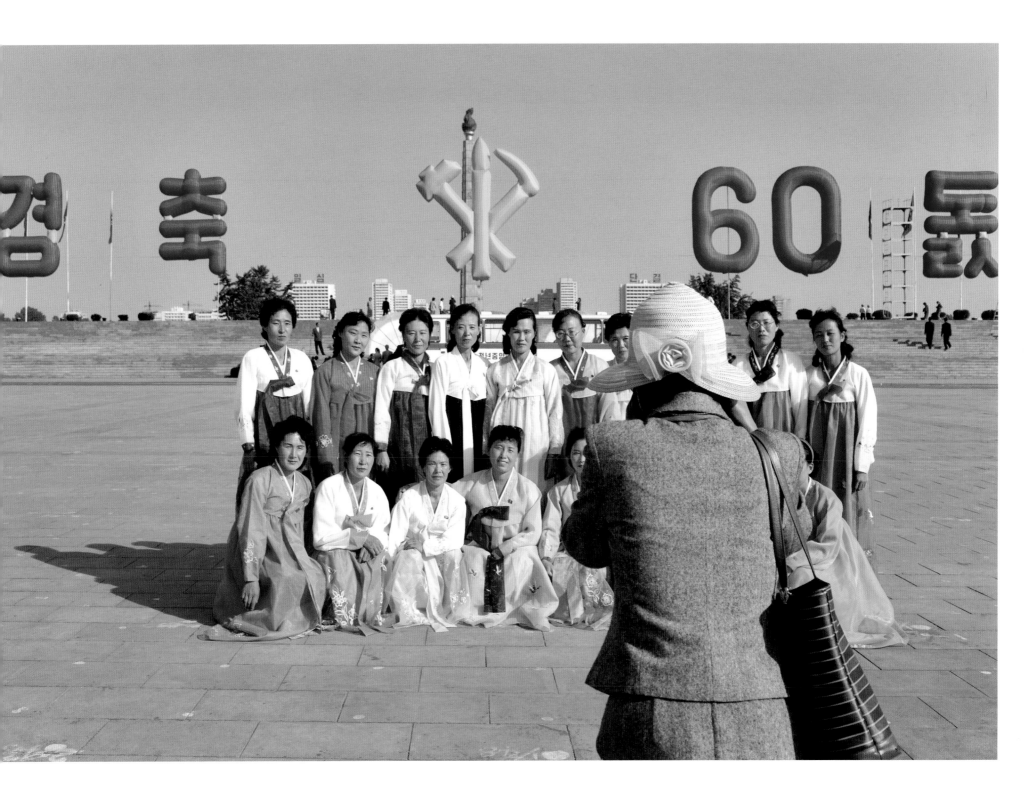

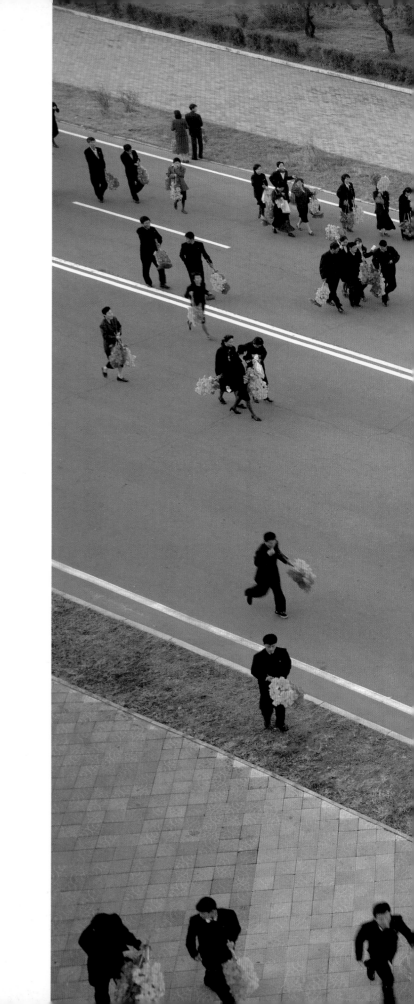

74 Participants head to the anniversary celebrations

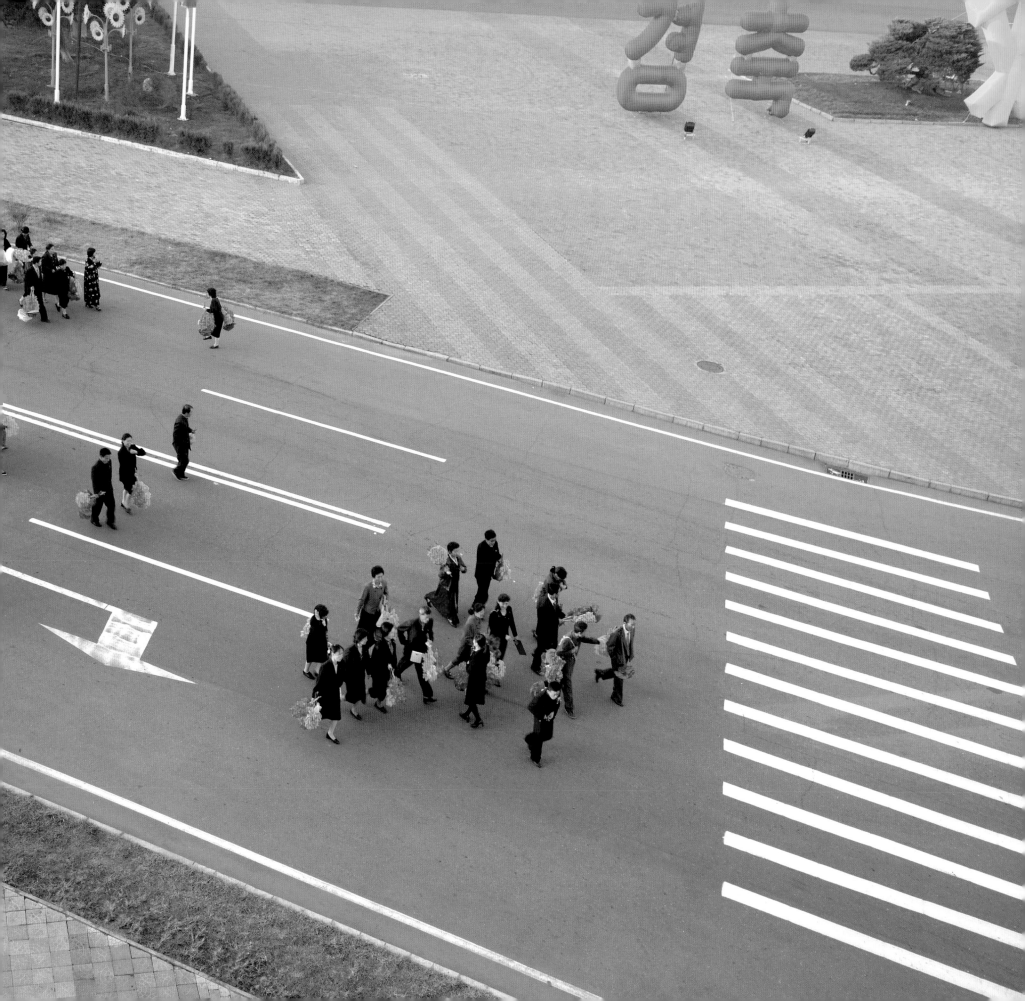

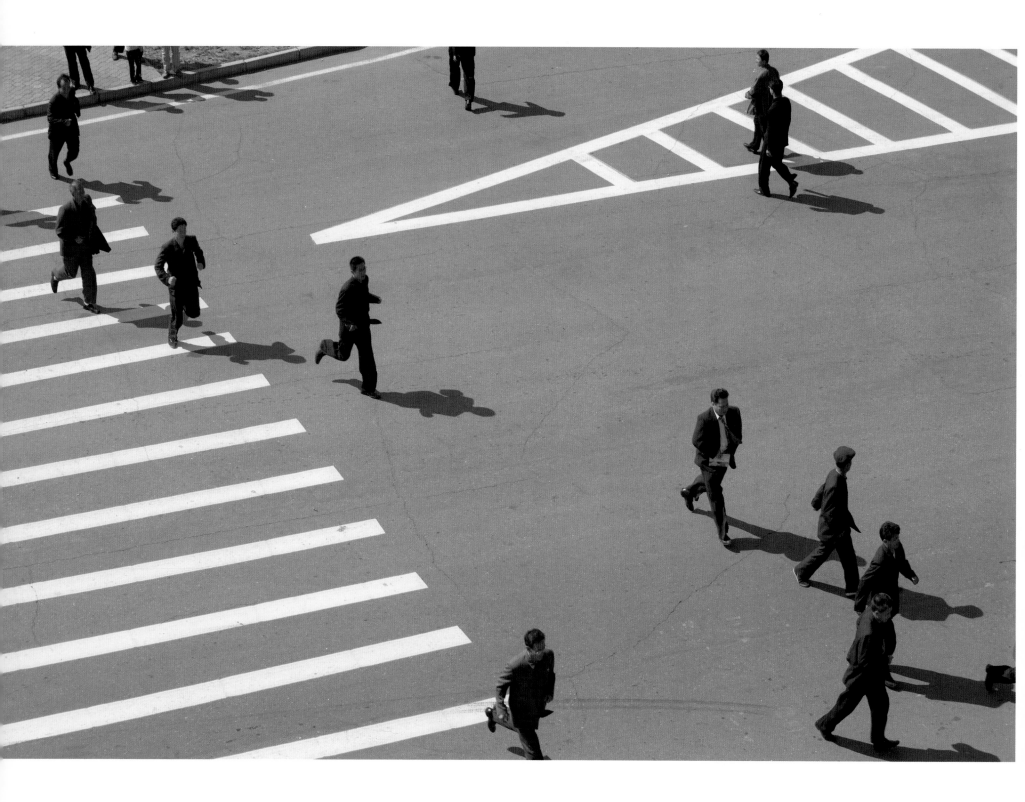

Spectators make their way to the anniversary celebrations

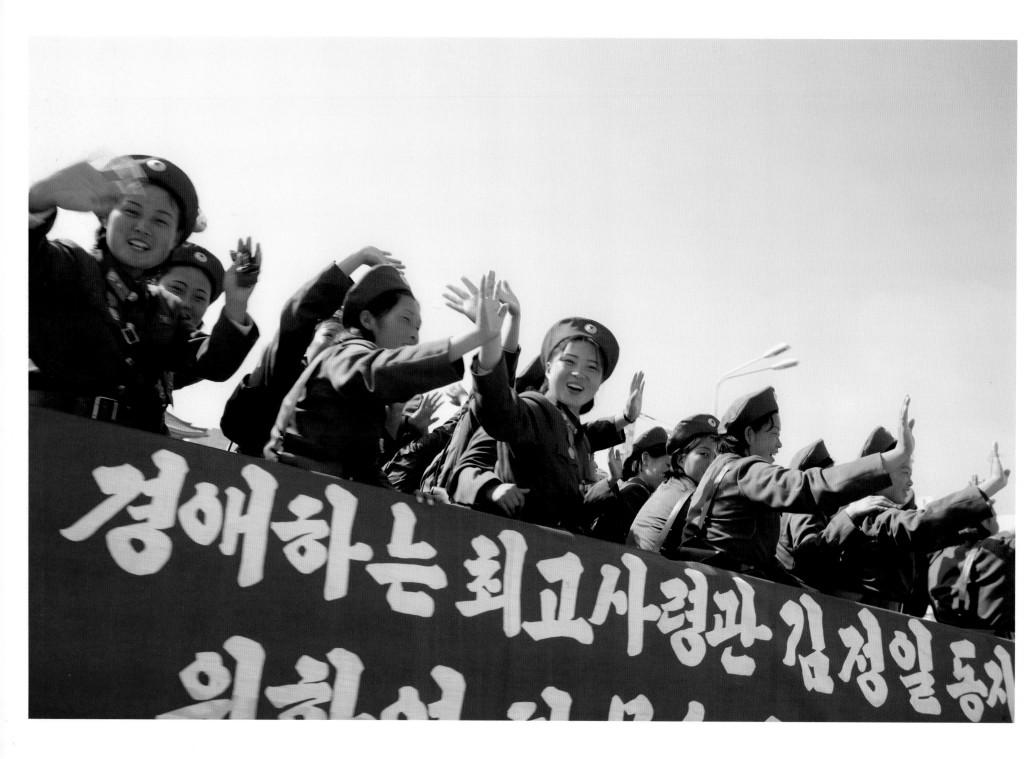

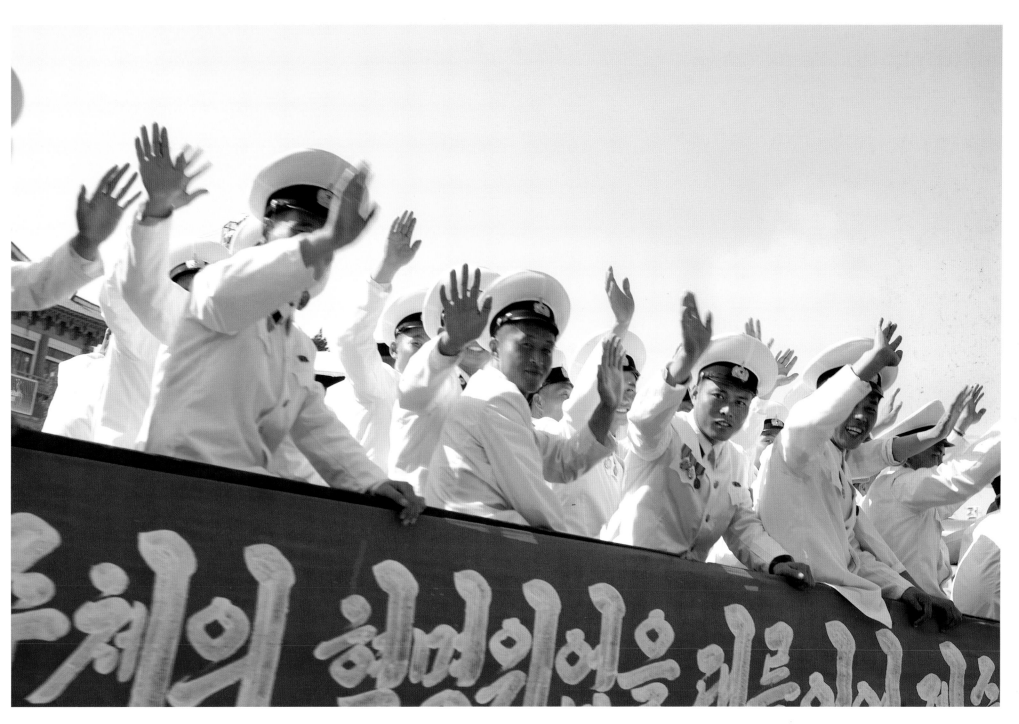

60th anniversary military parade. Left-hand banner: 'We would lay down our lives to protect our comrade Kim Jong-il, beloved supreme commander.'
Right-hand banner: 'We advance the revolutionary work of *Juche* by land, sea and air.'

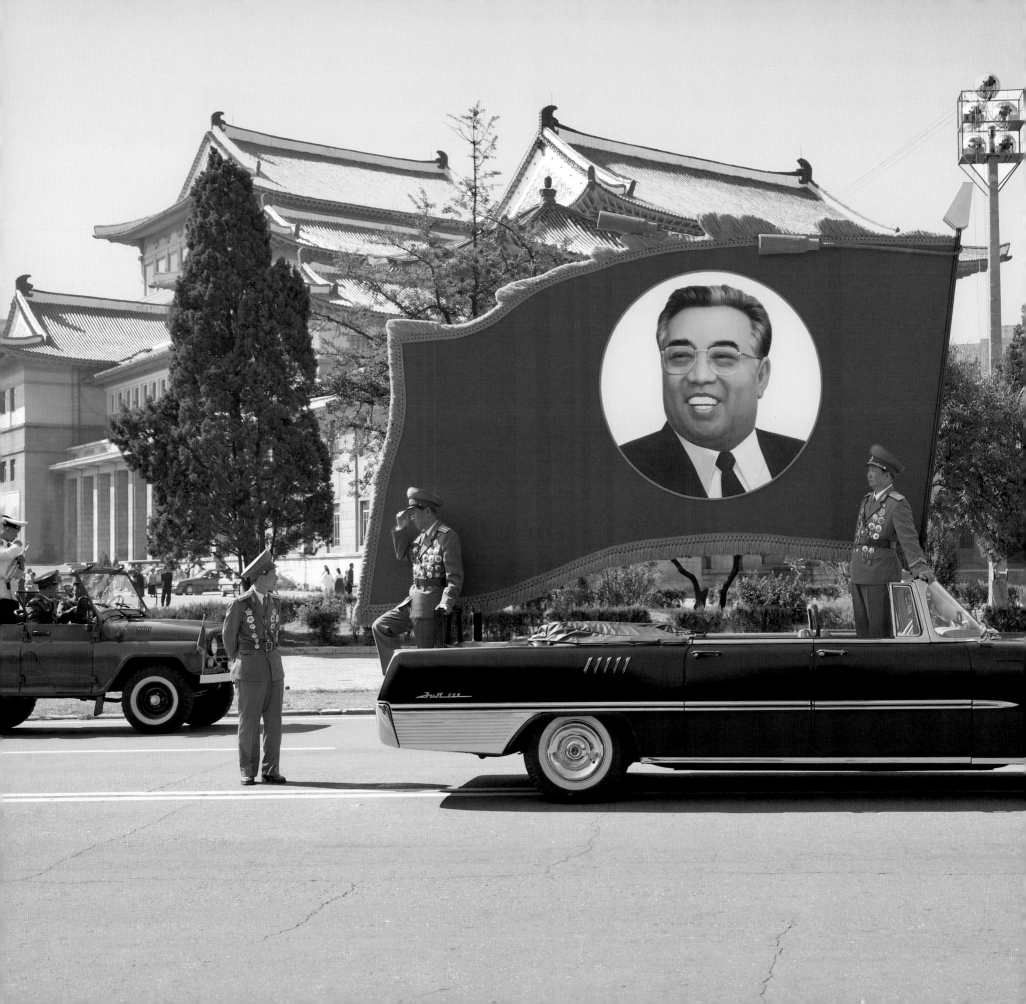

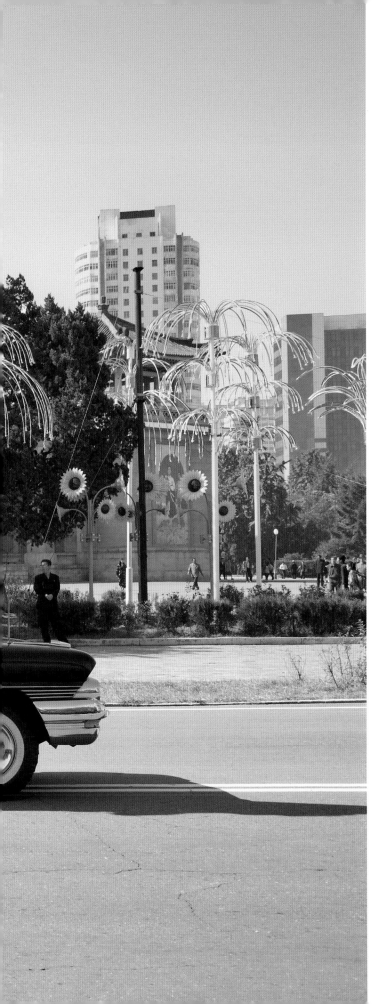

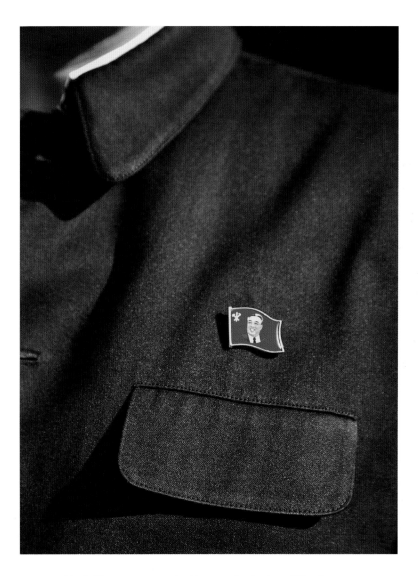

North Koreans are required to wear the badge of Kim Il-sung

The lead car in the military parade

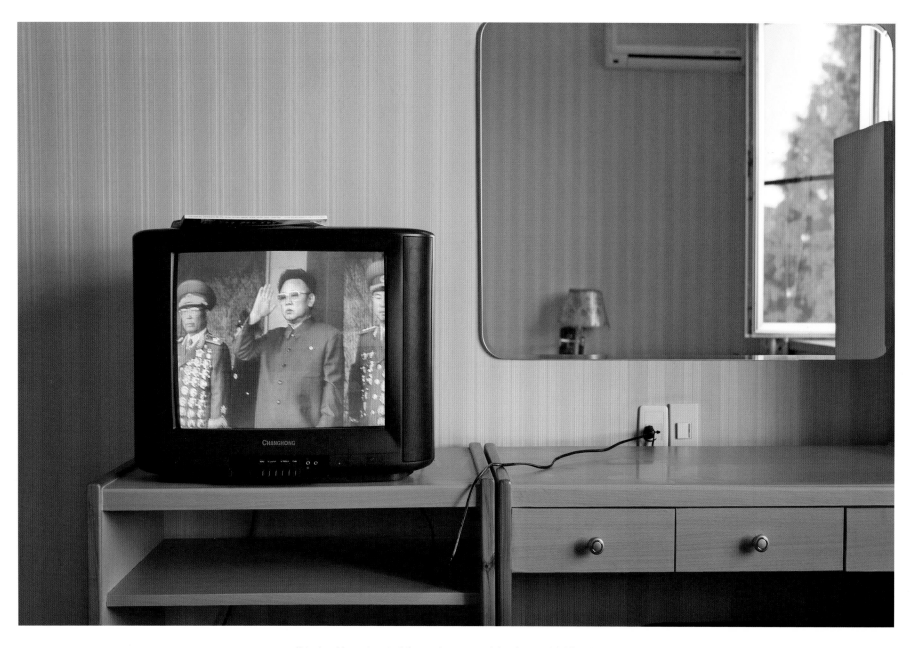

Televised broadcast of the anniversary celebrations, with Kim Jong-il

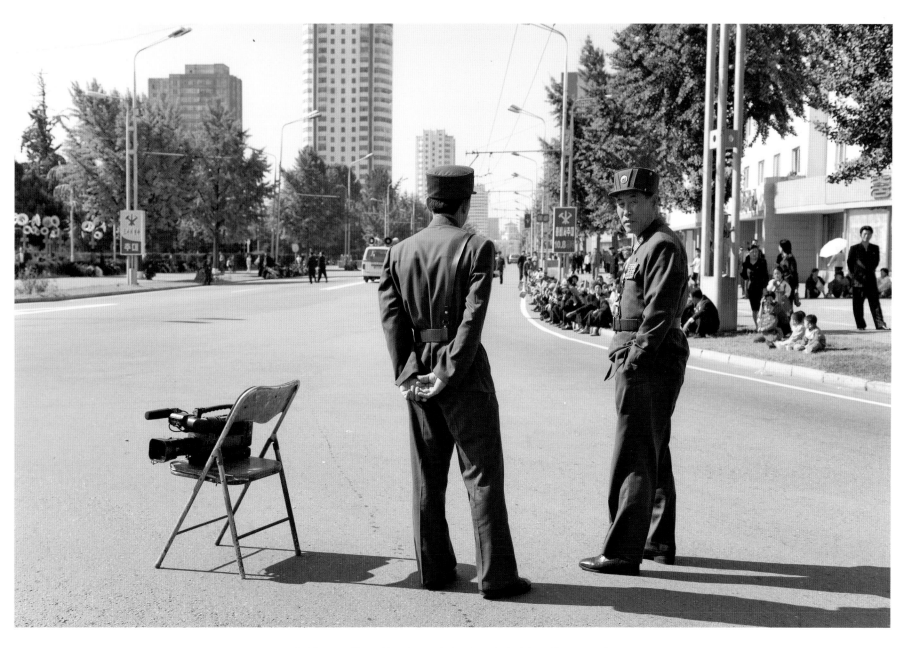

Soldiers on filmmaking duty wait for the arrival of the military parade

84 Red Guard cadet

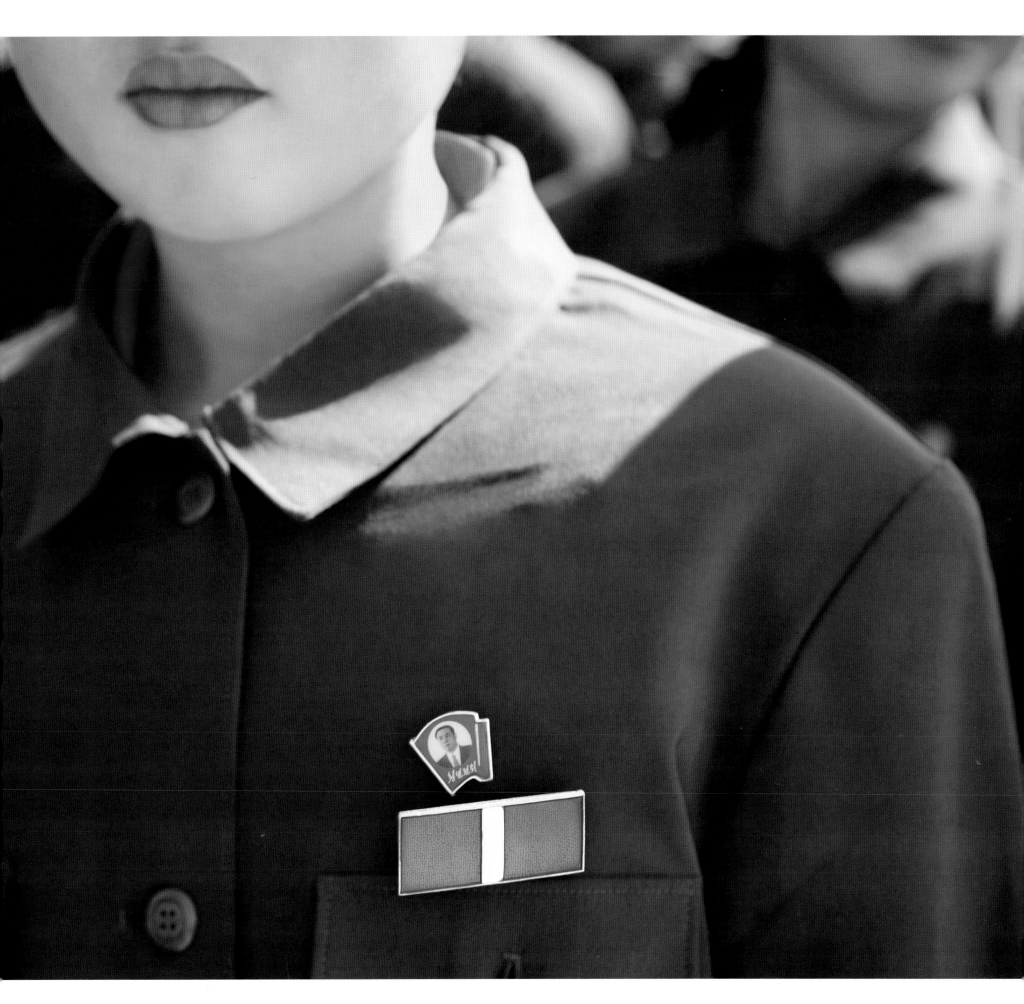

86 War Museum tour guide, Pyongyang

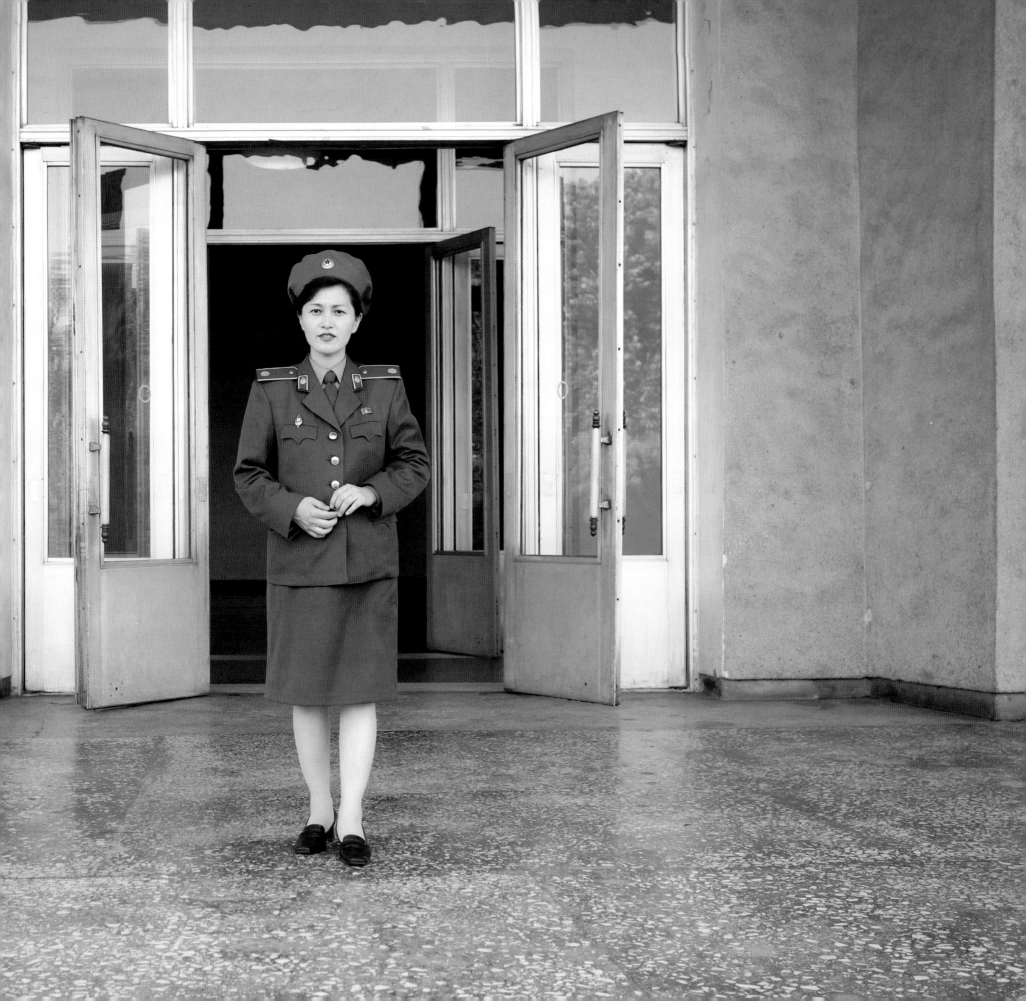

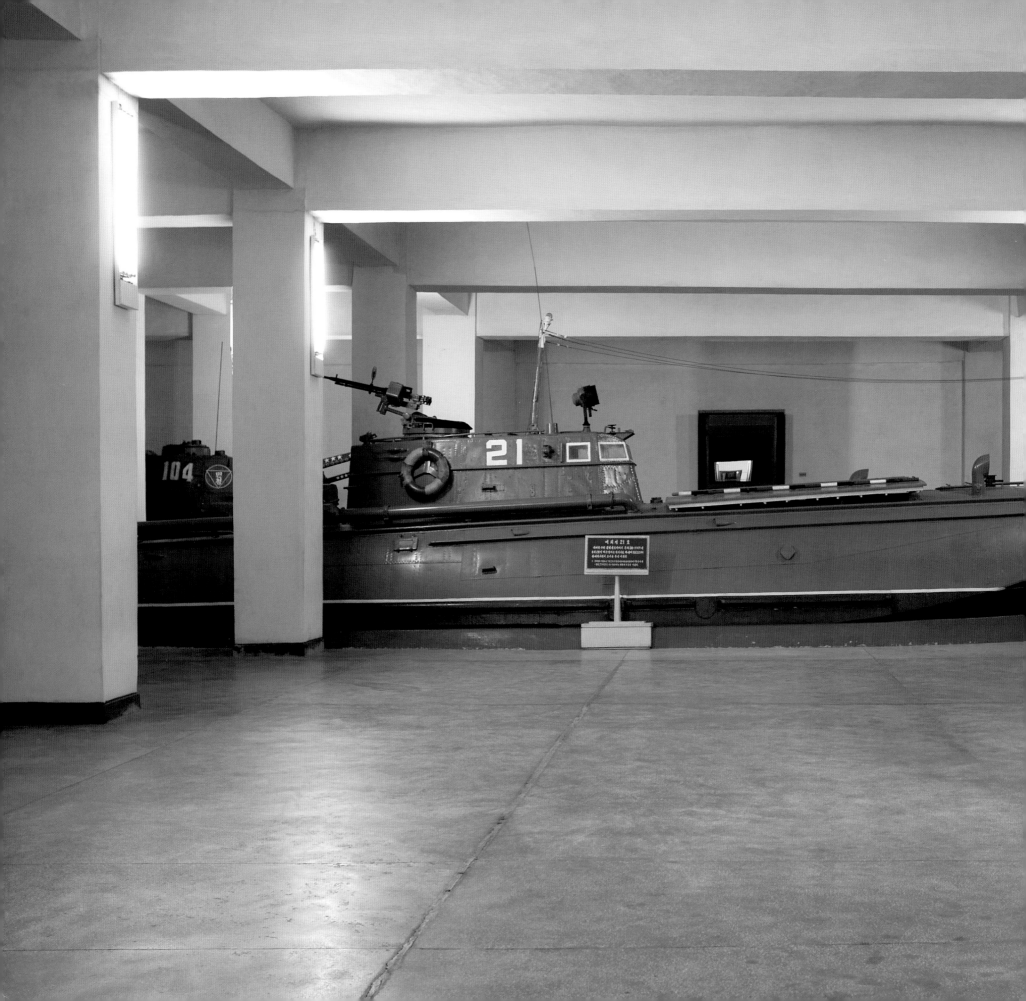

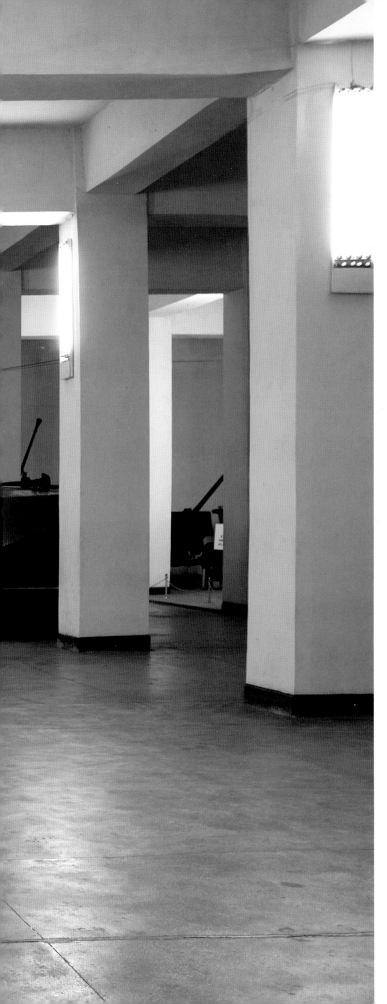

A captured enemy torpedo boat, War Museum 89

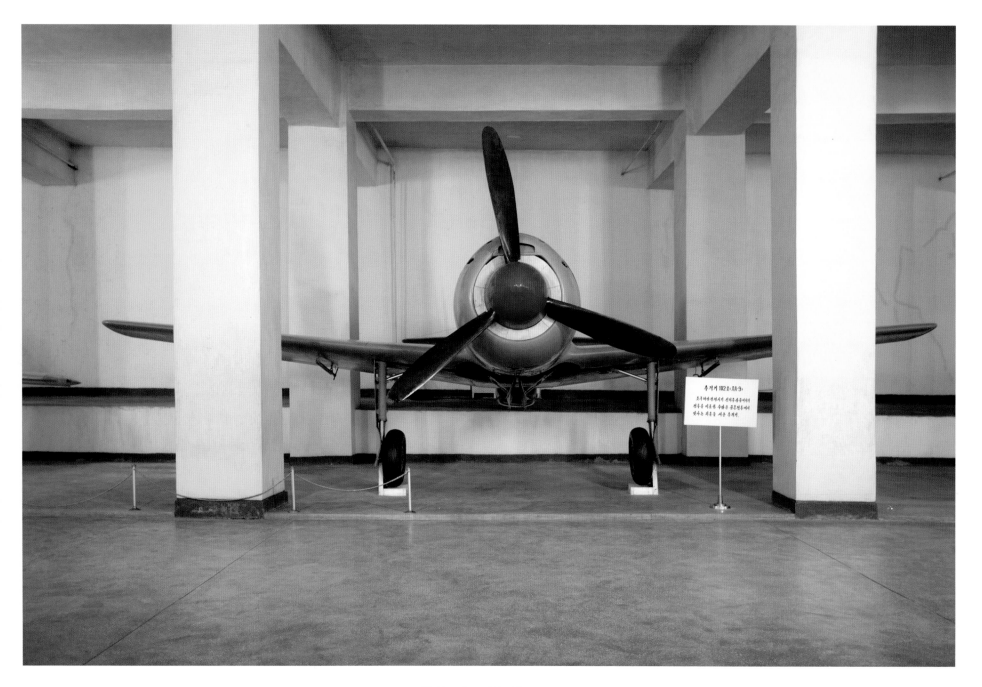

Fighter plane, War Museum

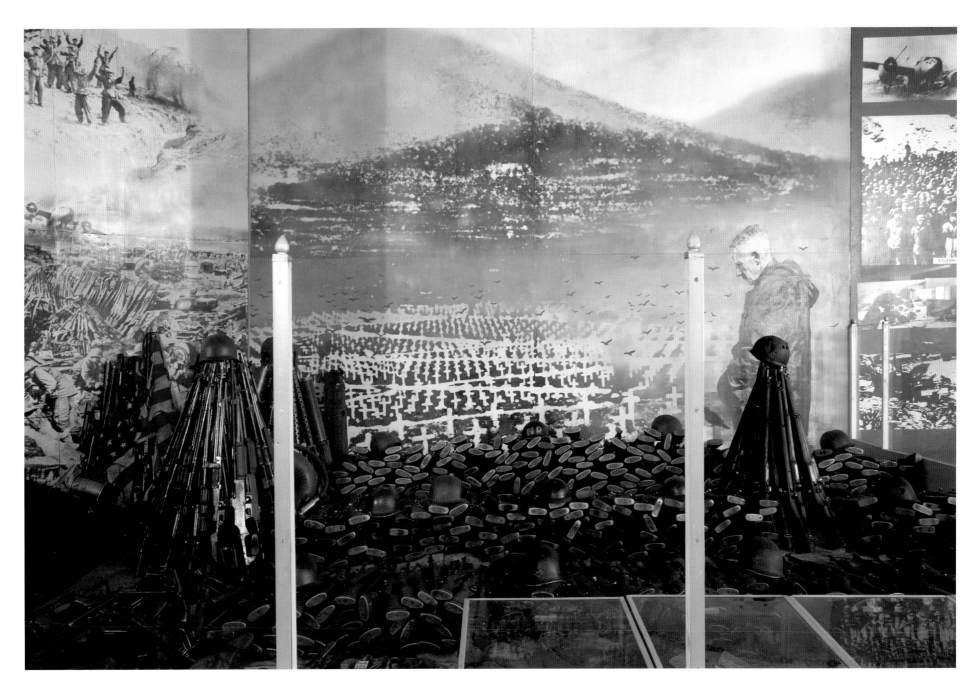

War Museum installation

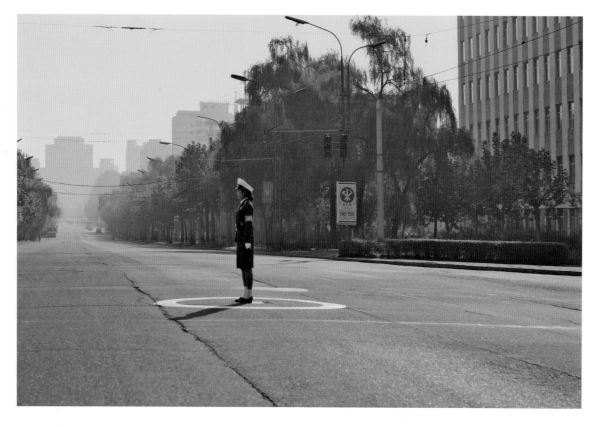

Early morning on the main road through Pyongyang.
Traffic police usually take the place of lights.

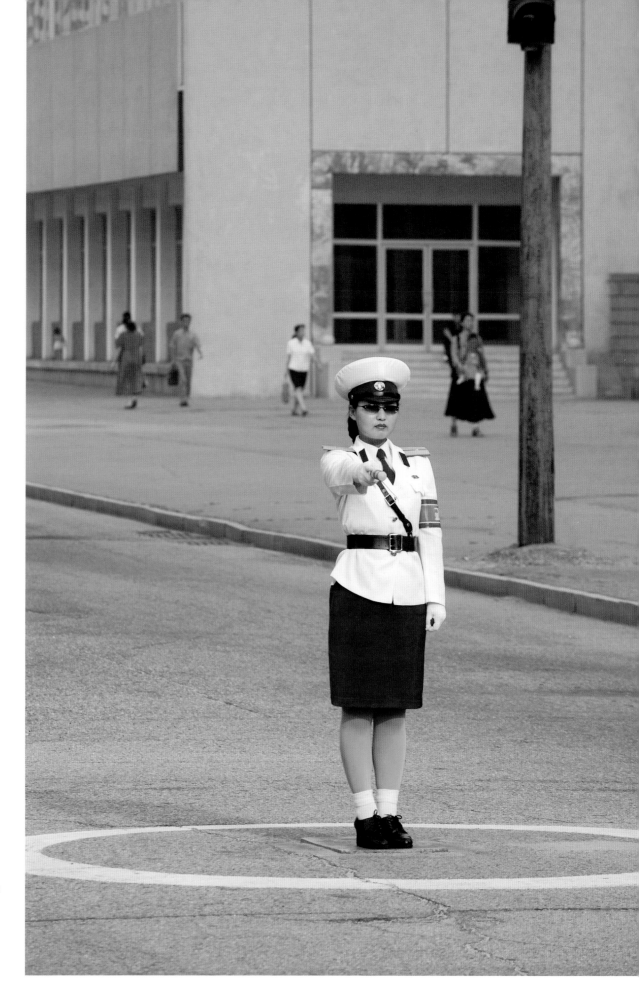

A policewoman directs traffic

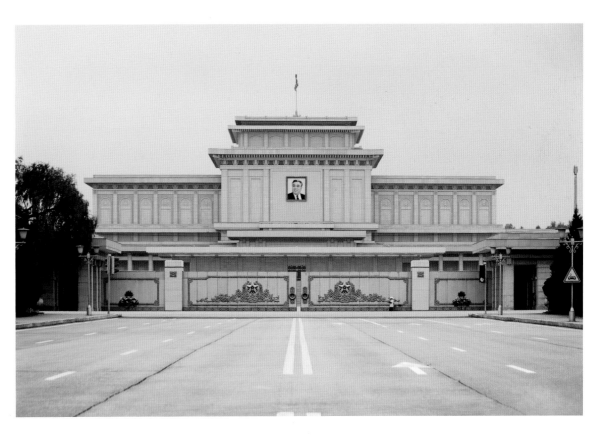

Kumsusan Memorial Palace

96 City-centre tram lines

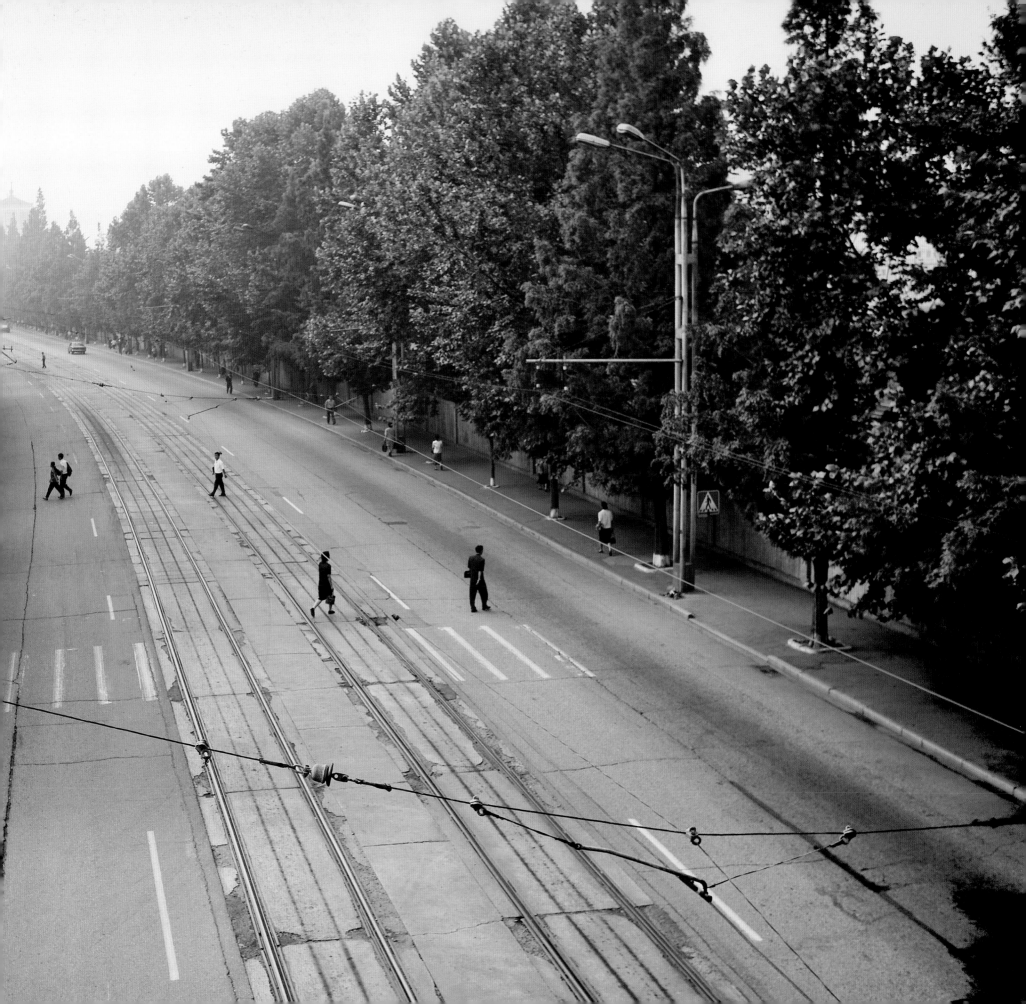

98 Reunification Avenue, south Pyongyang

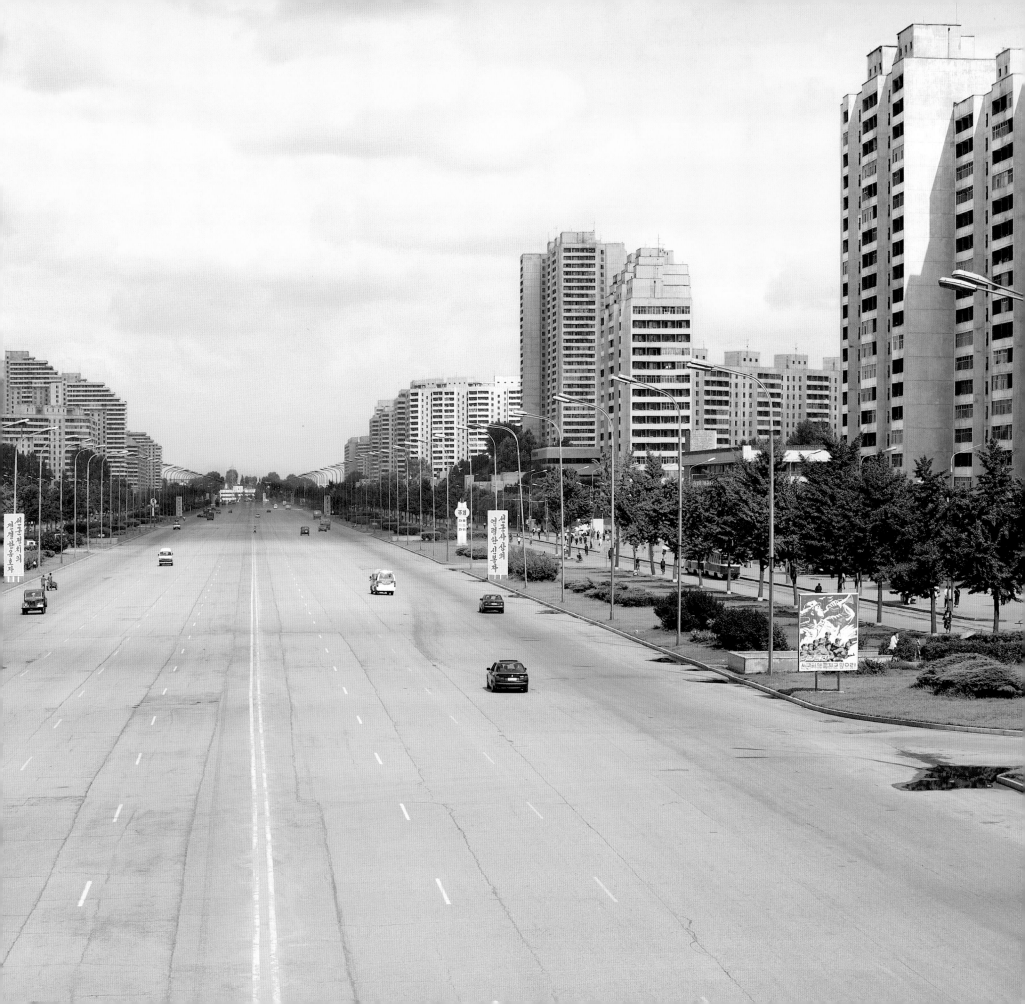

100 Mansudae Grand Monument to Kim Il-sung

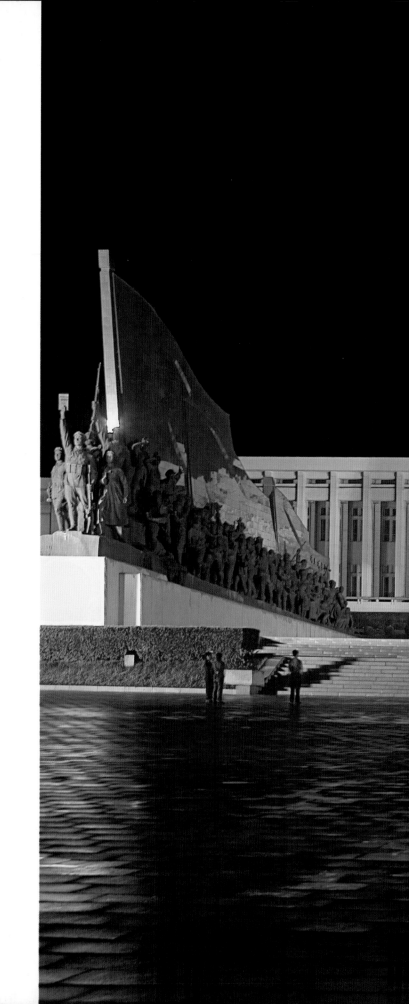

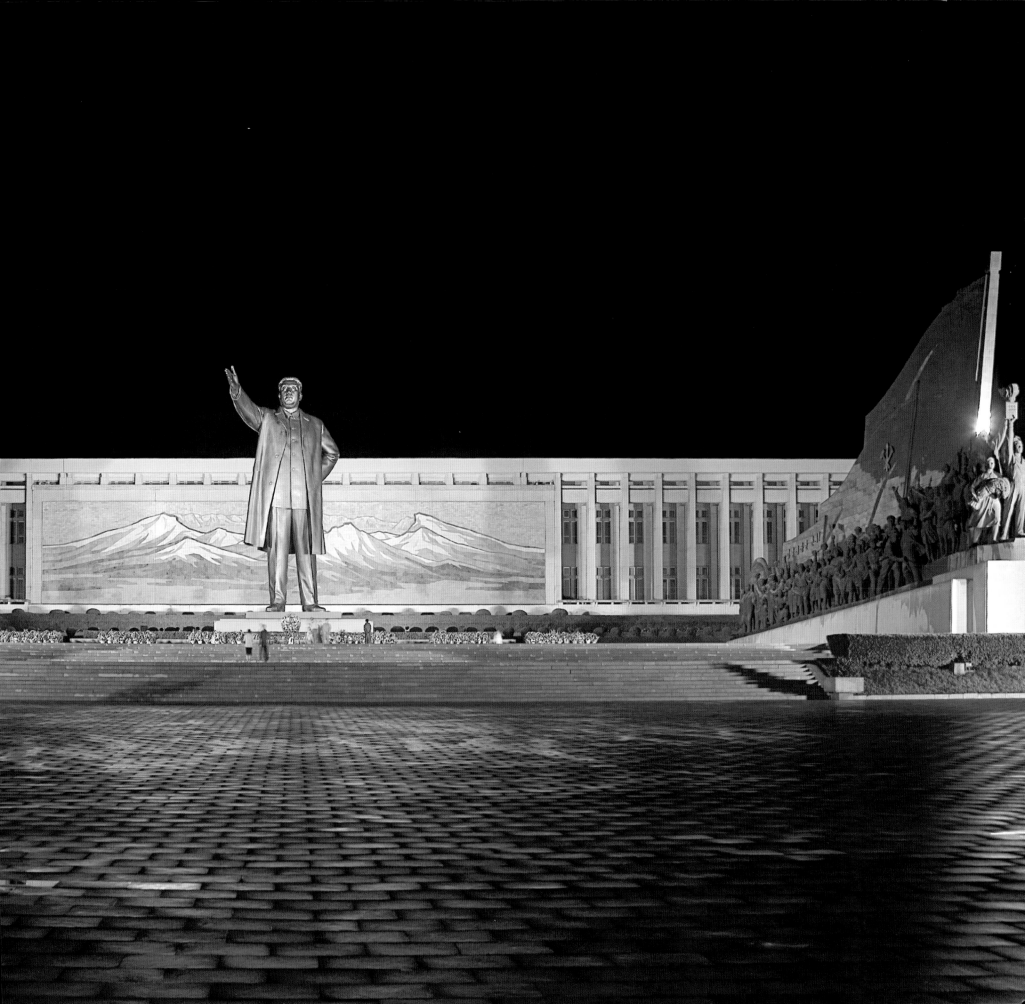

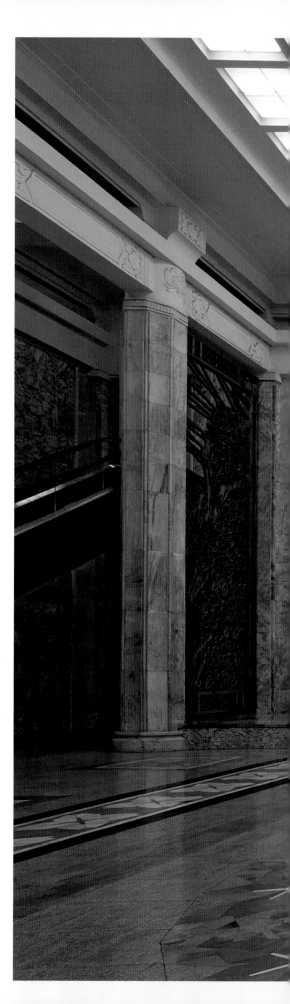

A marble statue of Kim Il-sung dominates the entrance
hall of the Grand People's Study House, Pyongyang

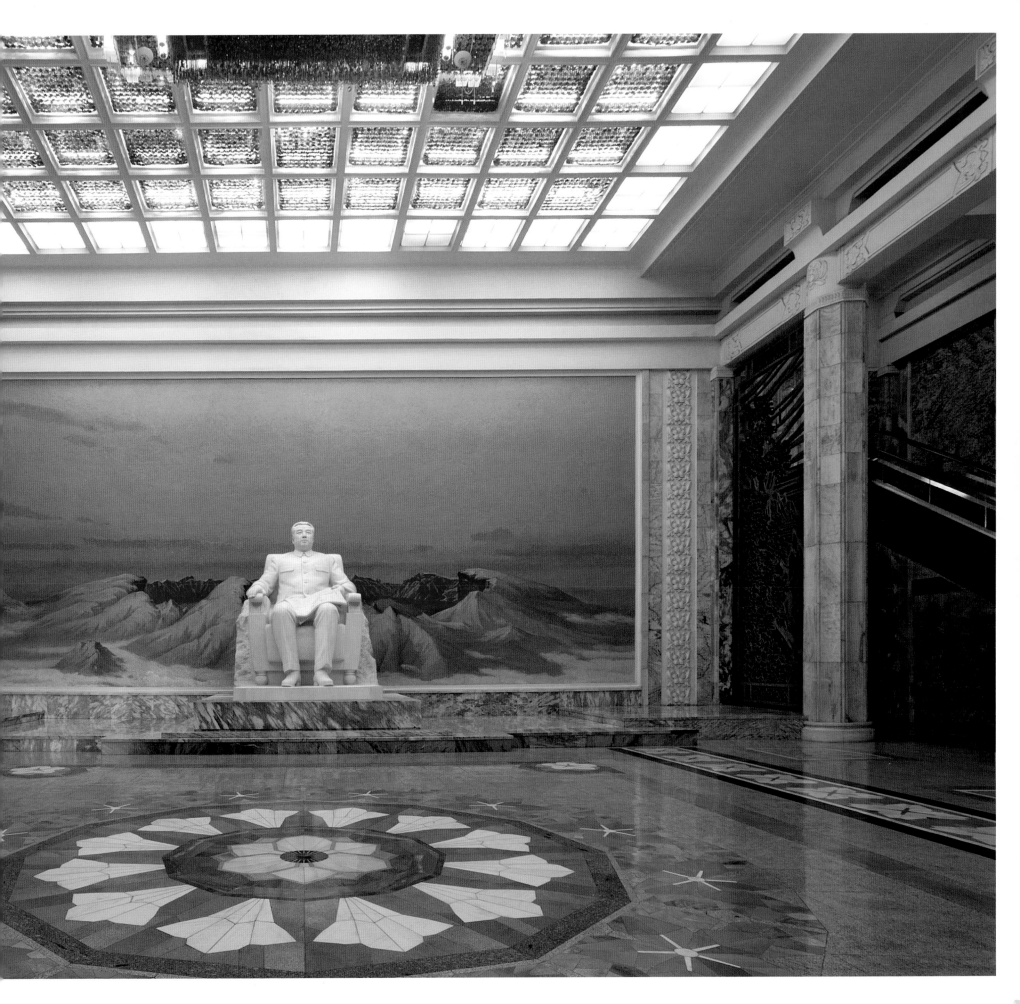

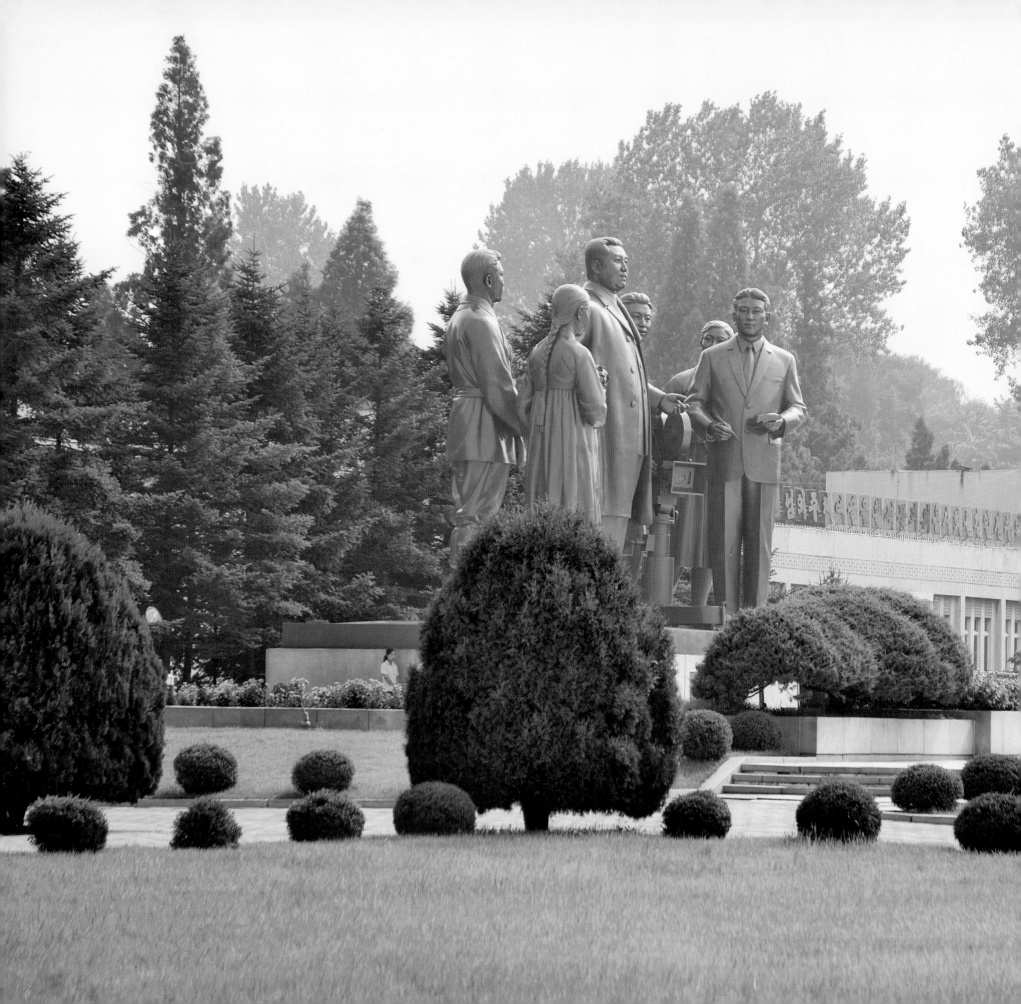

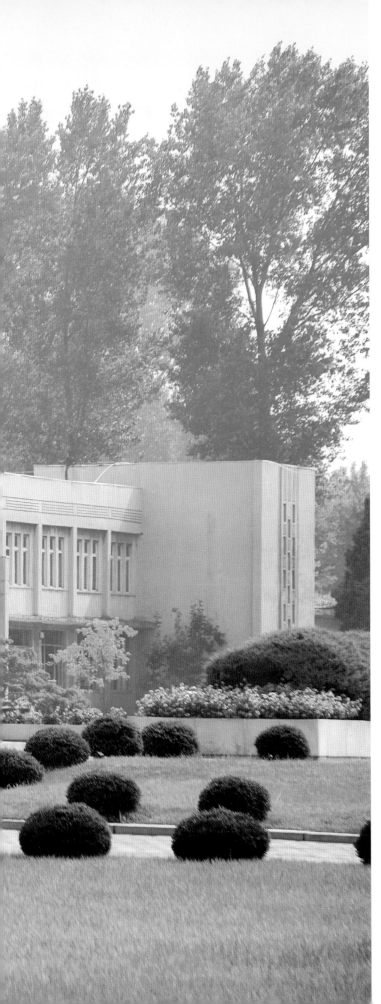

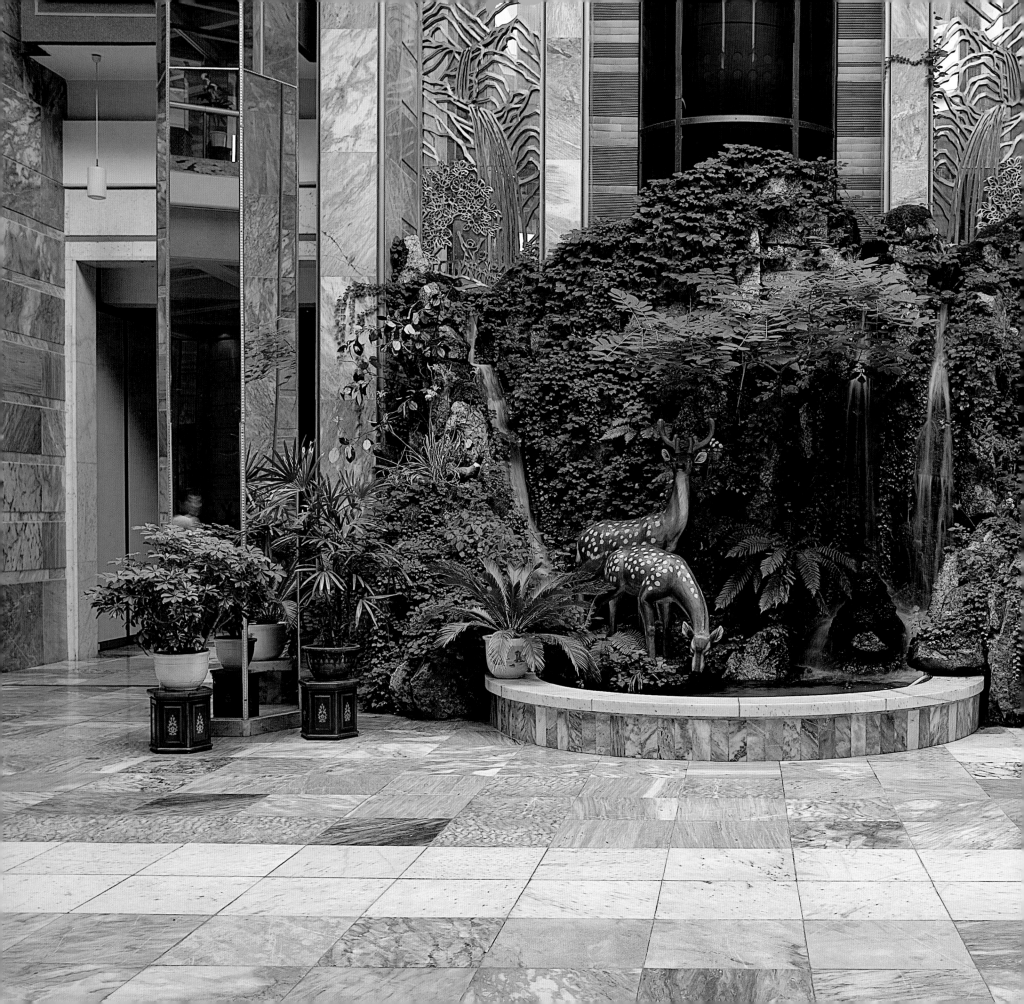

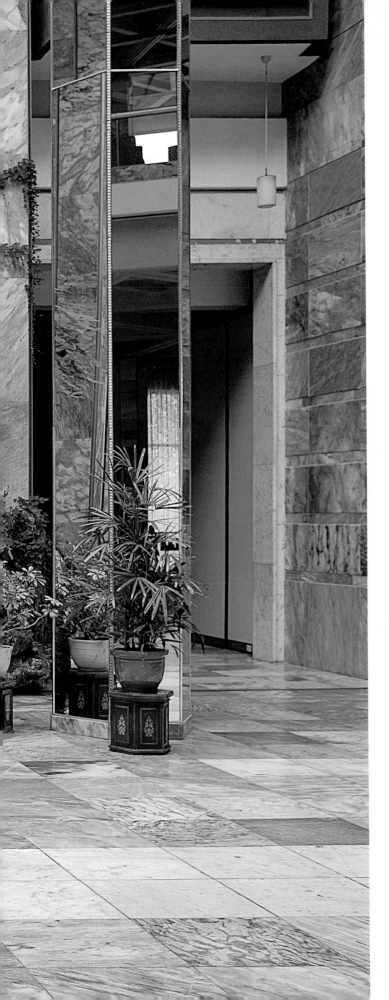

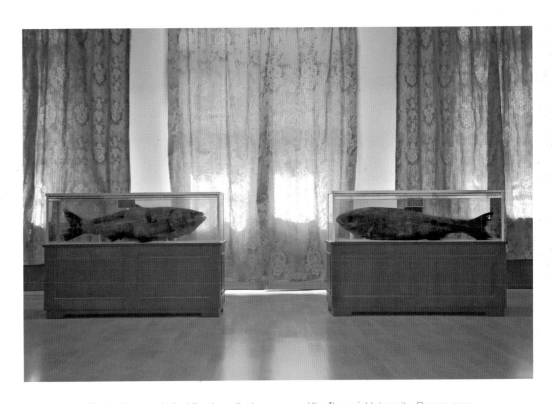

Giant pike caught by Kim Jong-il when young, Kim Il-sung University, Pyongyang

Entrance hall of the Hyangsan Hotel, Mount Myohyang, 200 kilometres north-east of Pyongyang

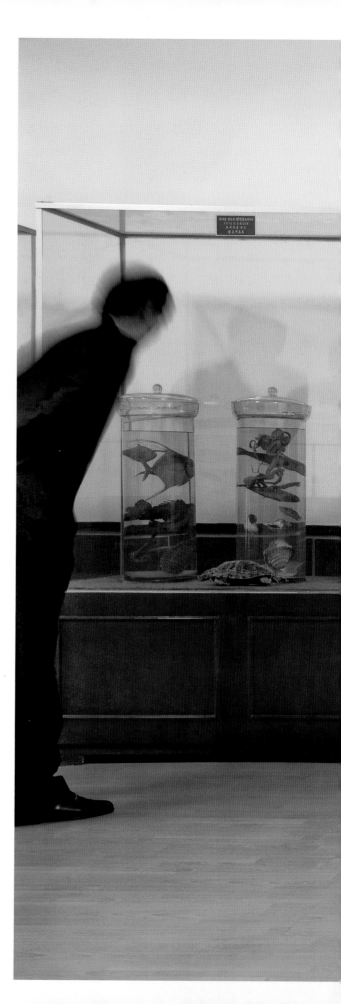

108 Specimen room, Kim Il-sung University

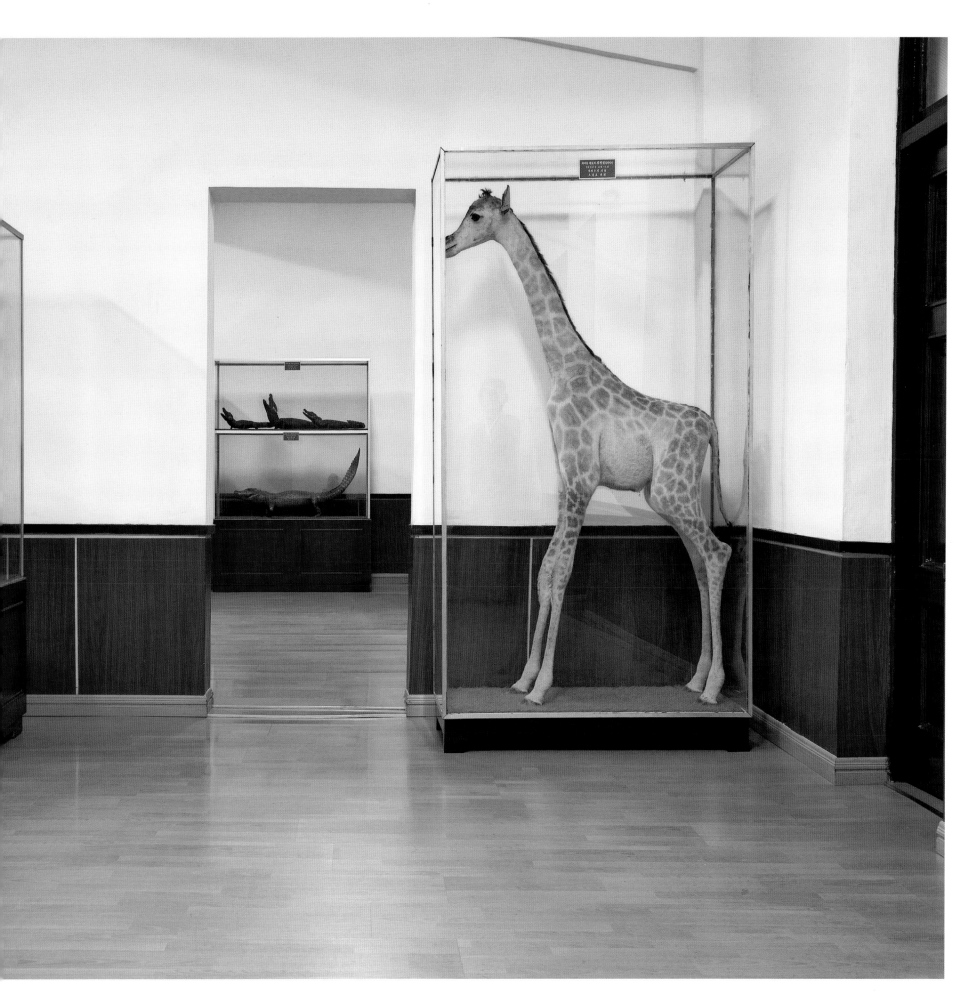

110 Ornithology room, Kim Il-sung University

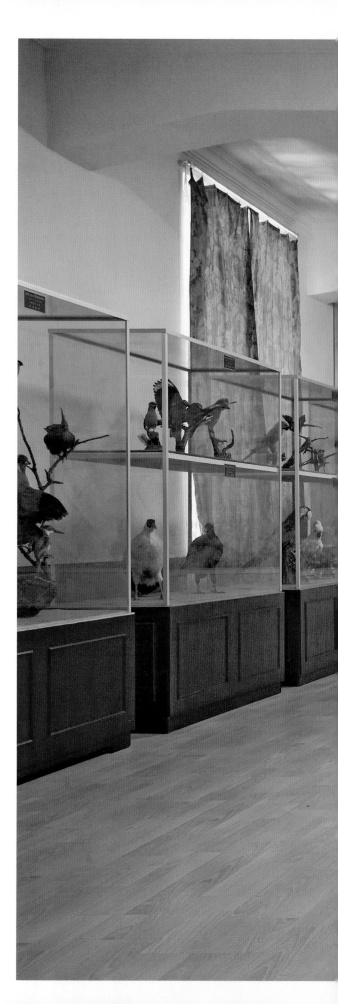

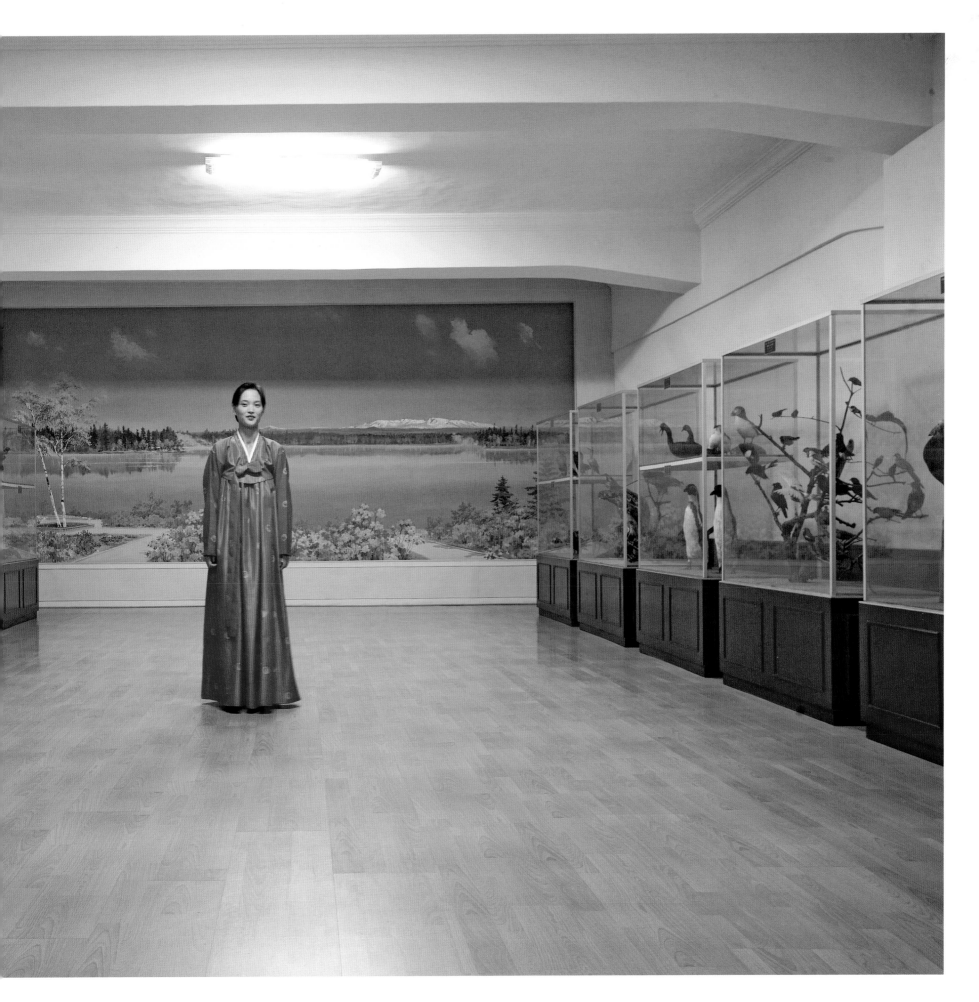

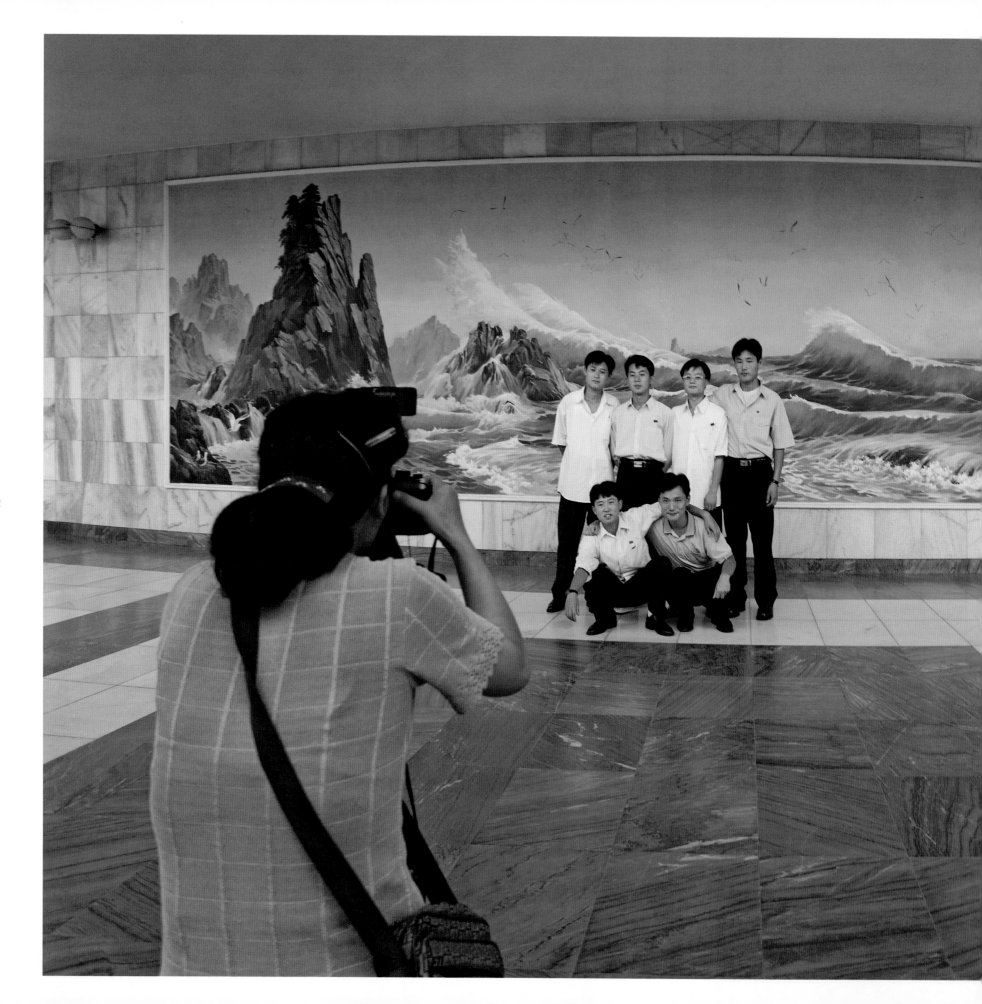

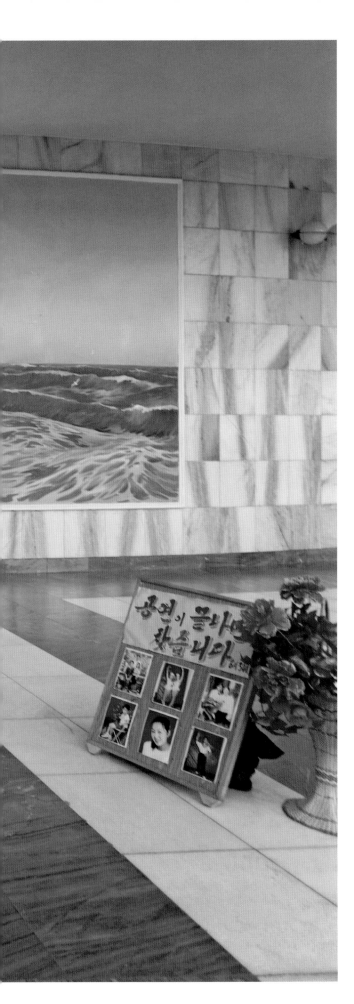

Posing for a photograph at the People's Army Circus, Pyongyang 113

Military uniforms worn during the War of Liberation (1940–45) by Kim Il-sung and his wife Kim Jong-suk, Museum of the Revolution, Pyongyang

114

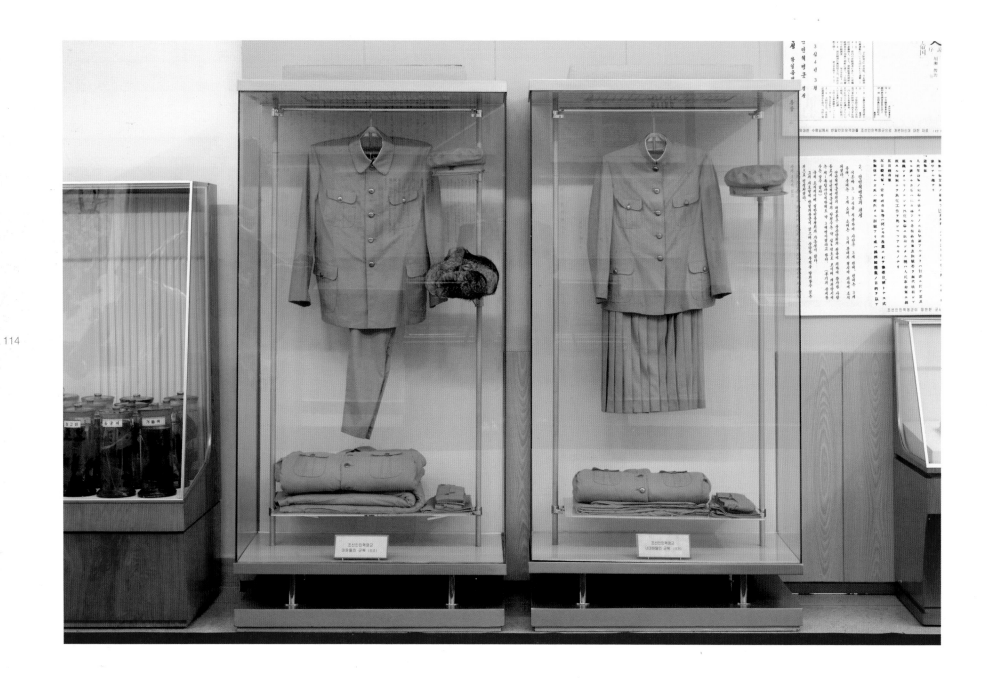

Floral installation with a photograph of Kim Il-sung and Kim Jong-suk, for the Kimilsungia/Kimjongilia competition, Pyongyang

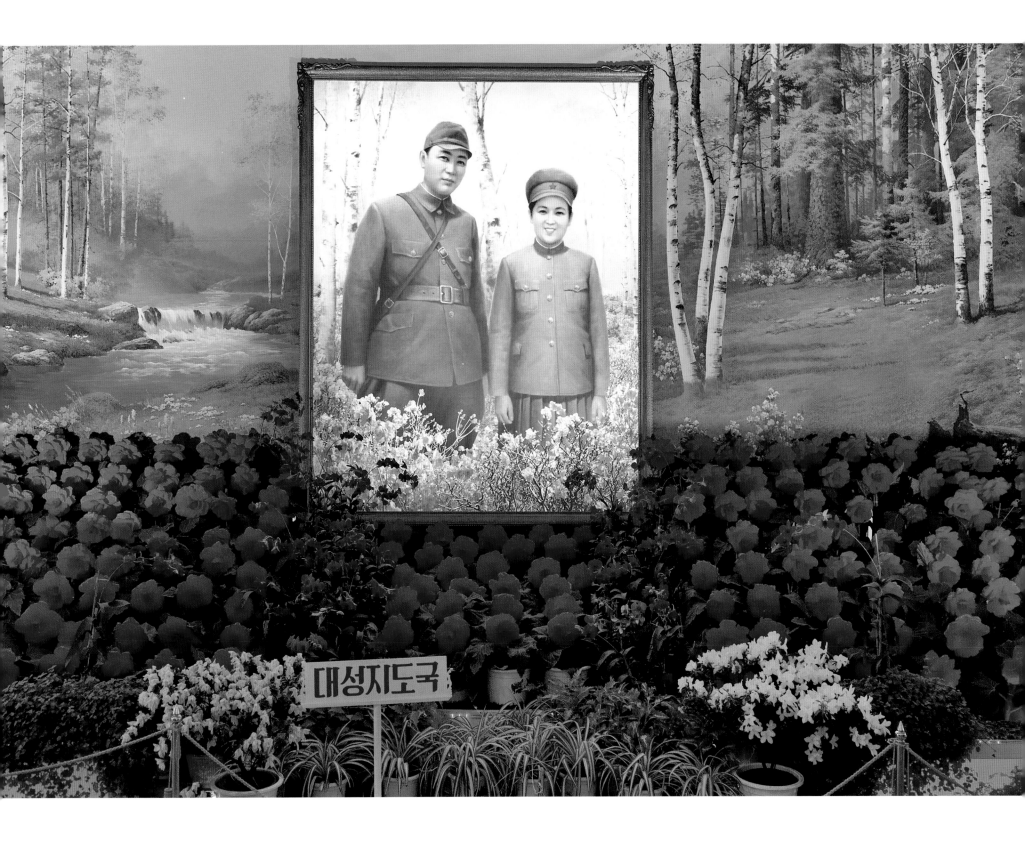

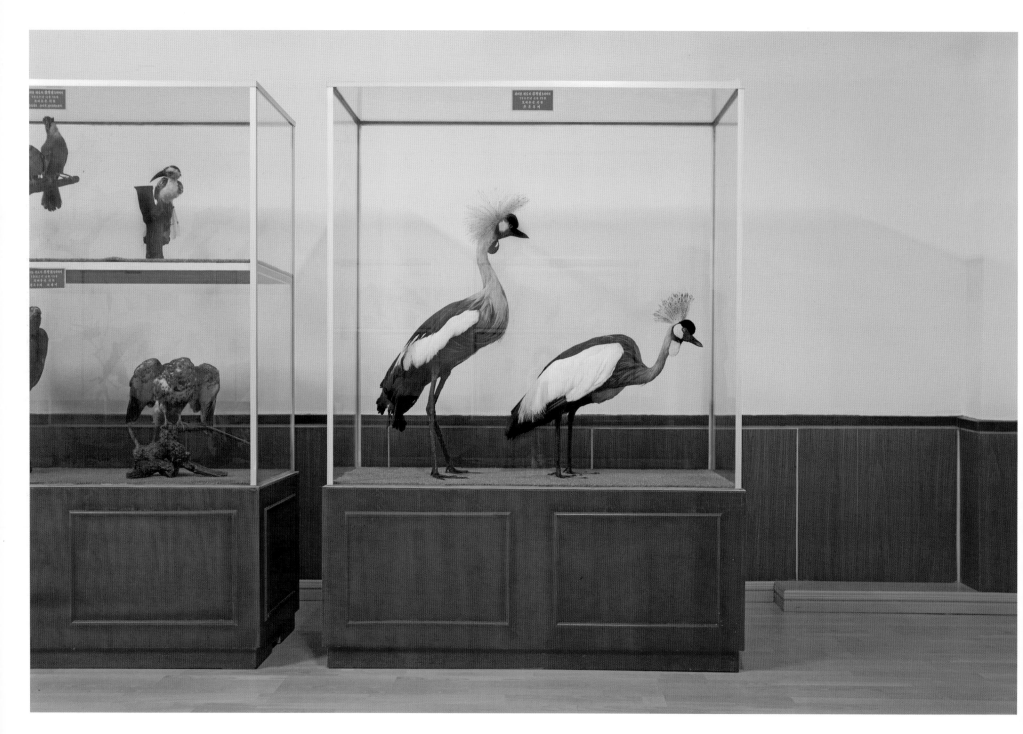

Ornithology room, Kim Il-sung University

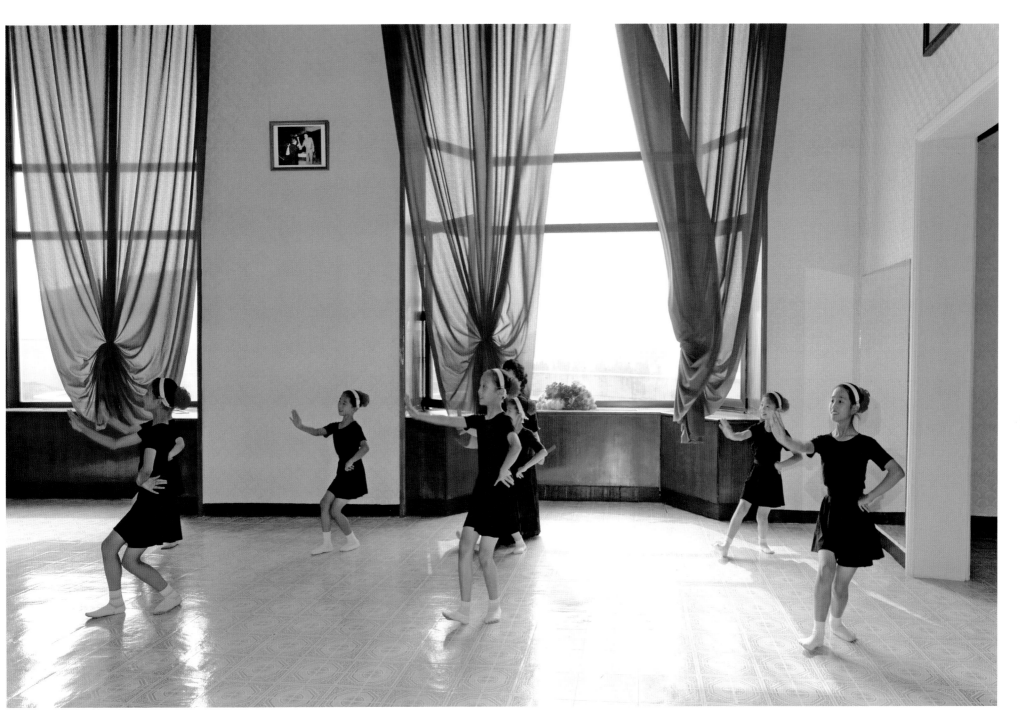

Dance rehearsal, Children's Palace

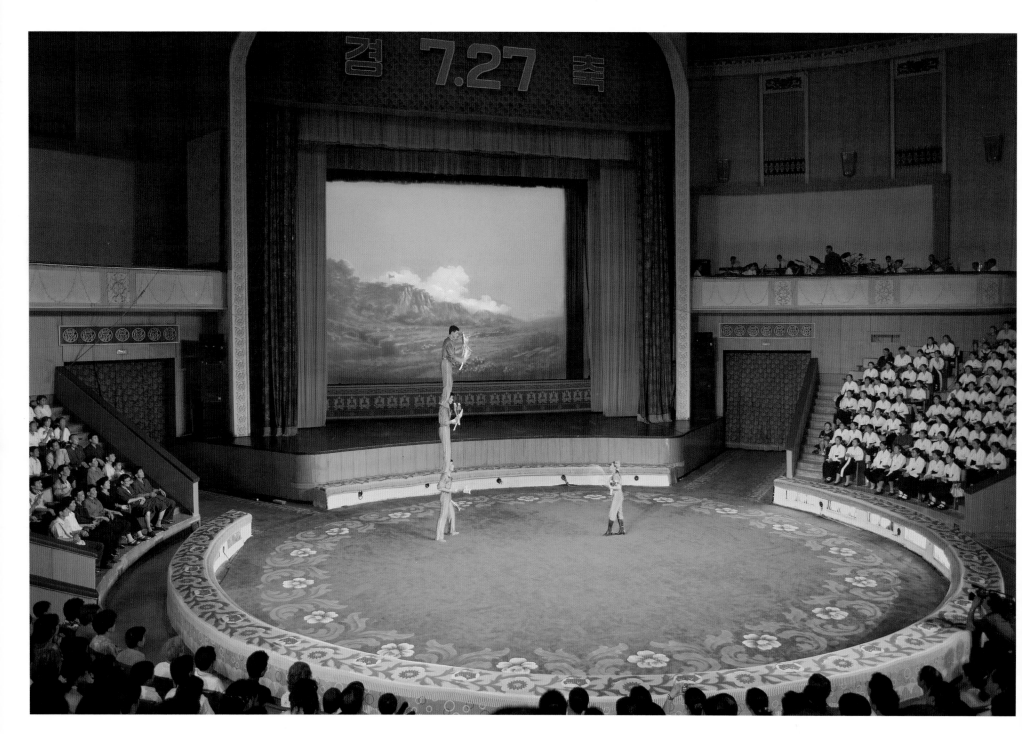

People's Army Circus

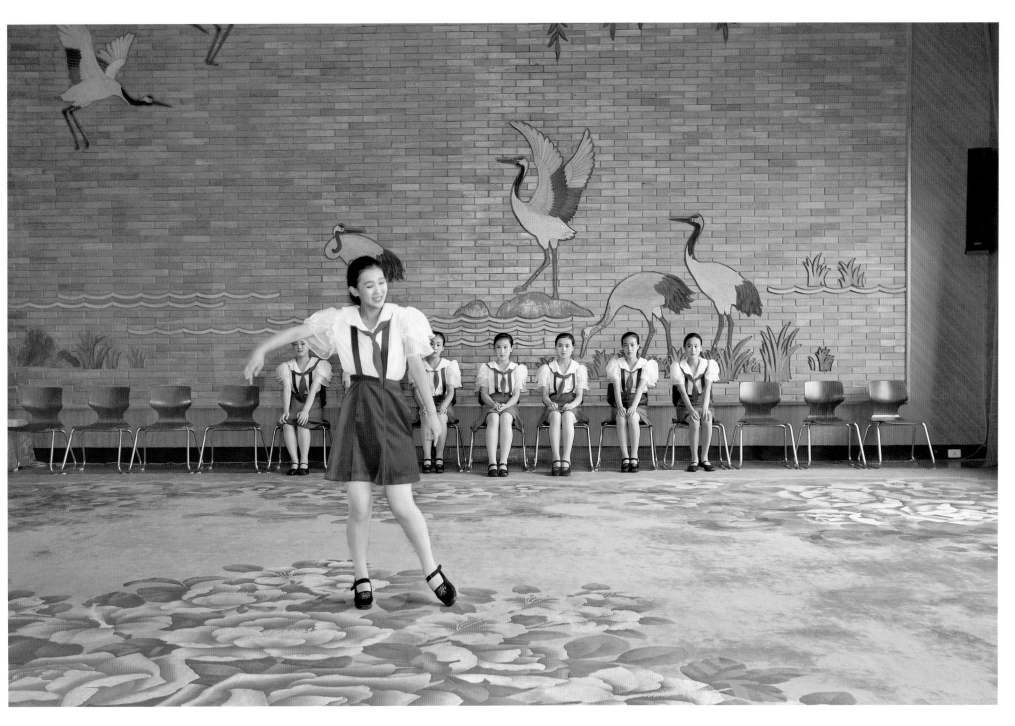

Singing class, Children's Palace

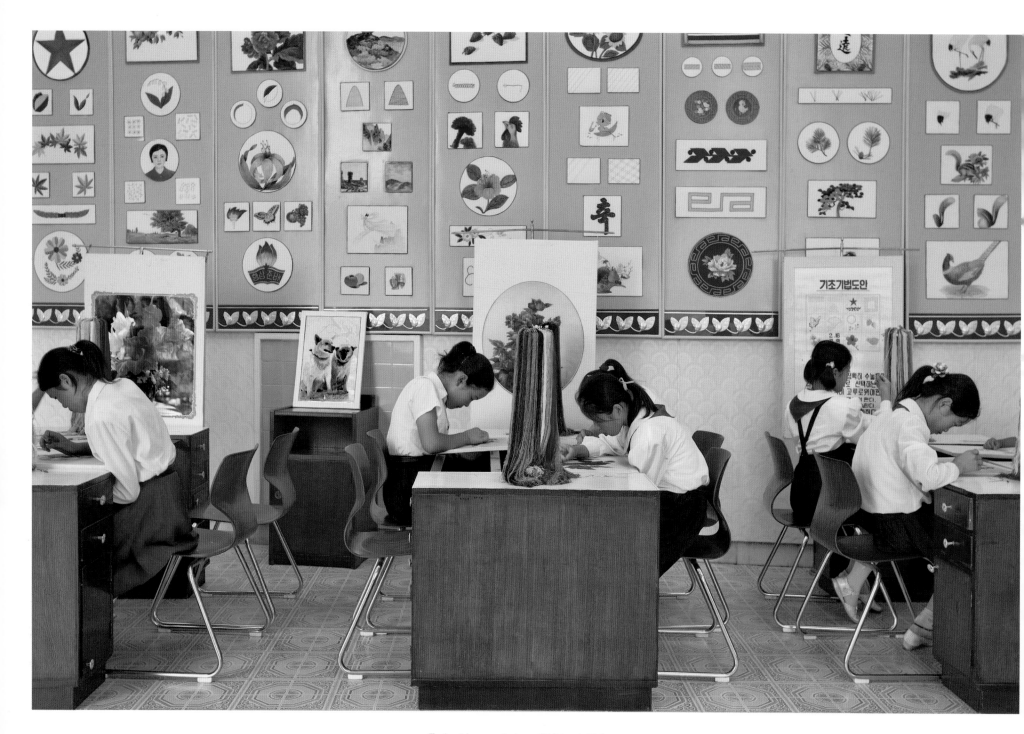

Embroidery workshop, Children's Palace

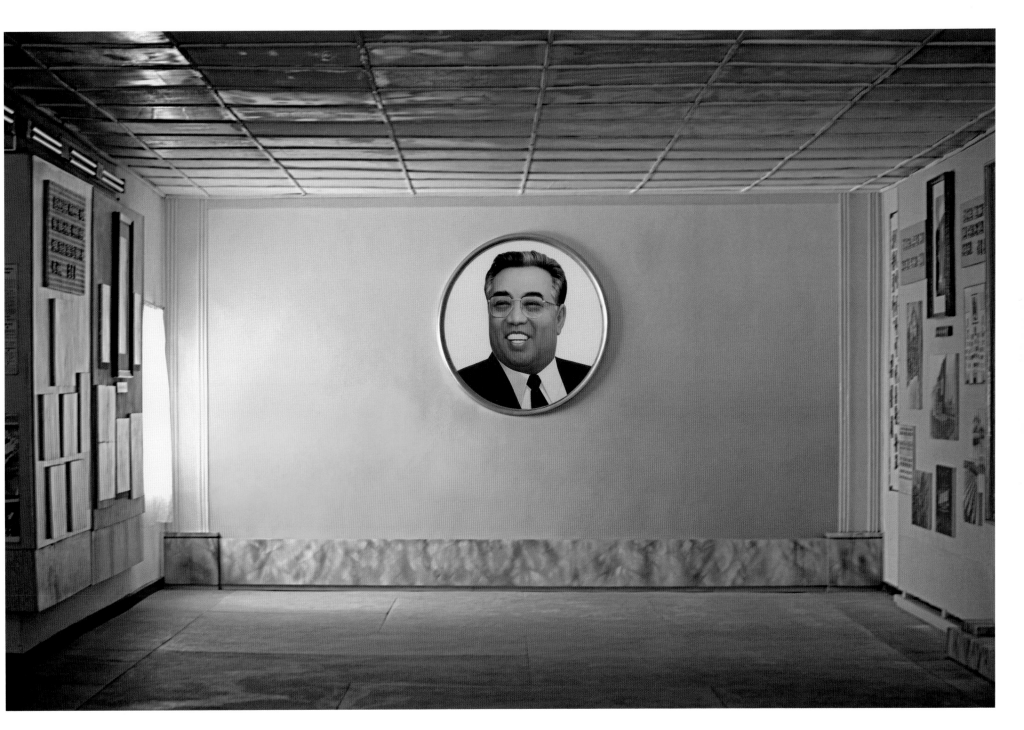

Official portrait of Kim Il-sung, Panmunjom

122 Music rehearsal, Children's Palace

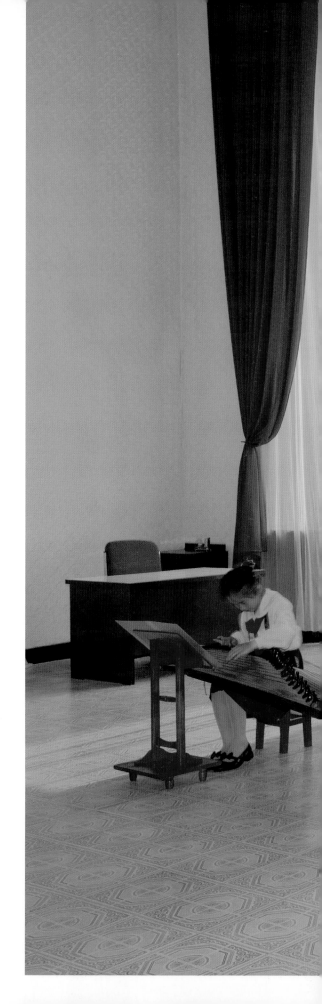

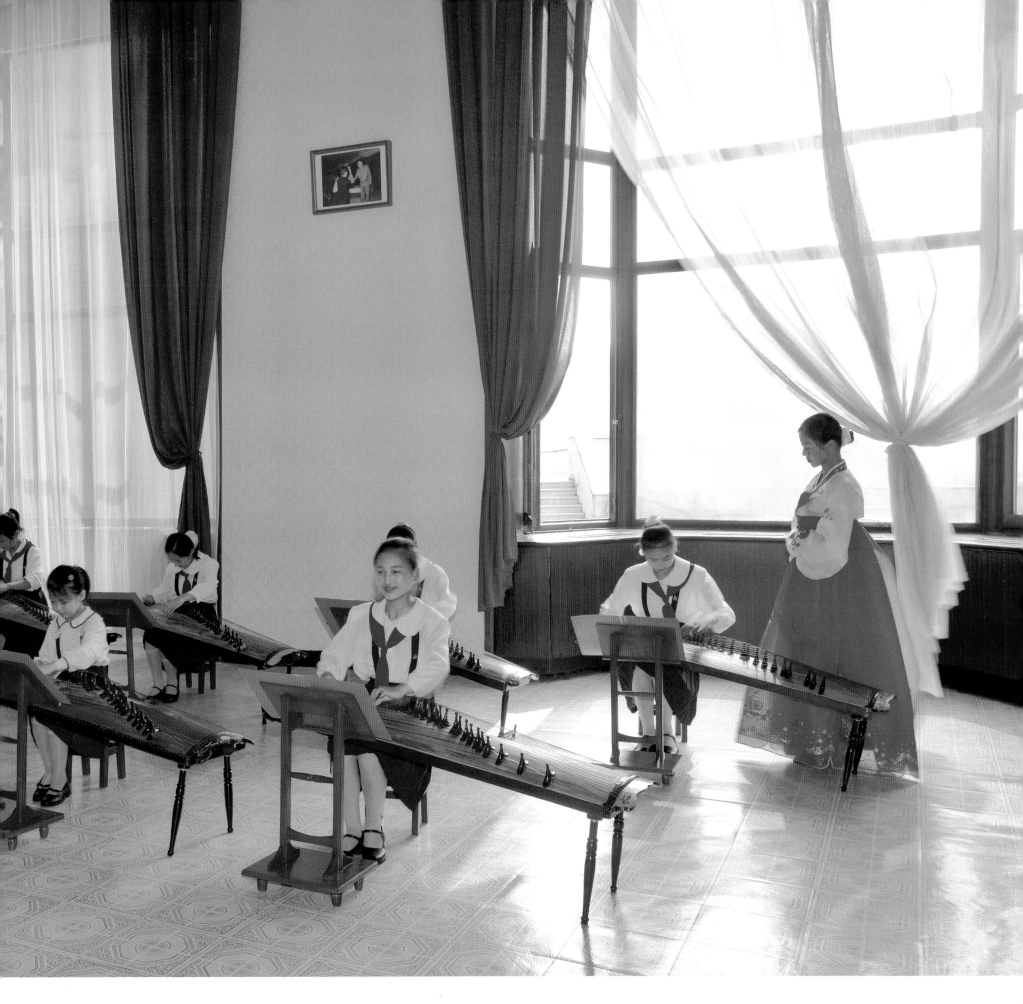

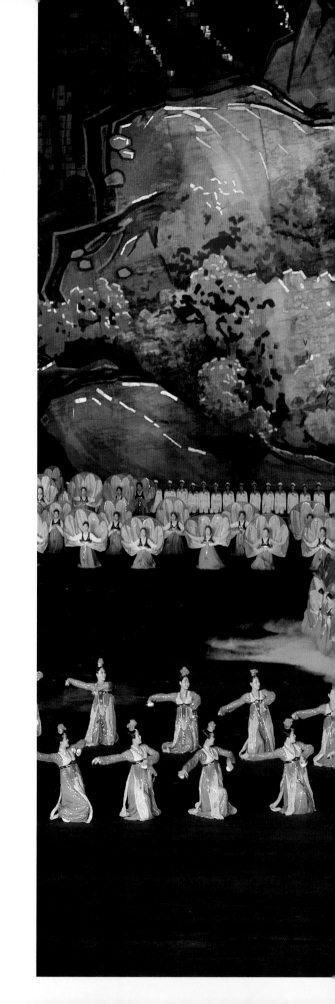

124 'A country where life is good', Arirang Festival

Overleaf: 'Follow the path of the Revolution come rain or snow'

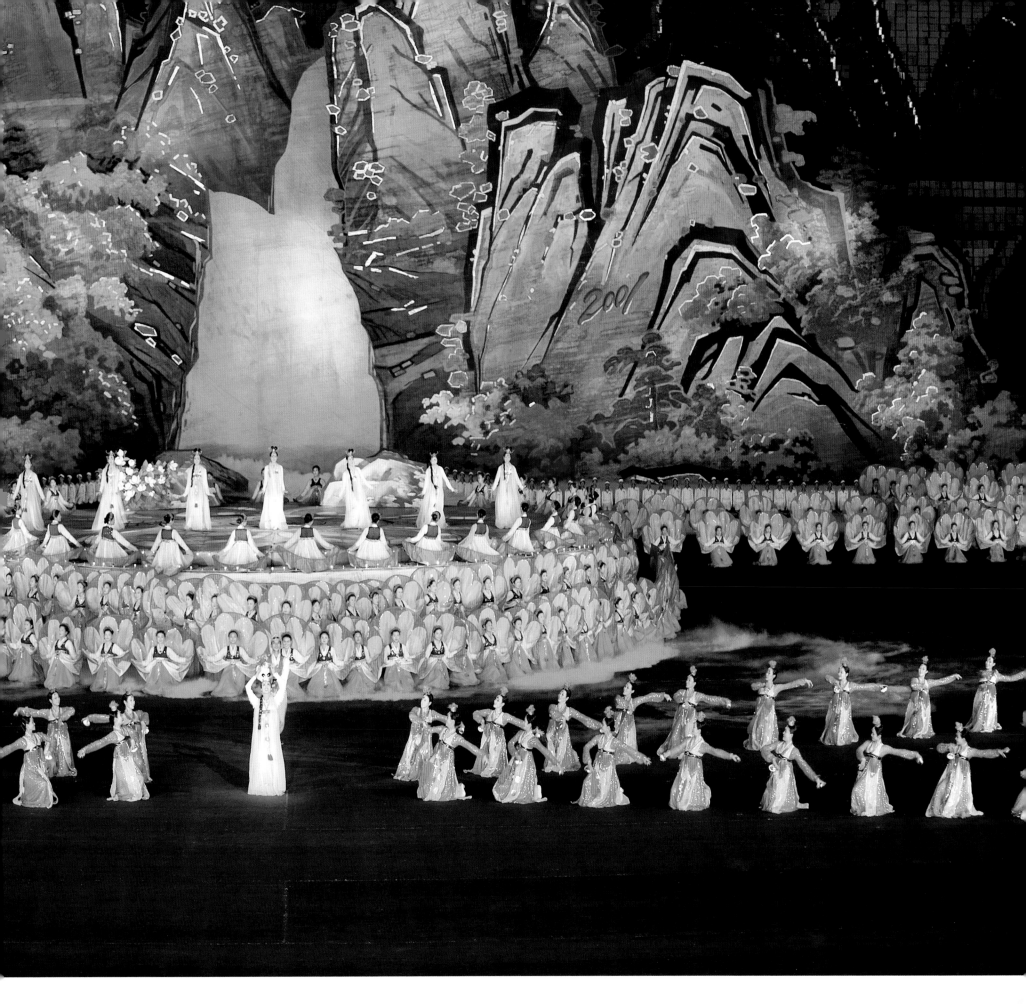

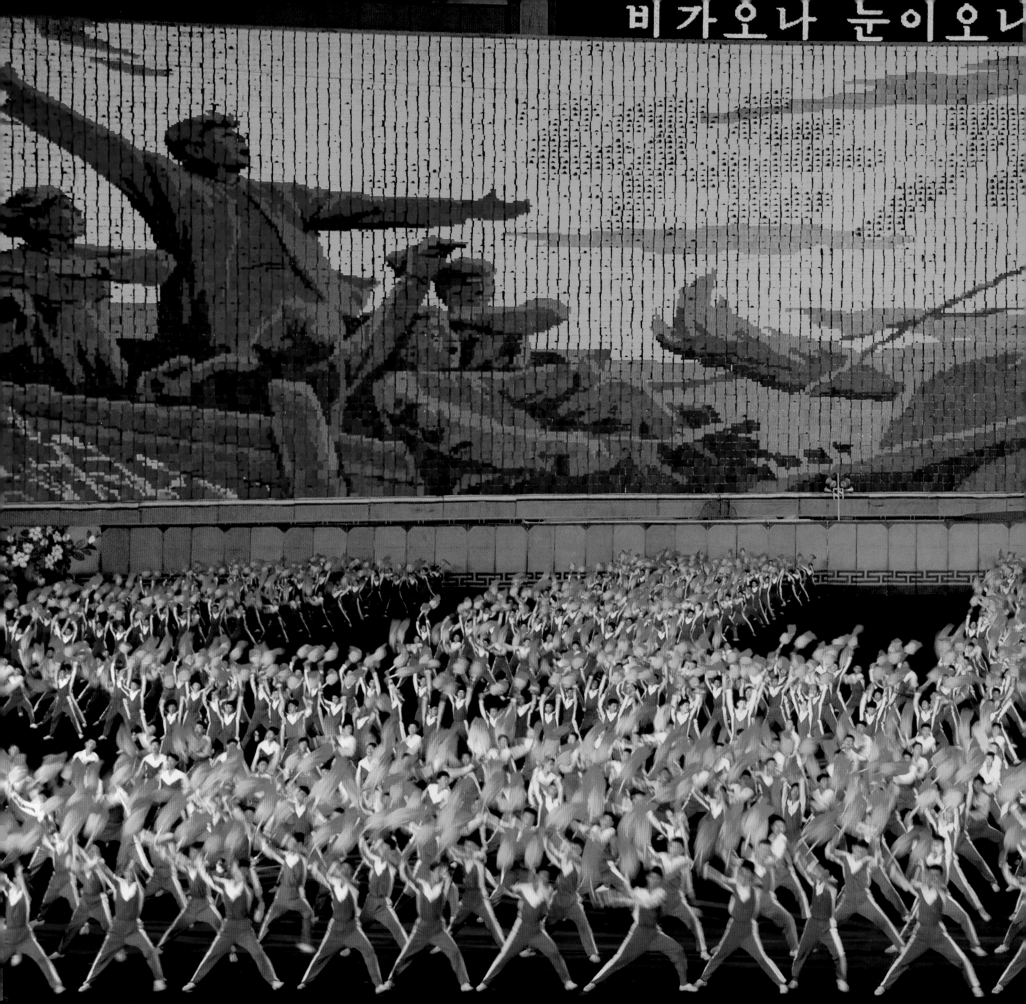

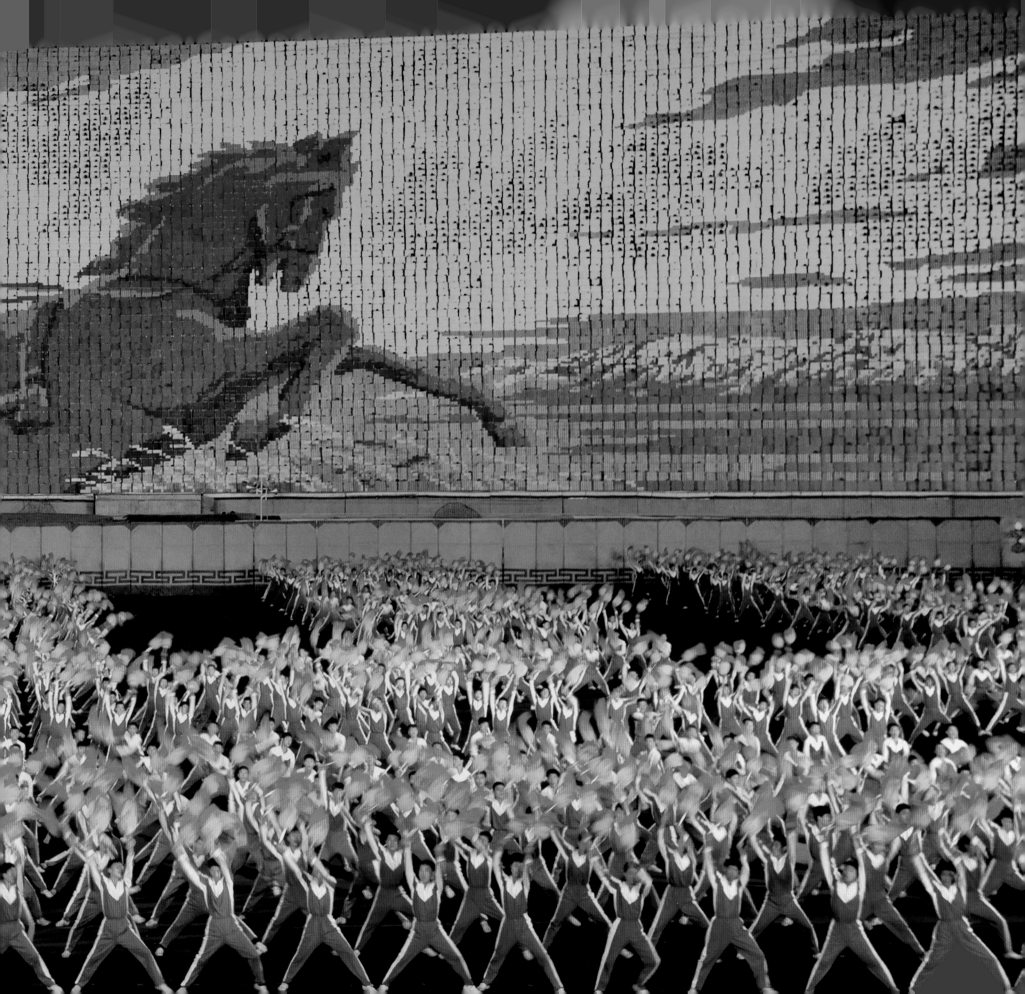

128 'The regrouping of lands'

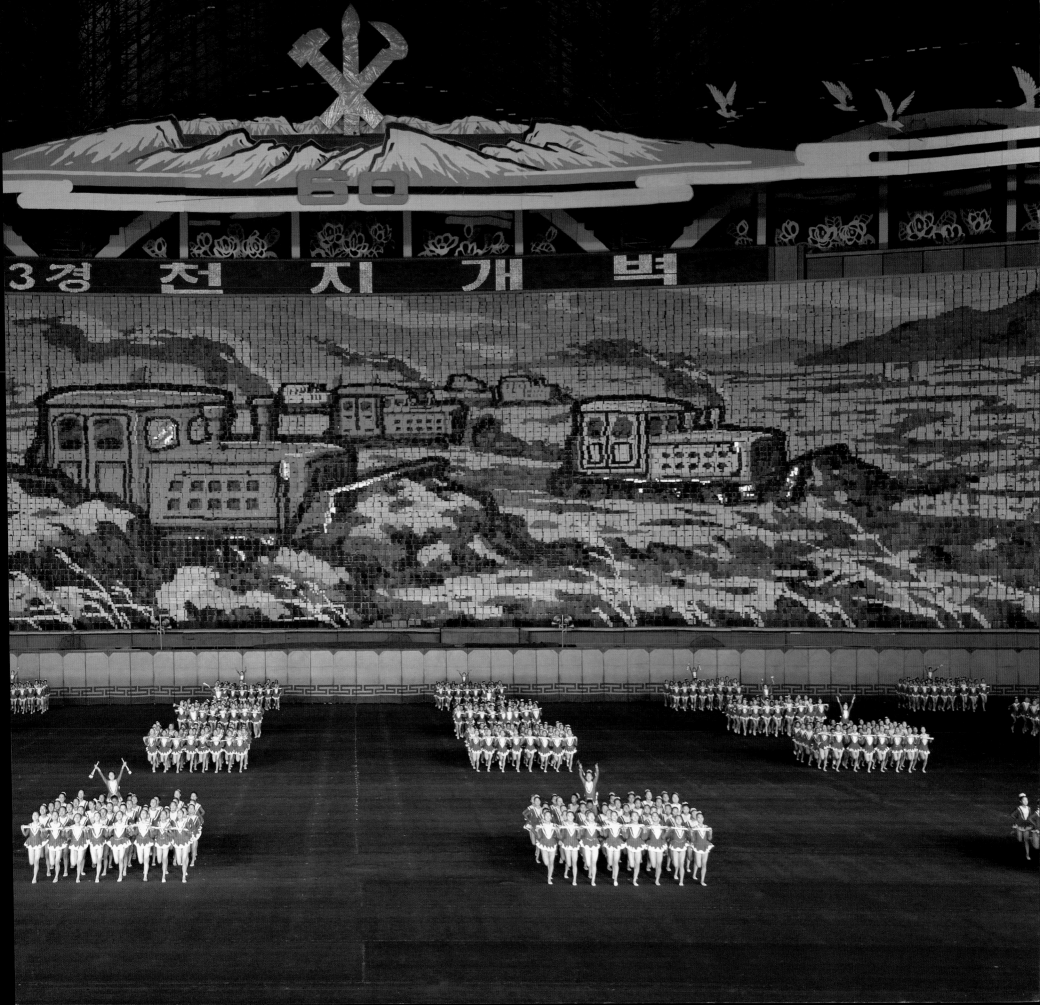

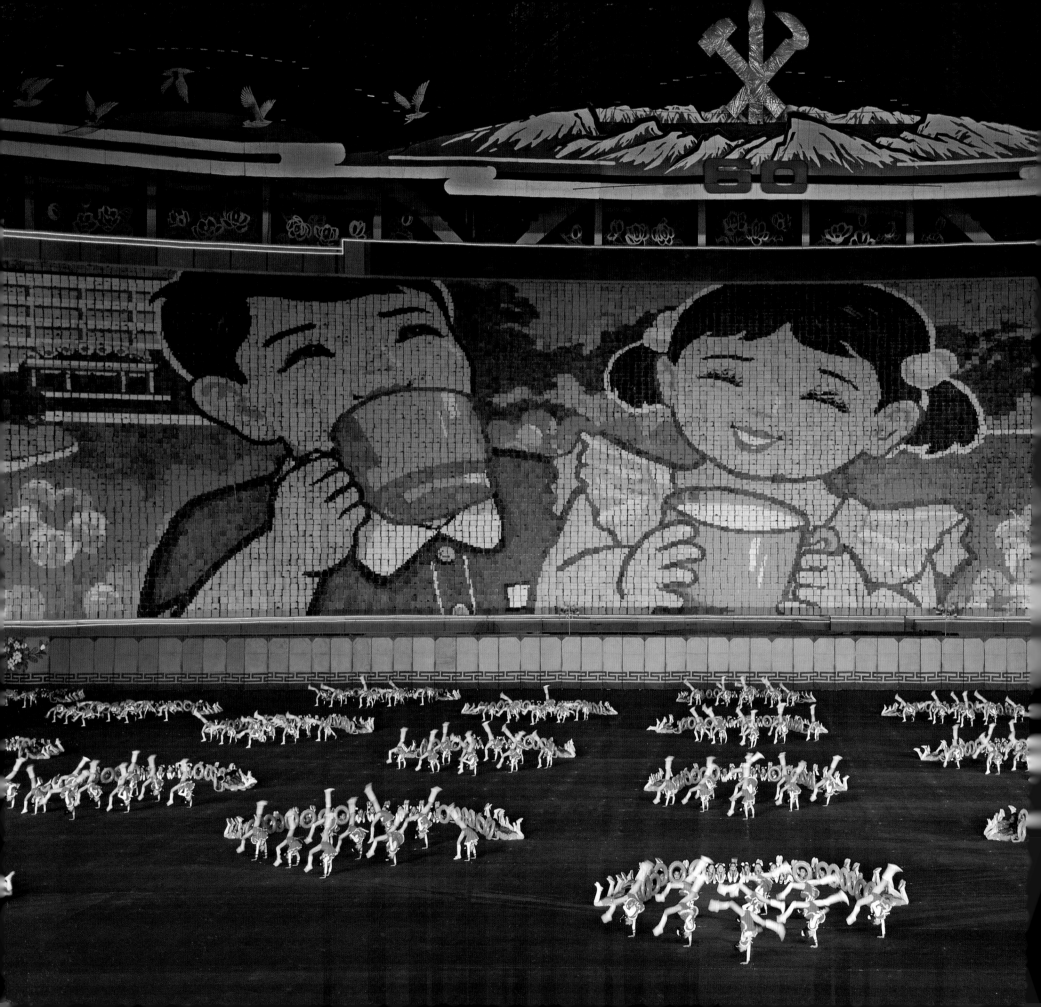

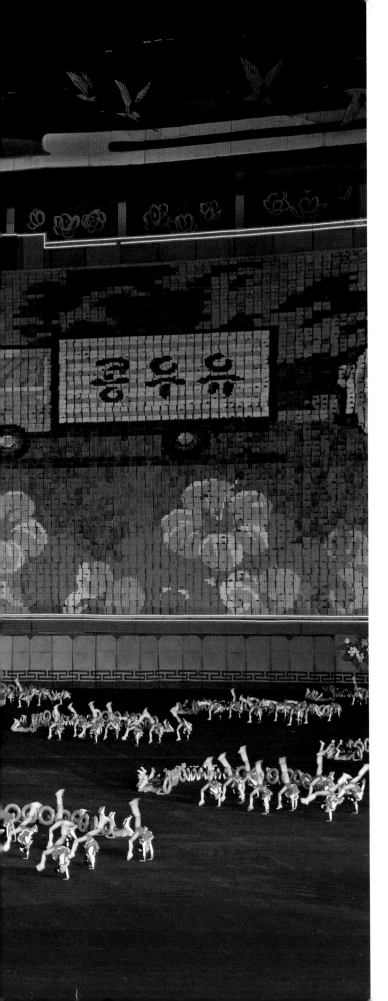

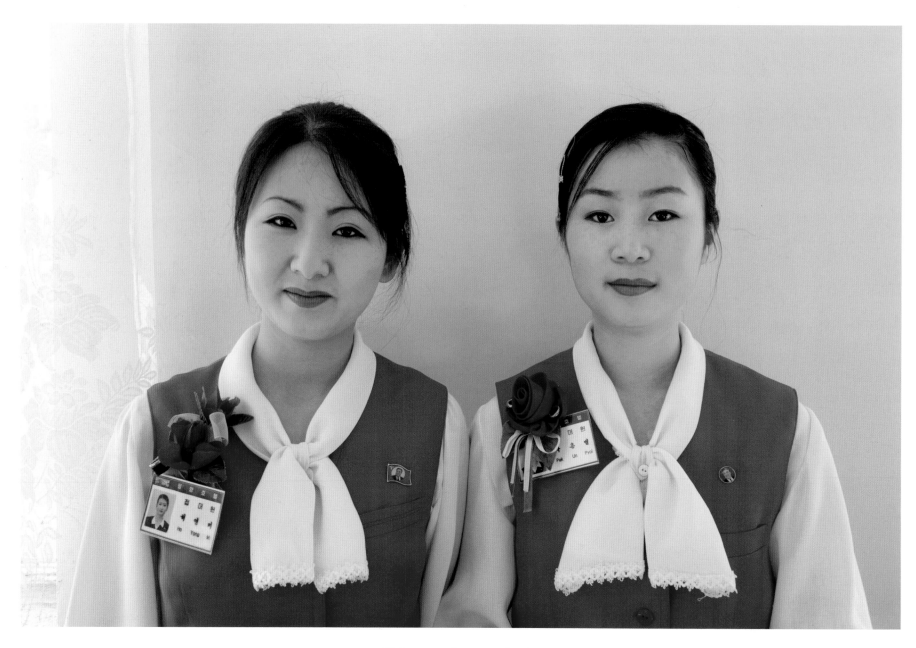

Waitresses at Pyongyang Hotel

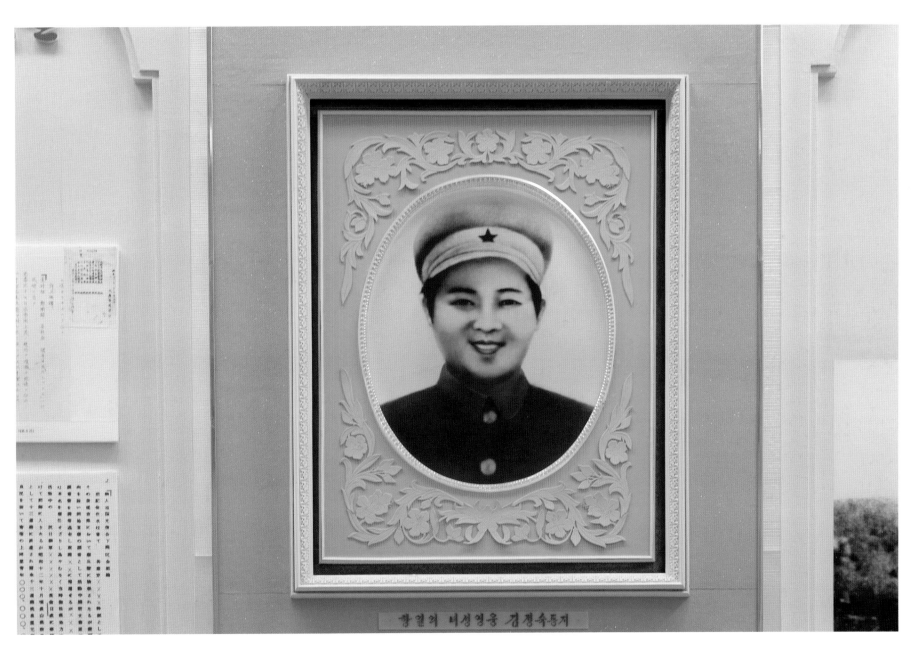

Effigy of Kim Jong-suk, 'Mother of the Homeland'

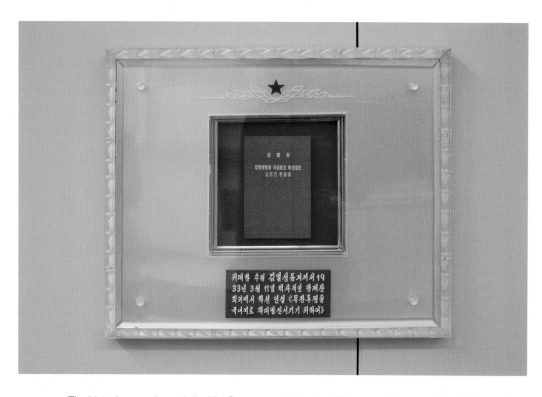

The historic speech made by Kim Il-sung on 11 March 1933 supporting armed conflict

Juche Tower tour guide wearing a *jogori* (a traditional jacket)

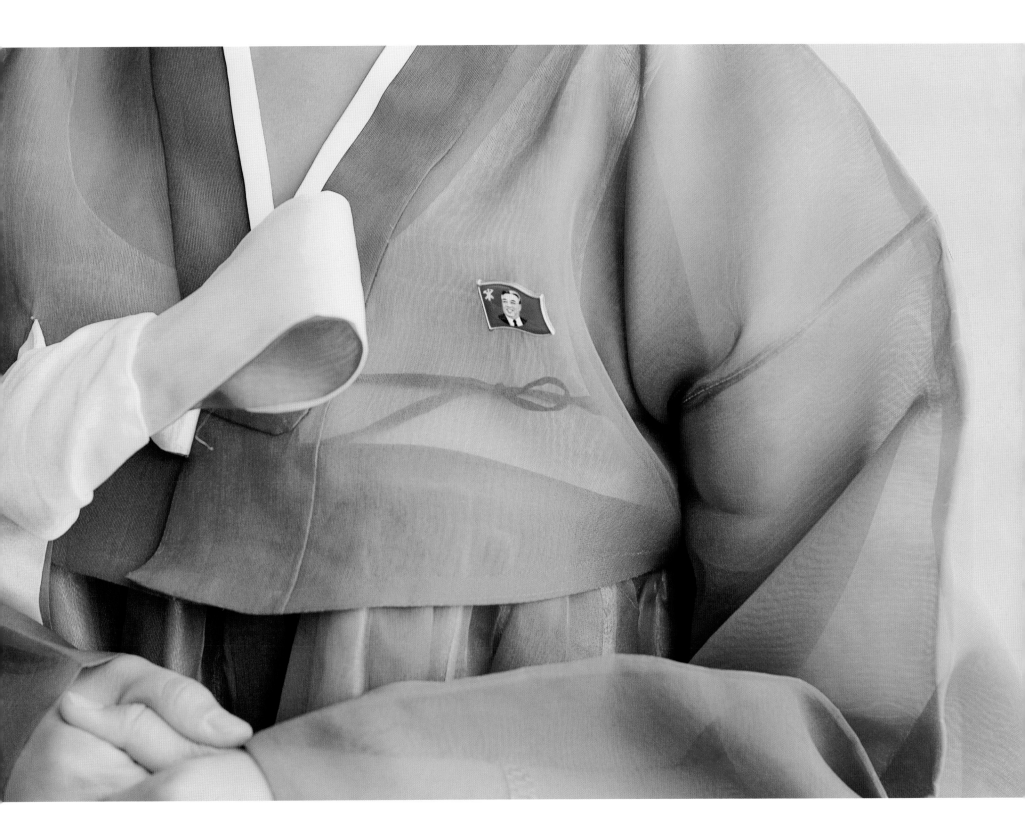

136 Inside the Koryo Hotel café, Pyongyang

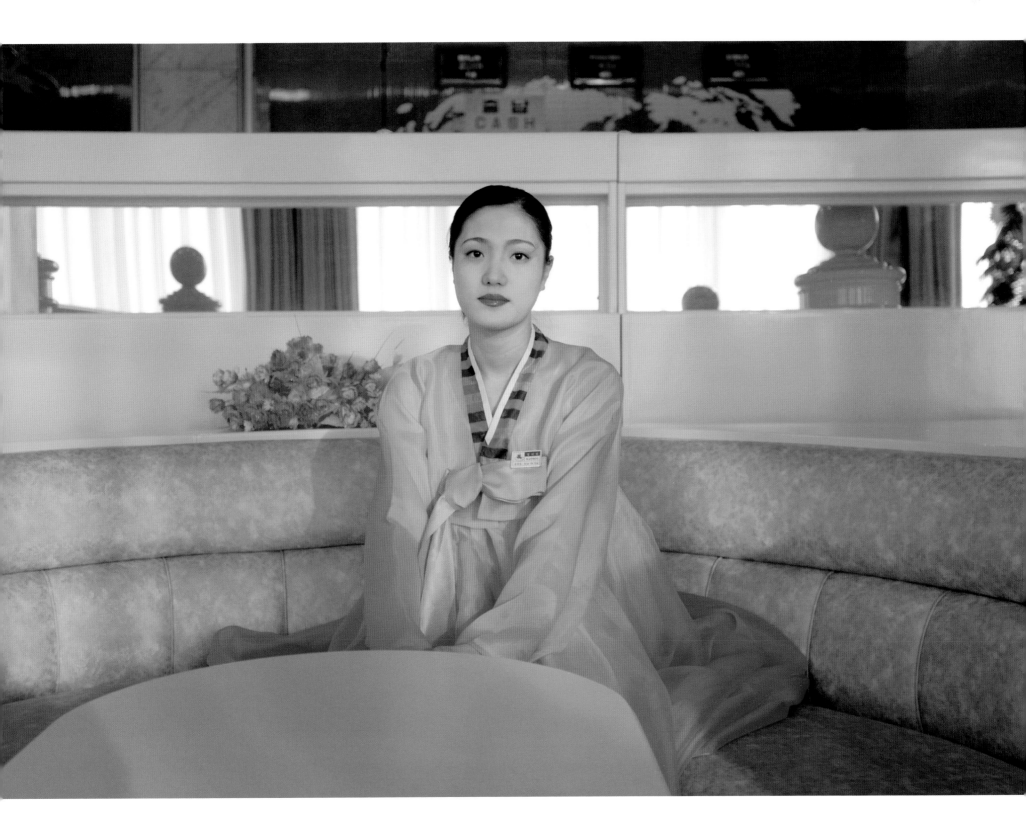

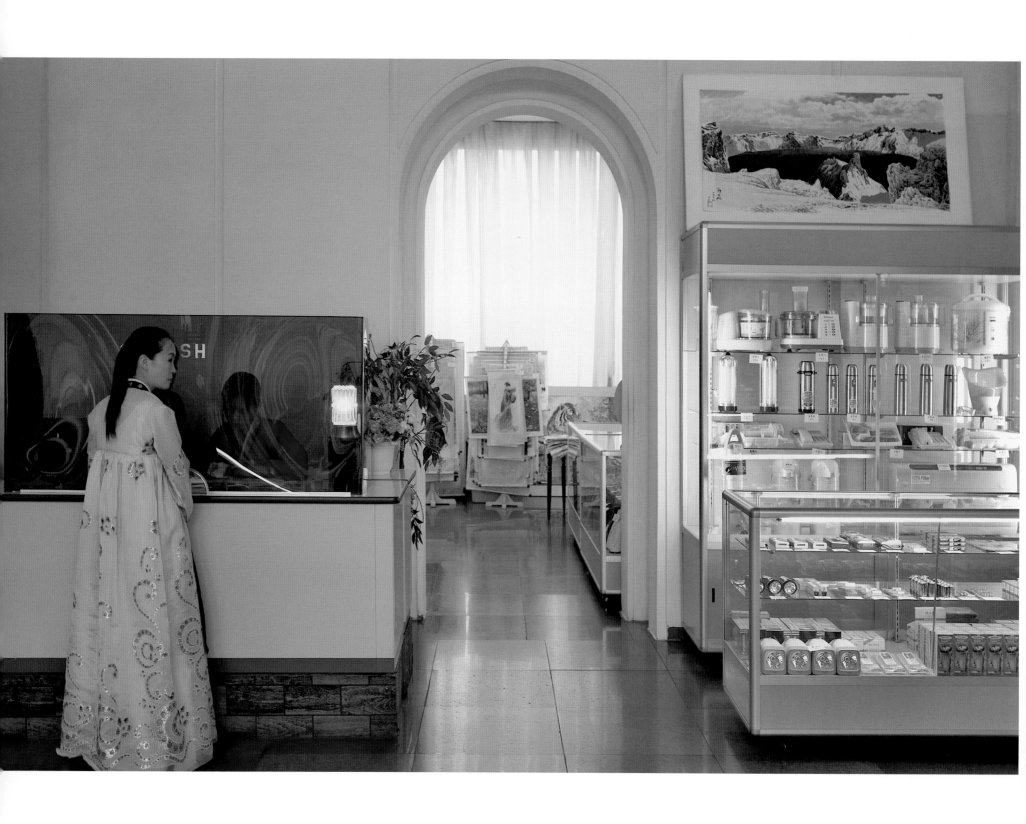

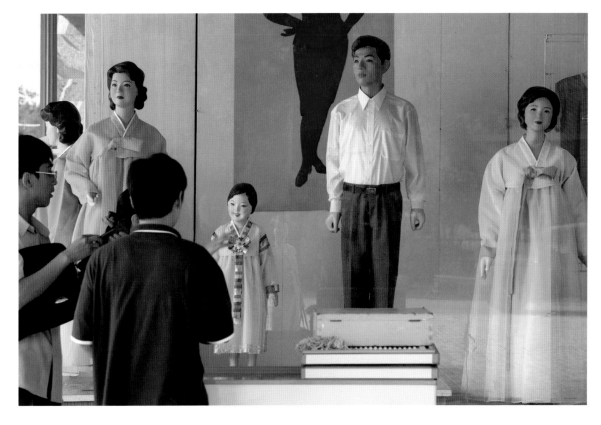

Window display at Department Store No. 1, Pyongyang

The Koryo Hotel gift shop

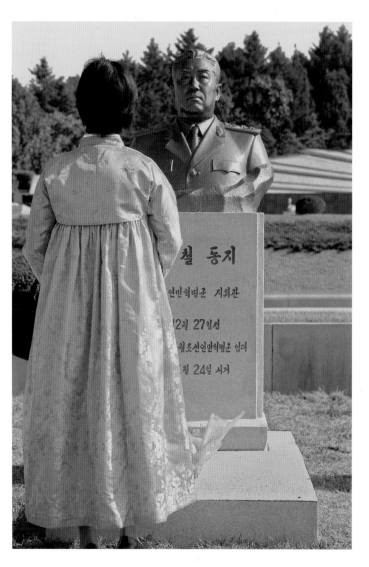

The daughter of a general in the Liberation Army stands
in silent remembrance before the tomb of her father,
Revolutionary Martyrs' Cemetery

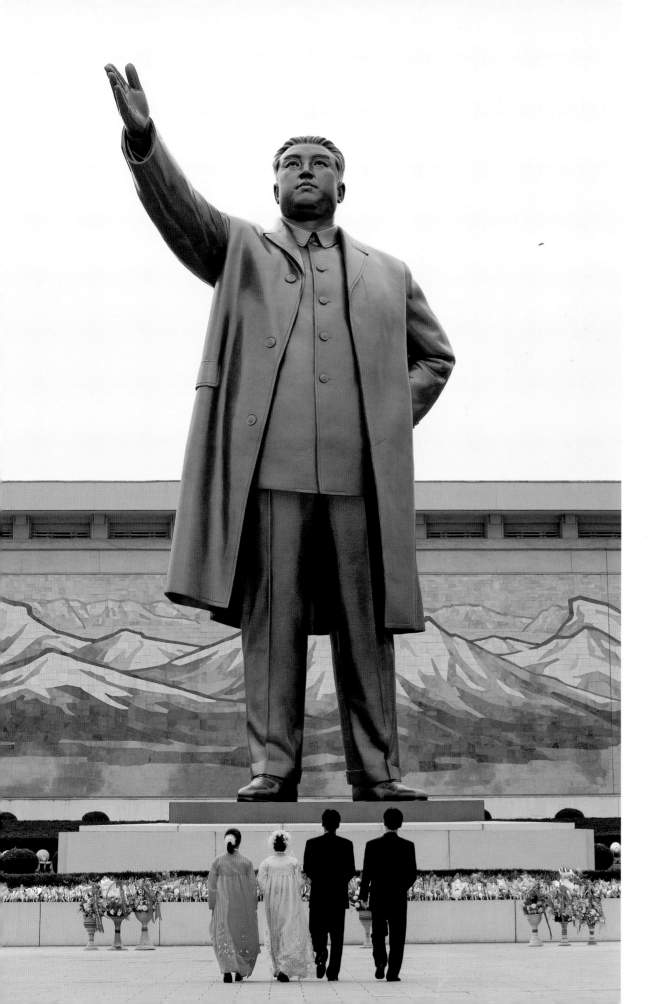

142 A mosaic behind the Mansudae Grand Monument depicts Mount Paektu, the birthplace of the Revolution

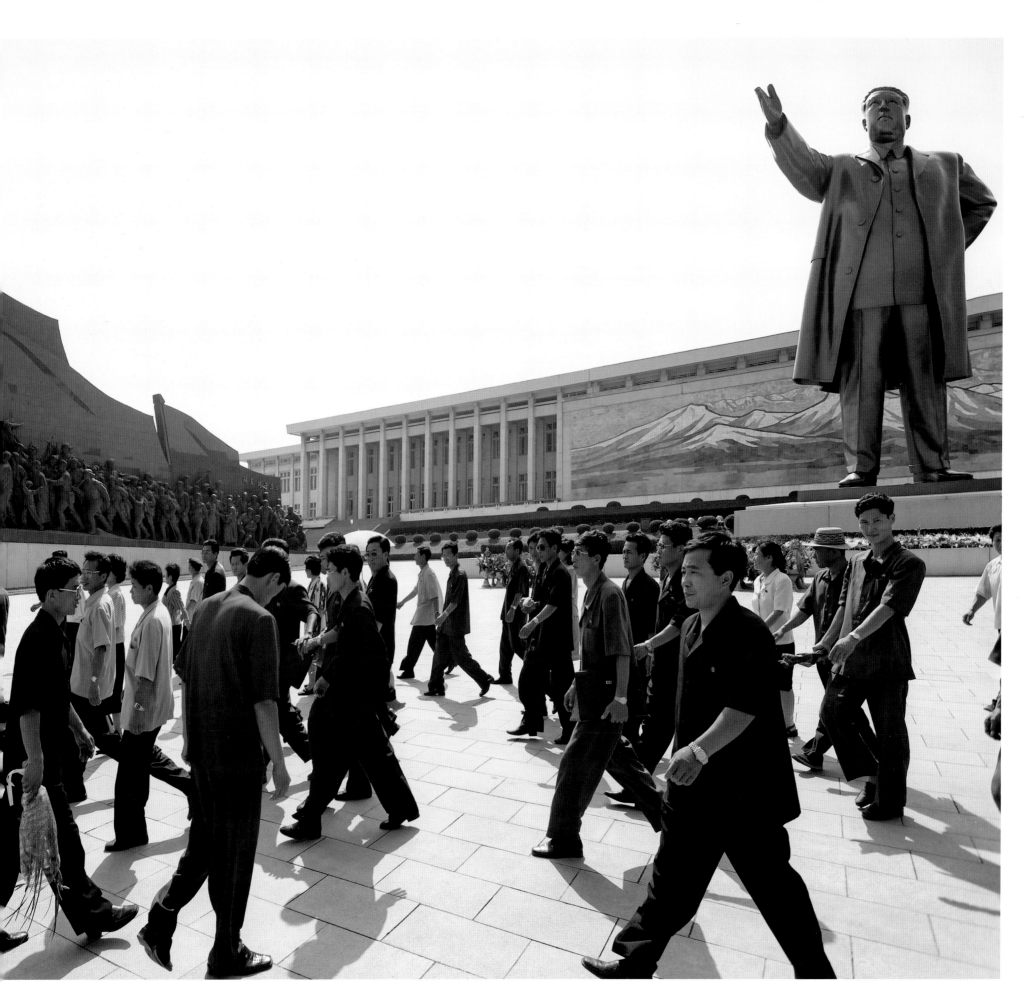

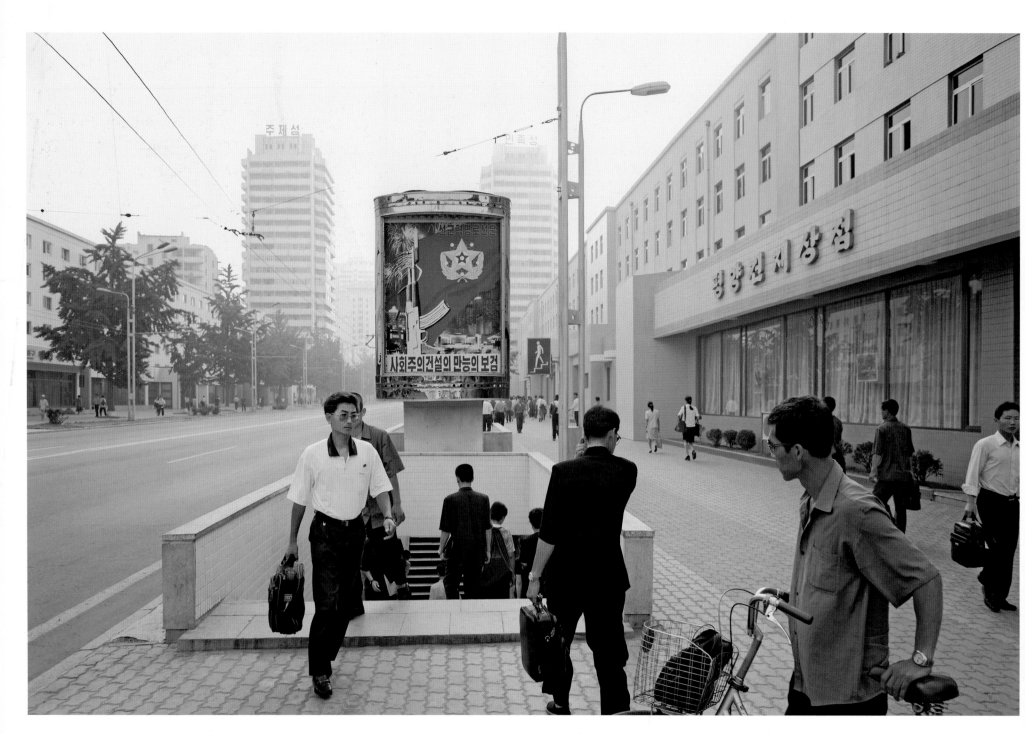

Pedestrian underpass

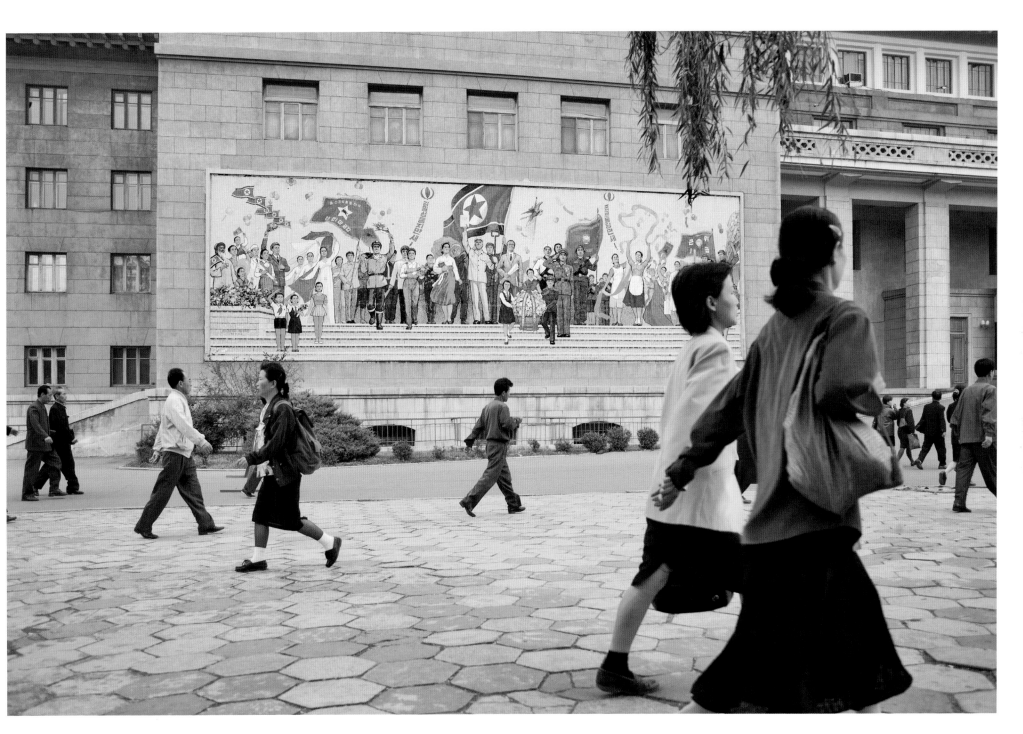

Pyongyang Grand Theatre

146 A delegation pays homage to the Martyrs of the Revolution

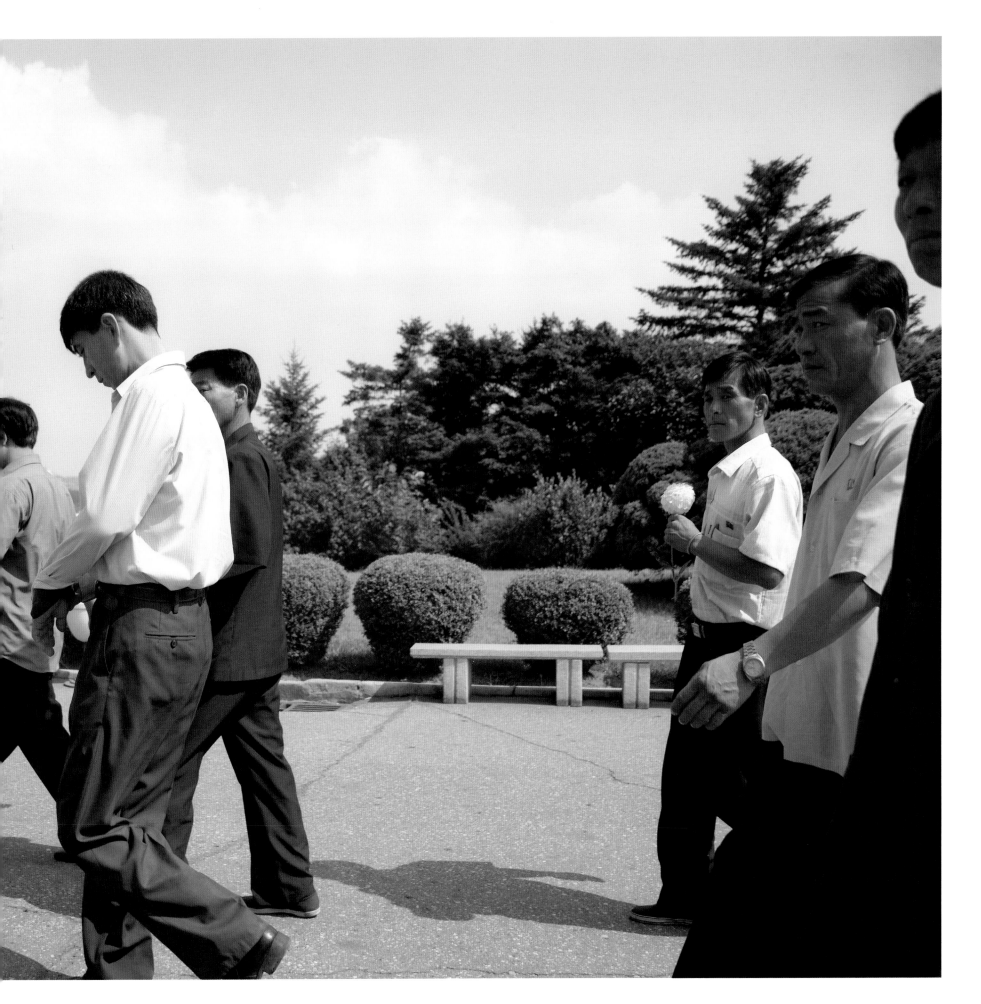

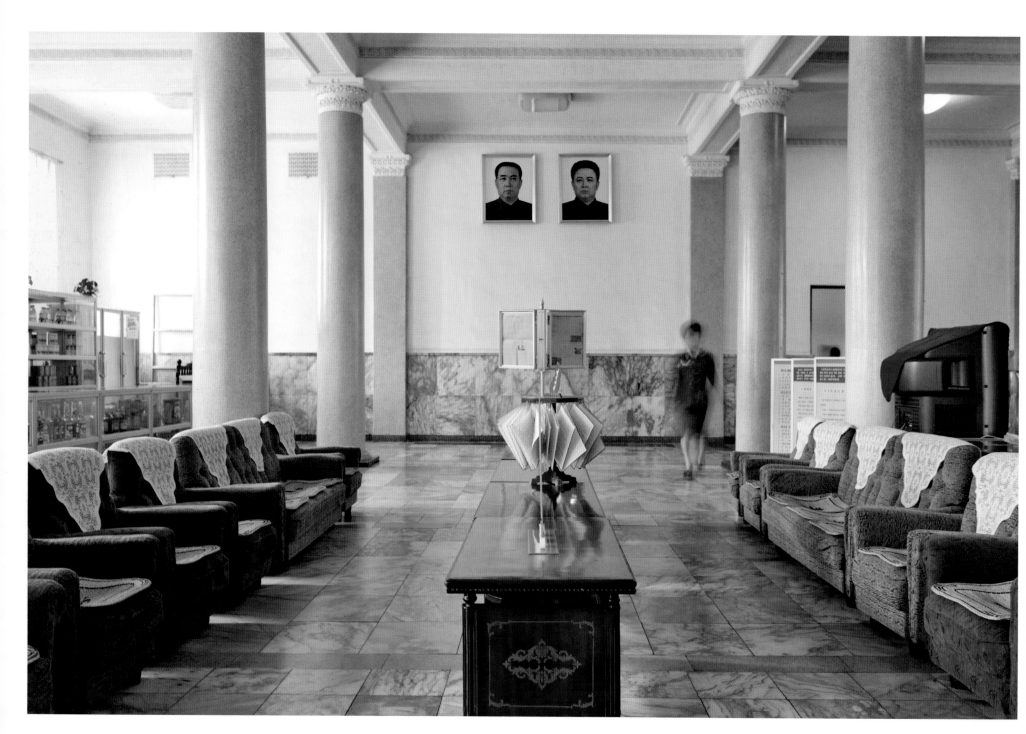

First class lounge, Pyongyang Station

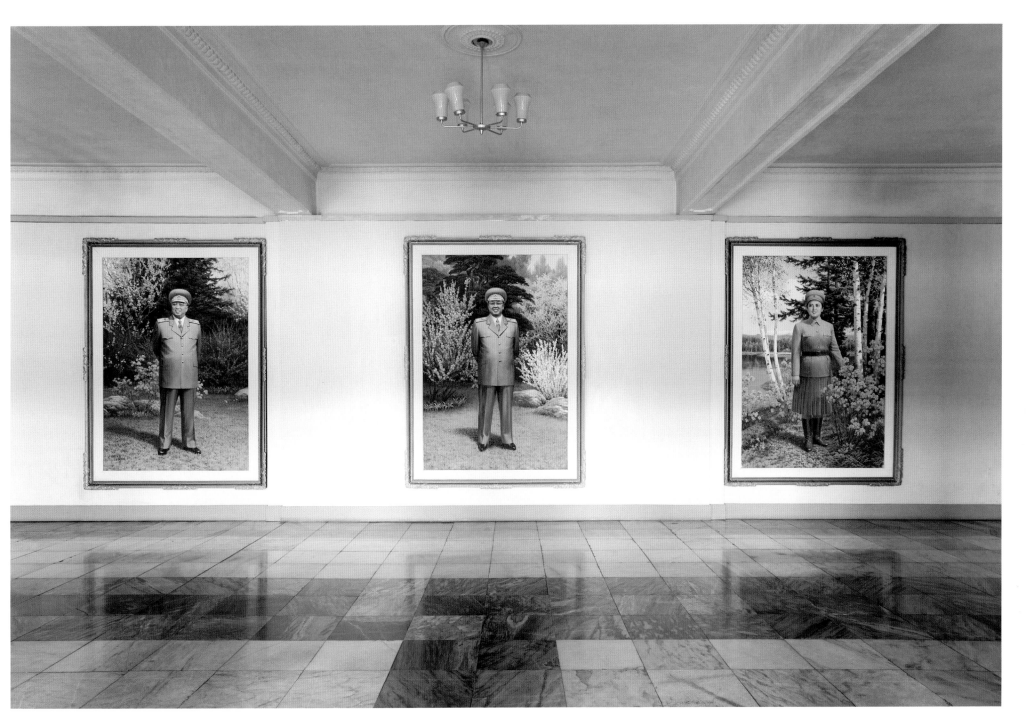

Entrance hall of the Museum of Fine Arts. From left to right: Kim Il-sung, Kim Jong-il and Kim Jong-suk

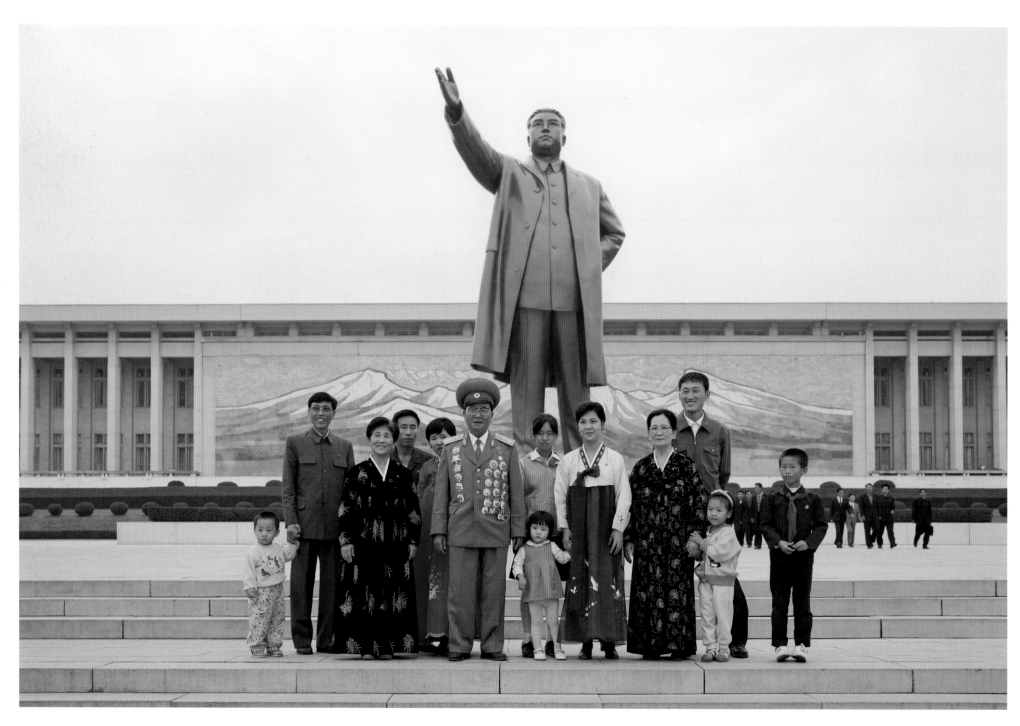

A Korean War veteran with his family at the Mansudae Grand Monument

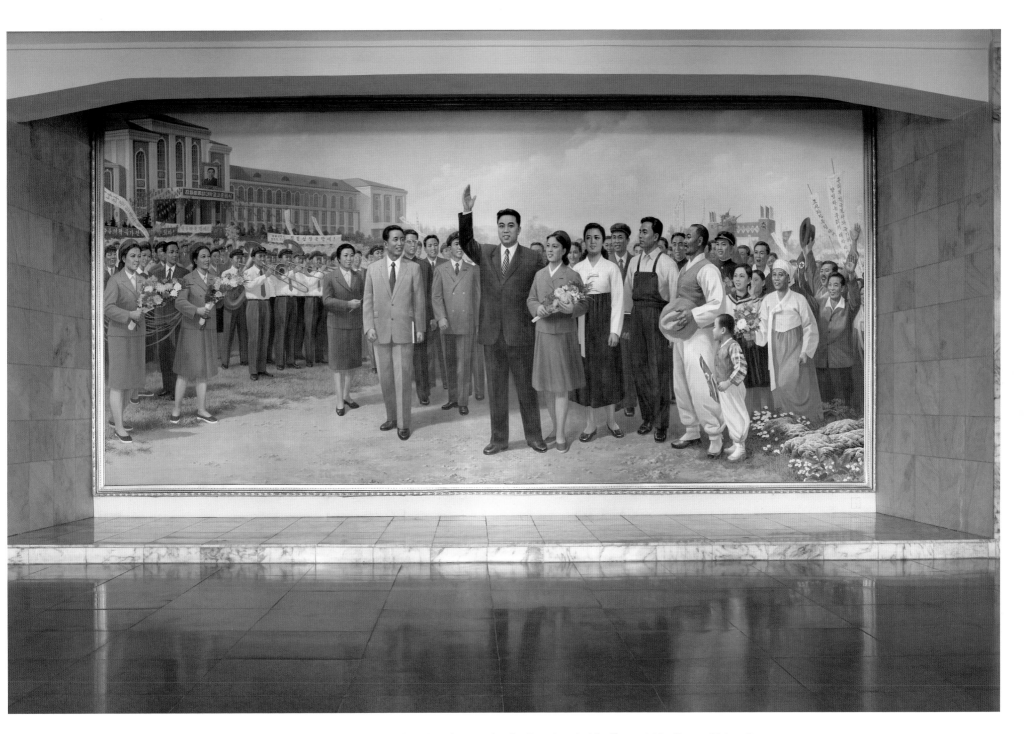

'Workers, peasants, intellectuals and students praise the Great Leader Kim Il-sung', Kim Il-sung University

152 The entrance hall of the Museum of the Revolution

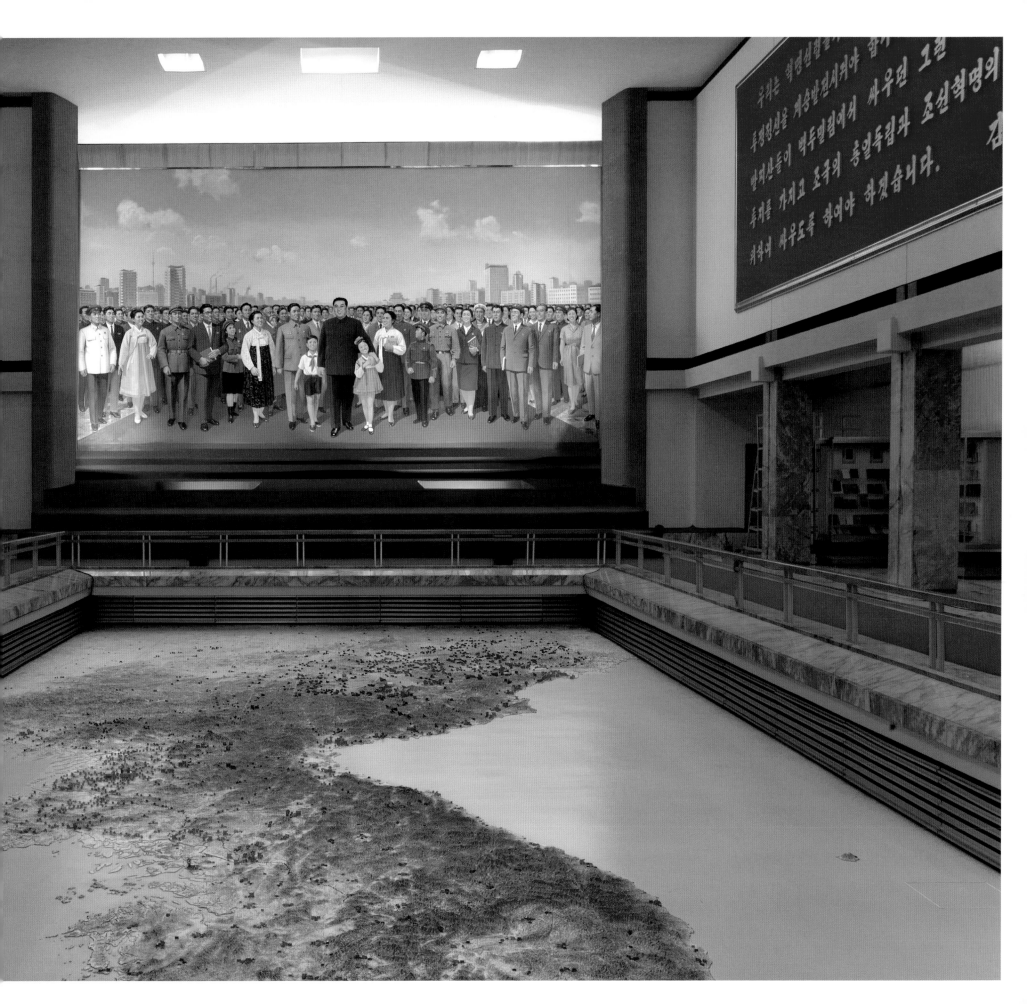

154 Children's Palace

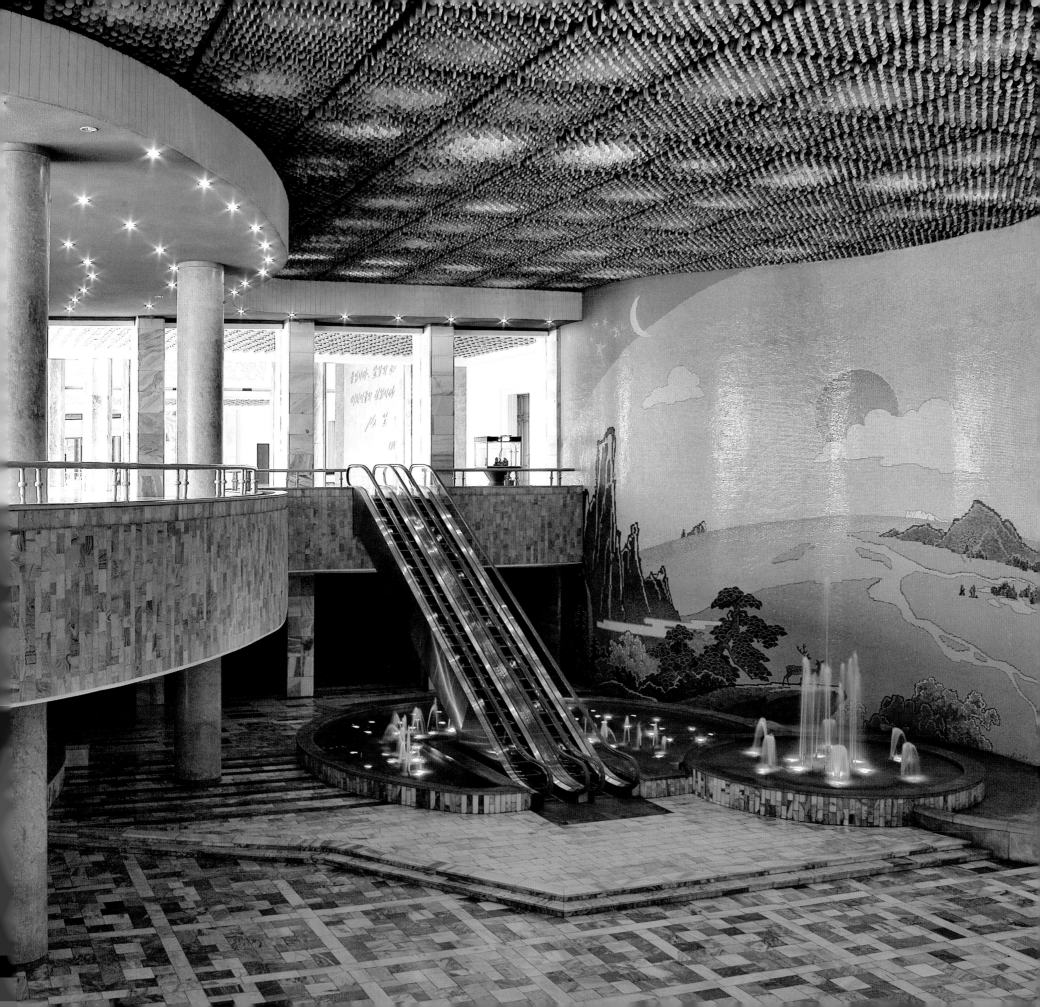

156　Chong Ryu Restaurant, Pyongyang

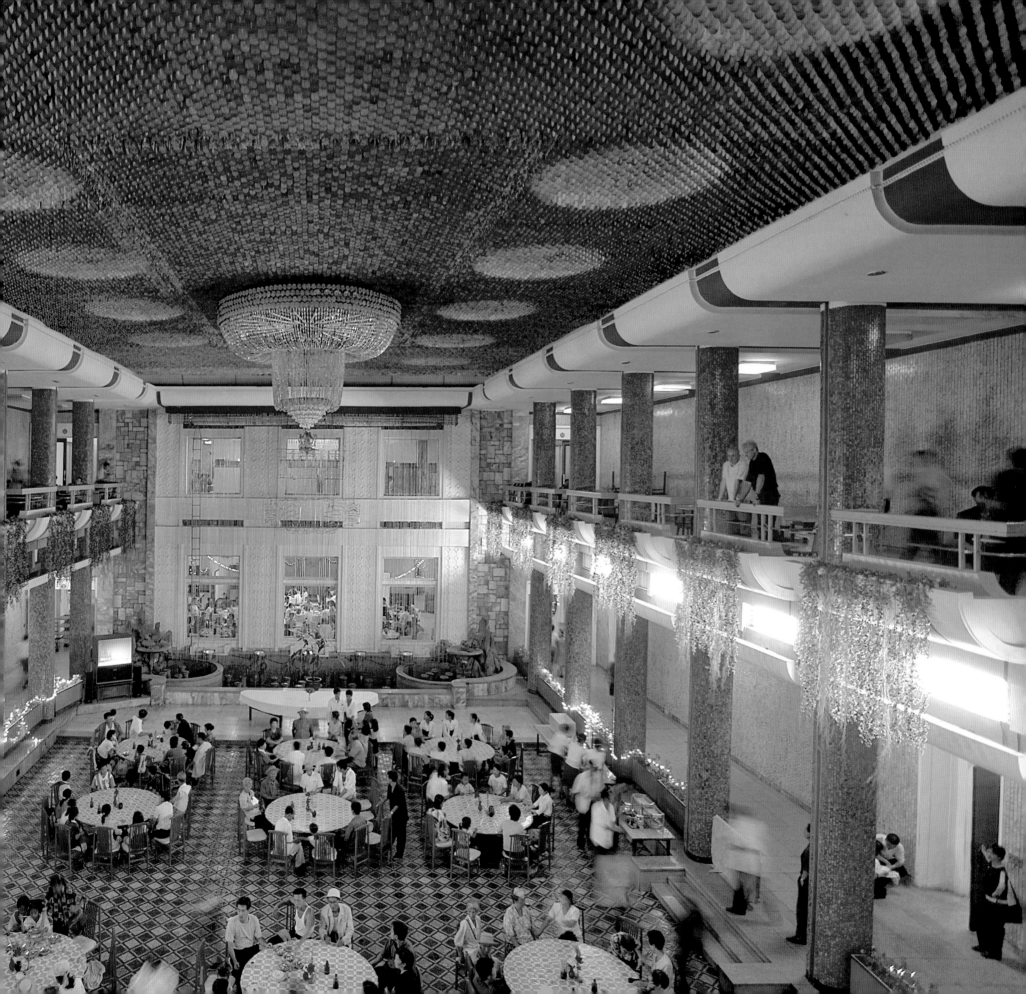

Space shuttle model in the lobby of the Children's Palace

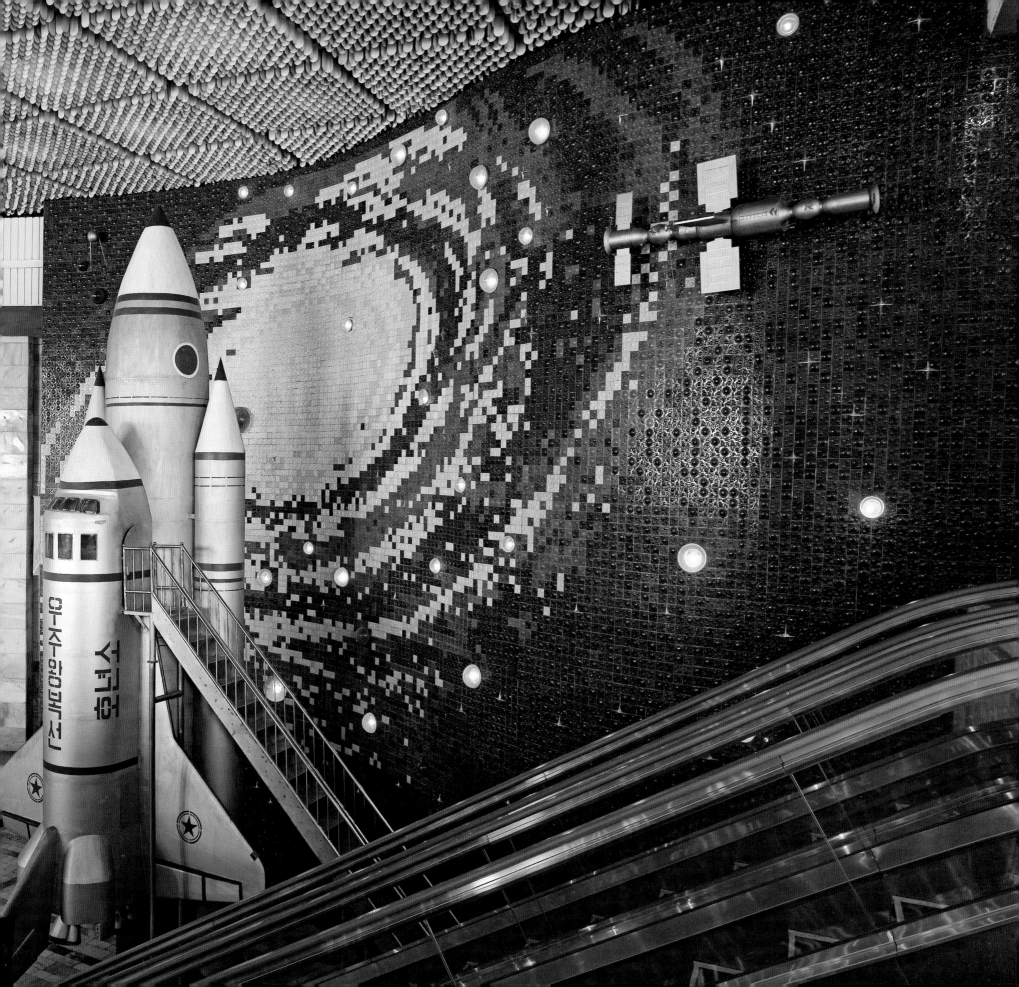

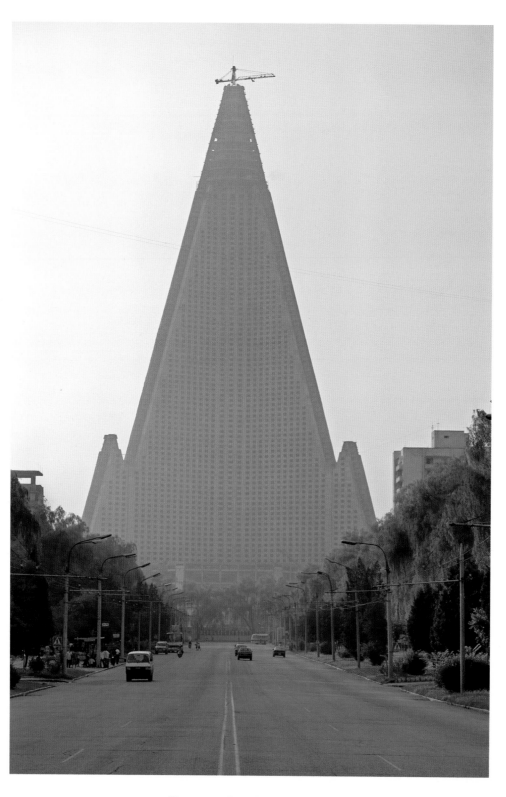

The uncompleted Ryugyong Hotel

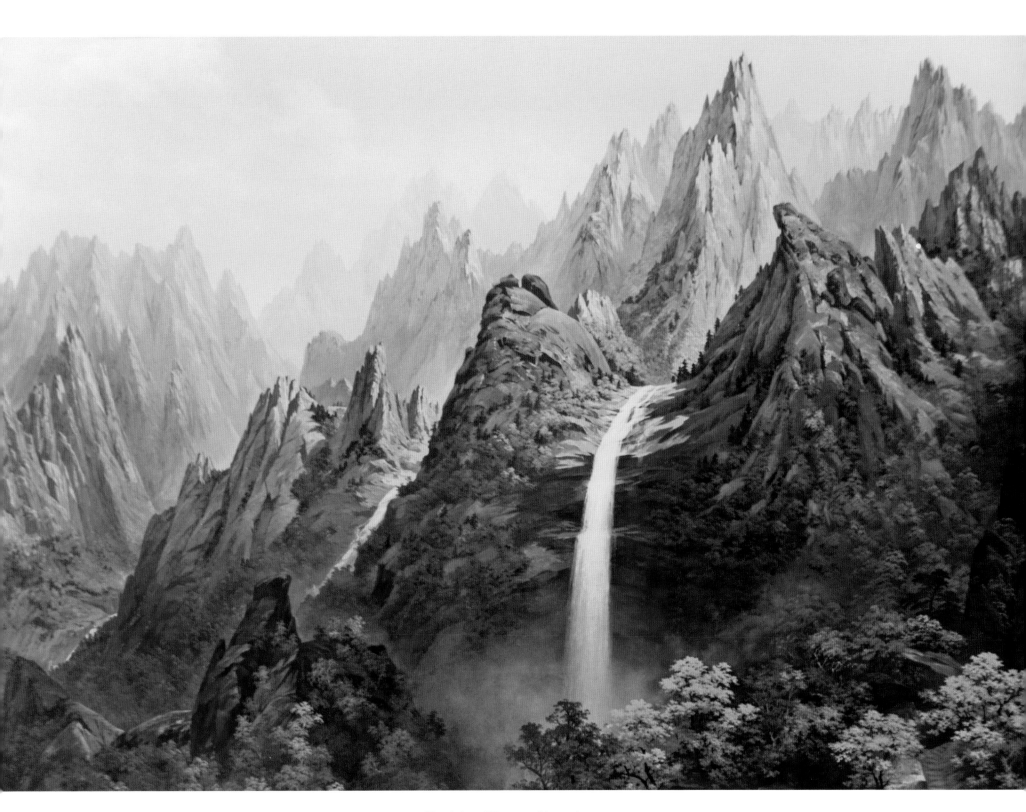

Oil painting of Kumgang Mountain

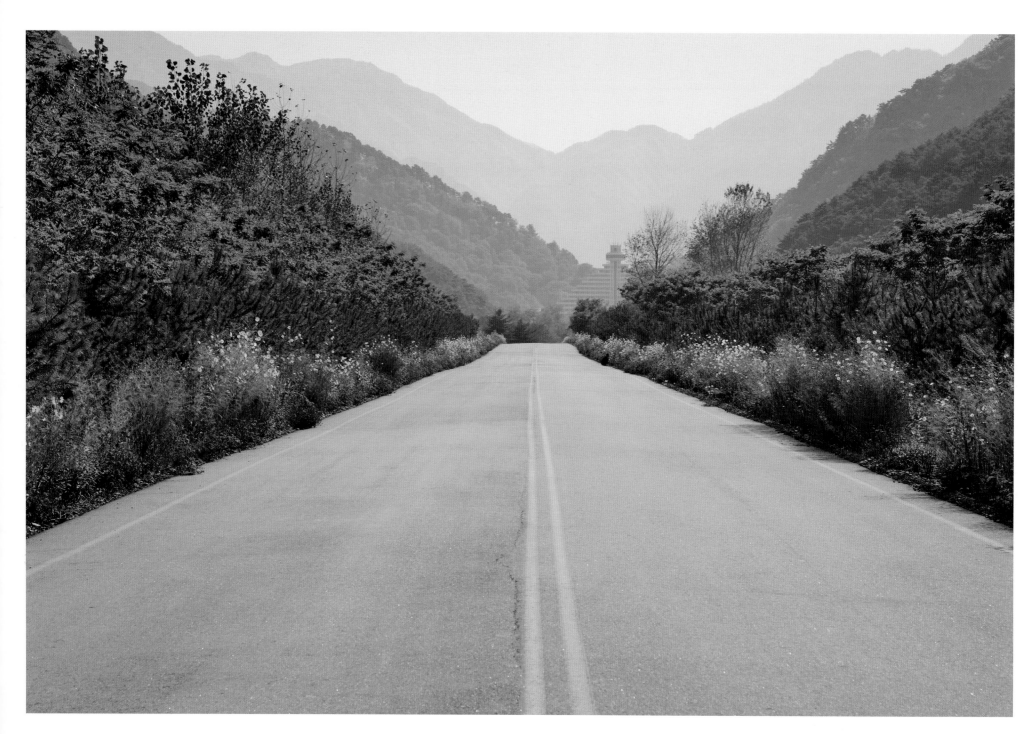

On the road to Myohyang Mountain

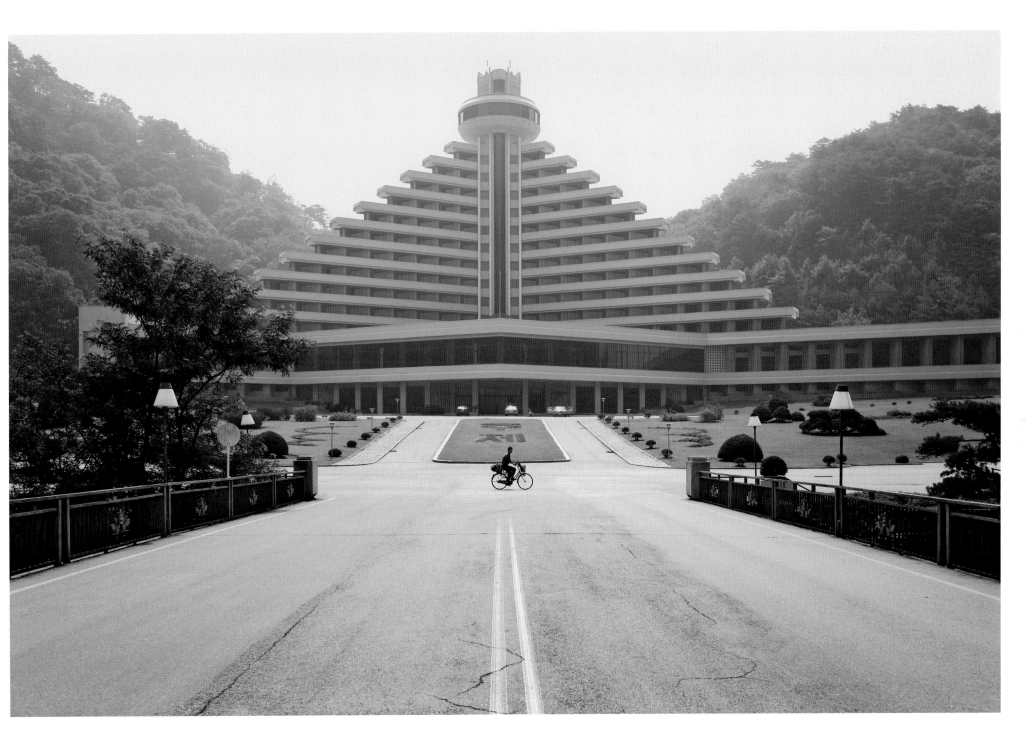

Hyangsan Hotel in the Myohyang Mountains with its revolving restaurant

164 Reunification Monument, on the road south from Pyongyang

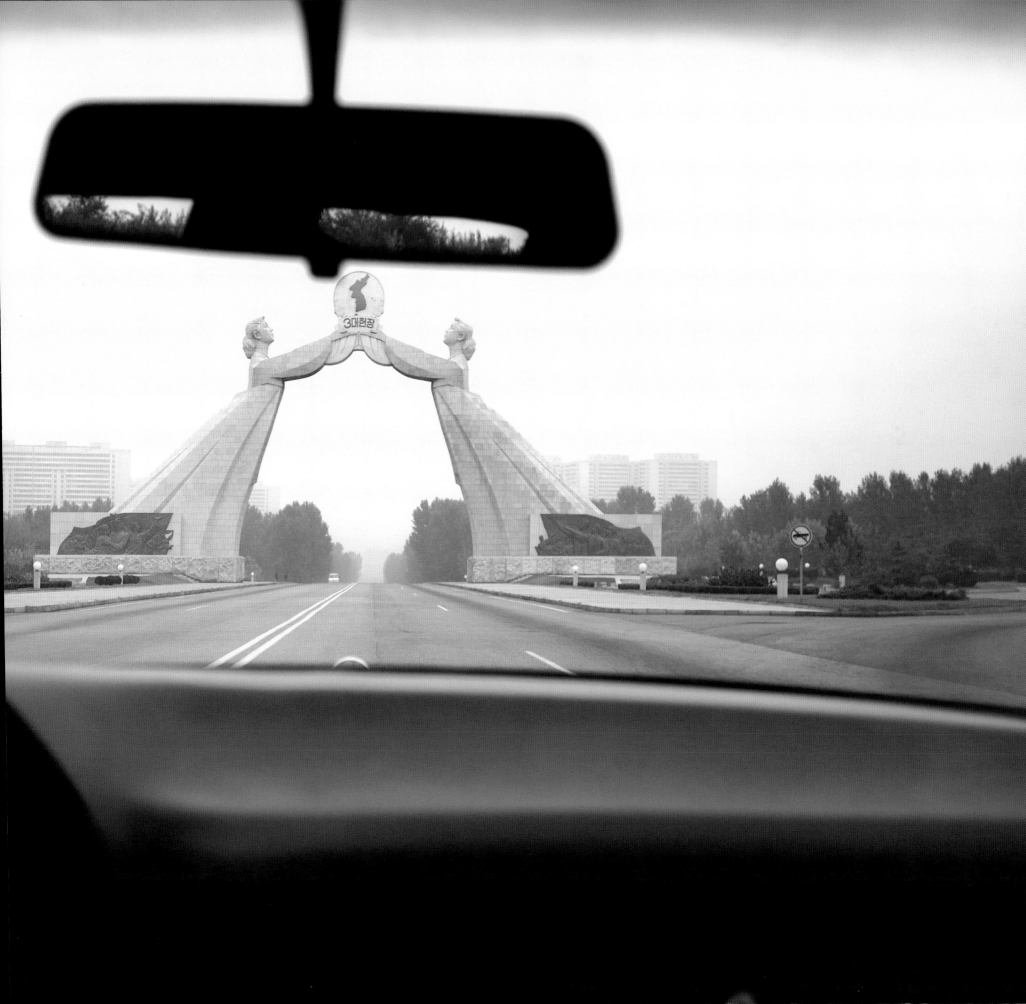

166 Street concert, Pyongyang

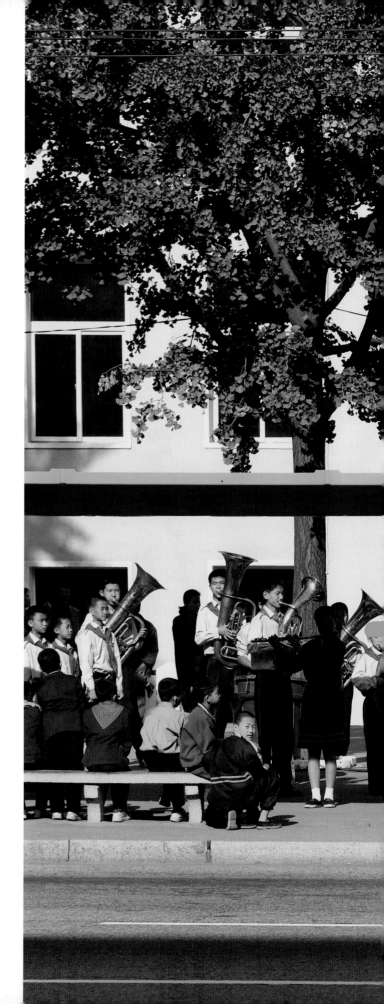

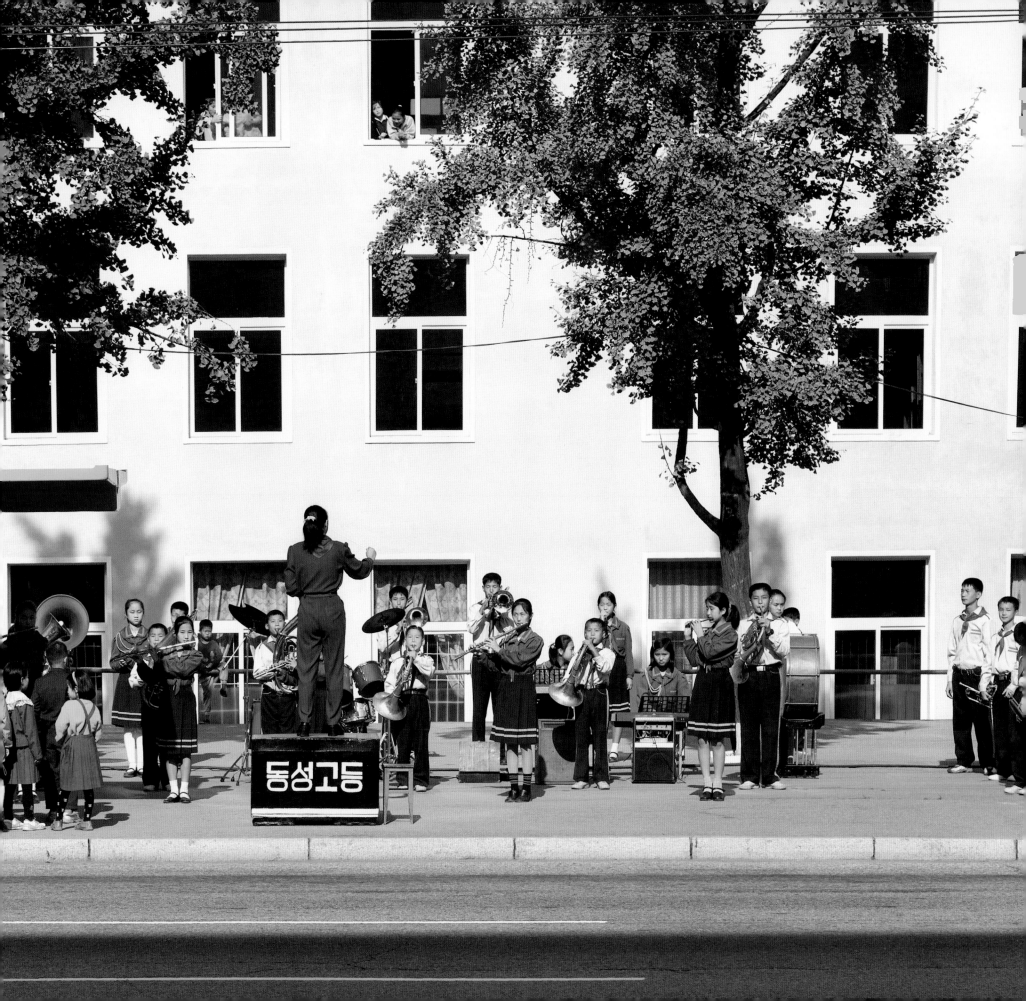

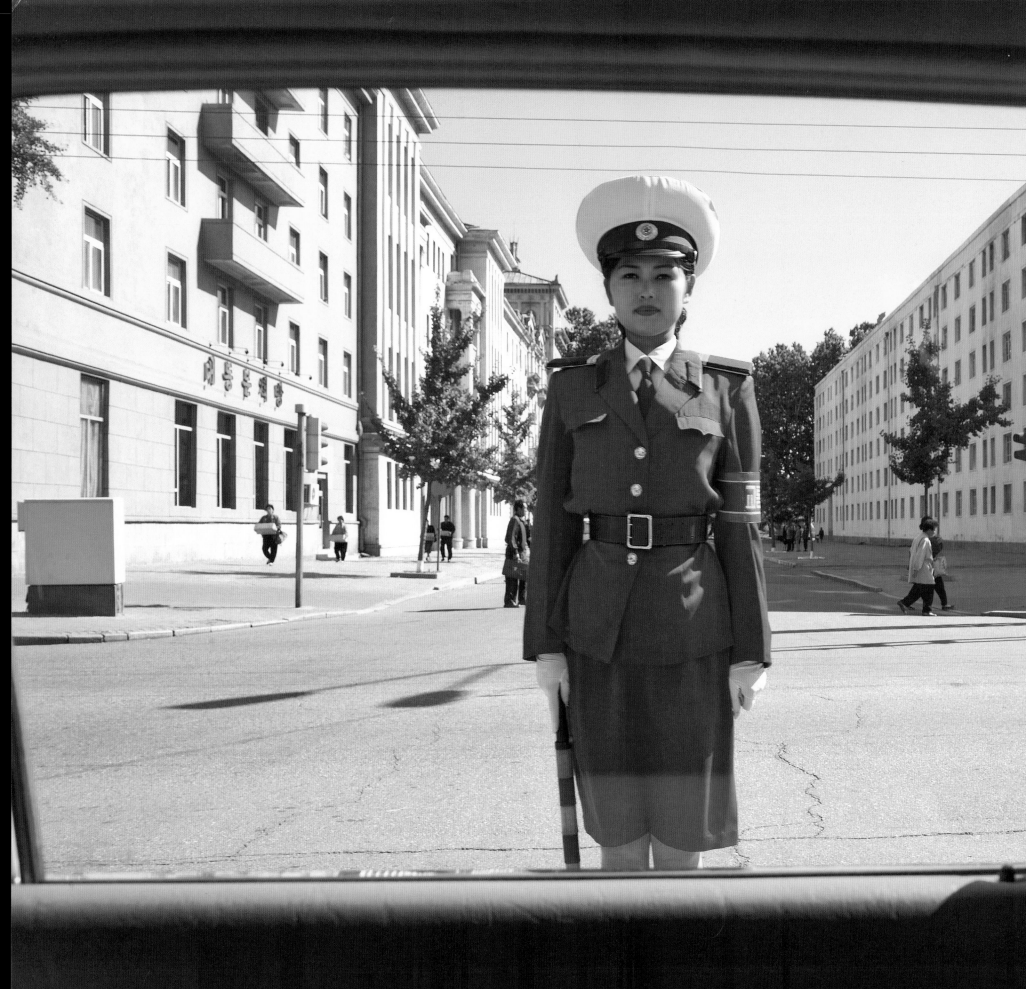

Traffic policewoman, Pyongyang 169

170 Decorations to mark the 60th anniversary, Pyongyang

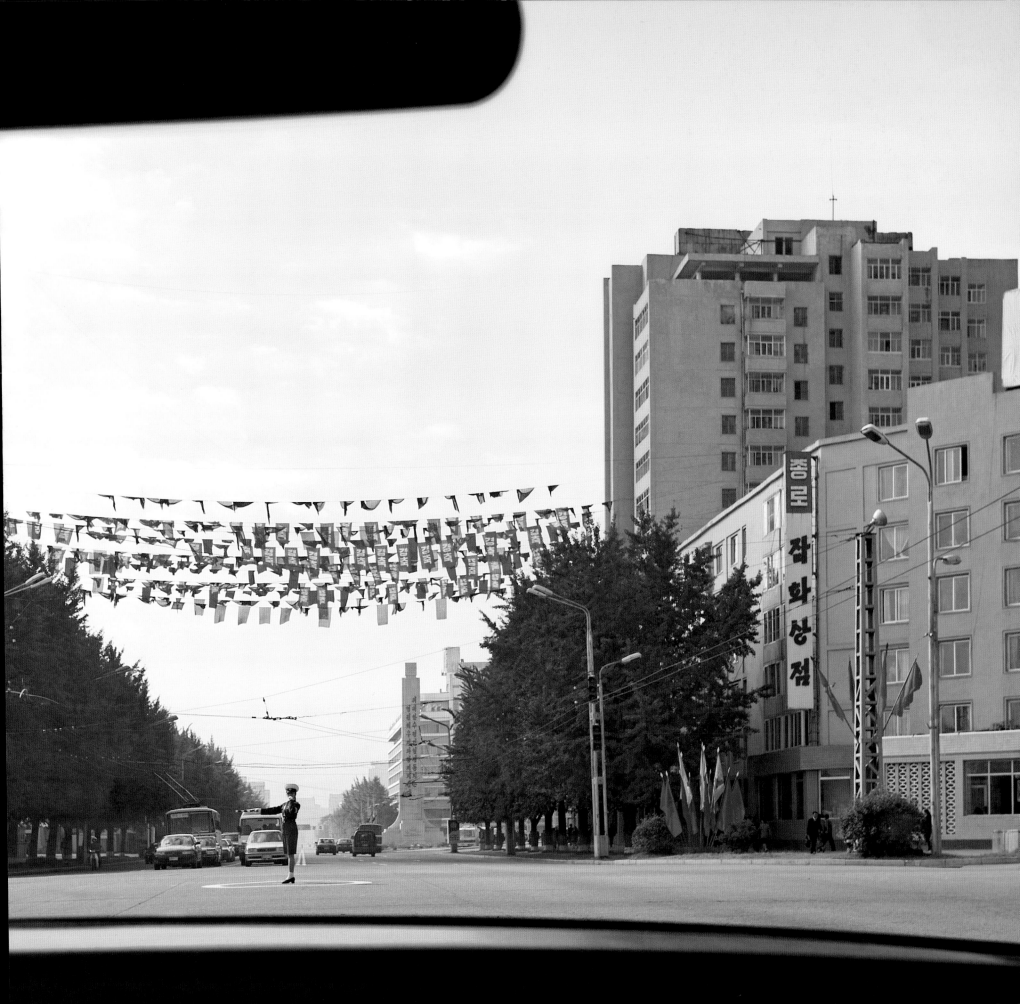

172 Making their way to the anniversary celebrations

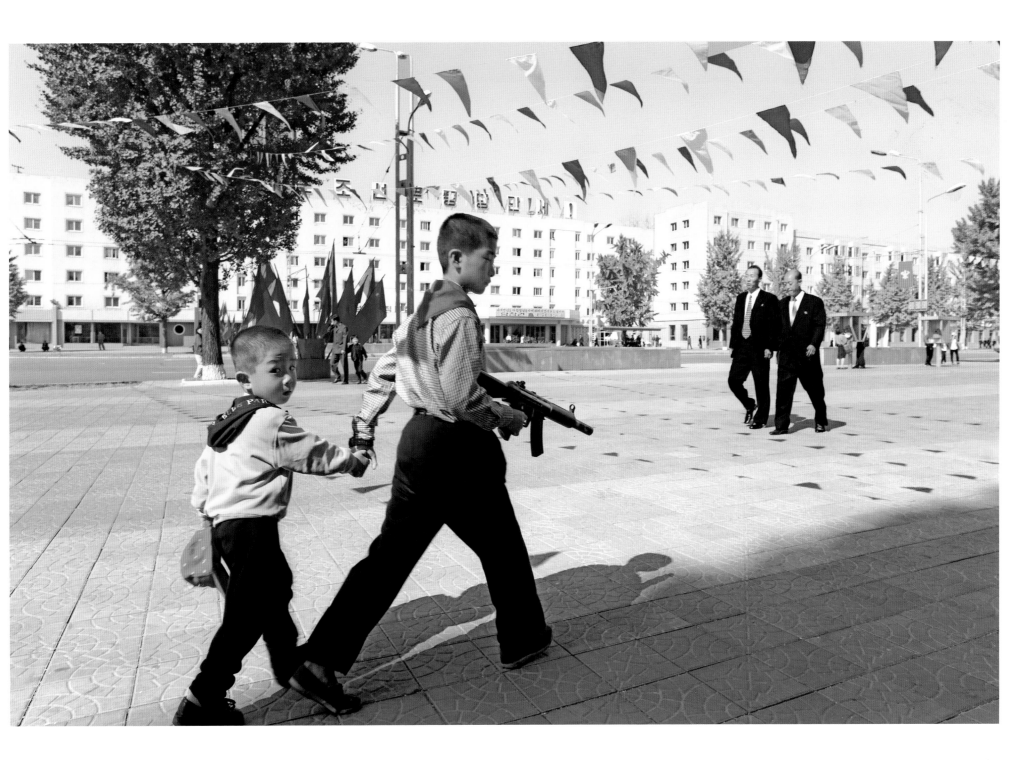

174 Schoolchildren at the Mansudae Grand Monument

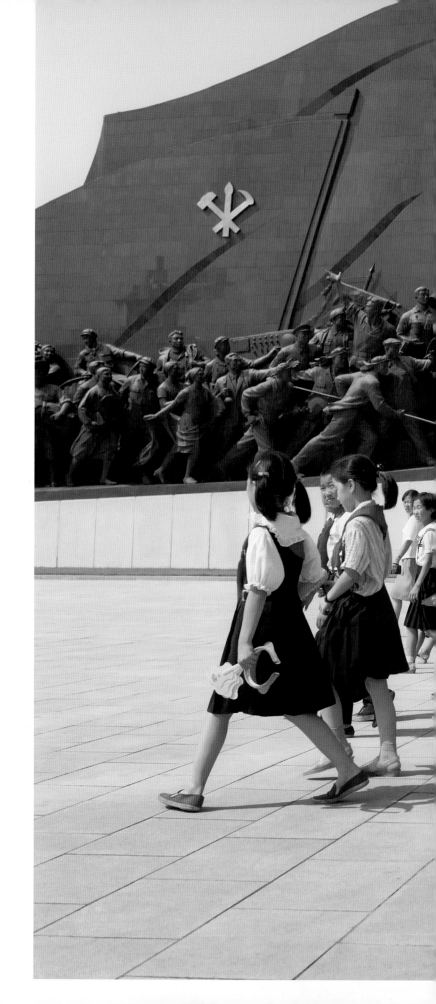

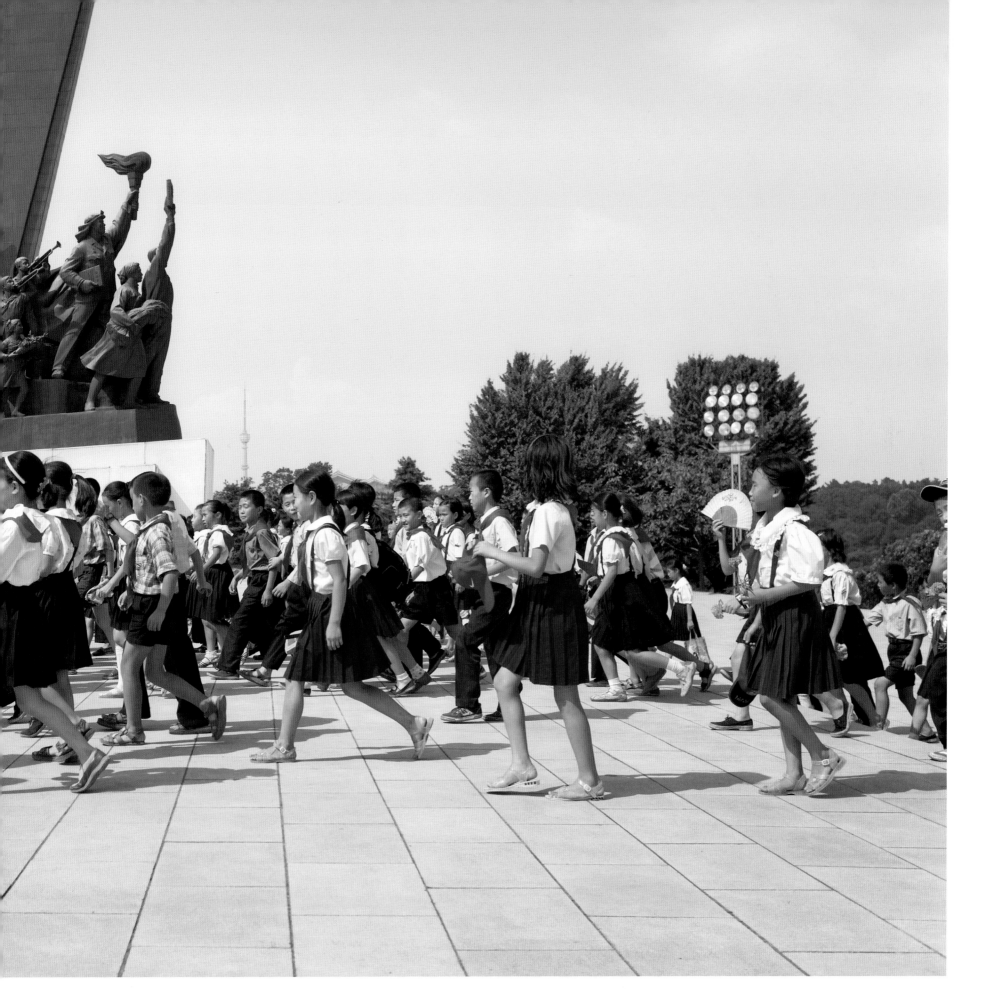

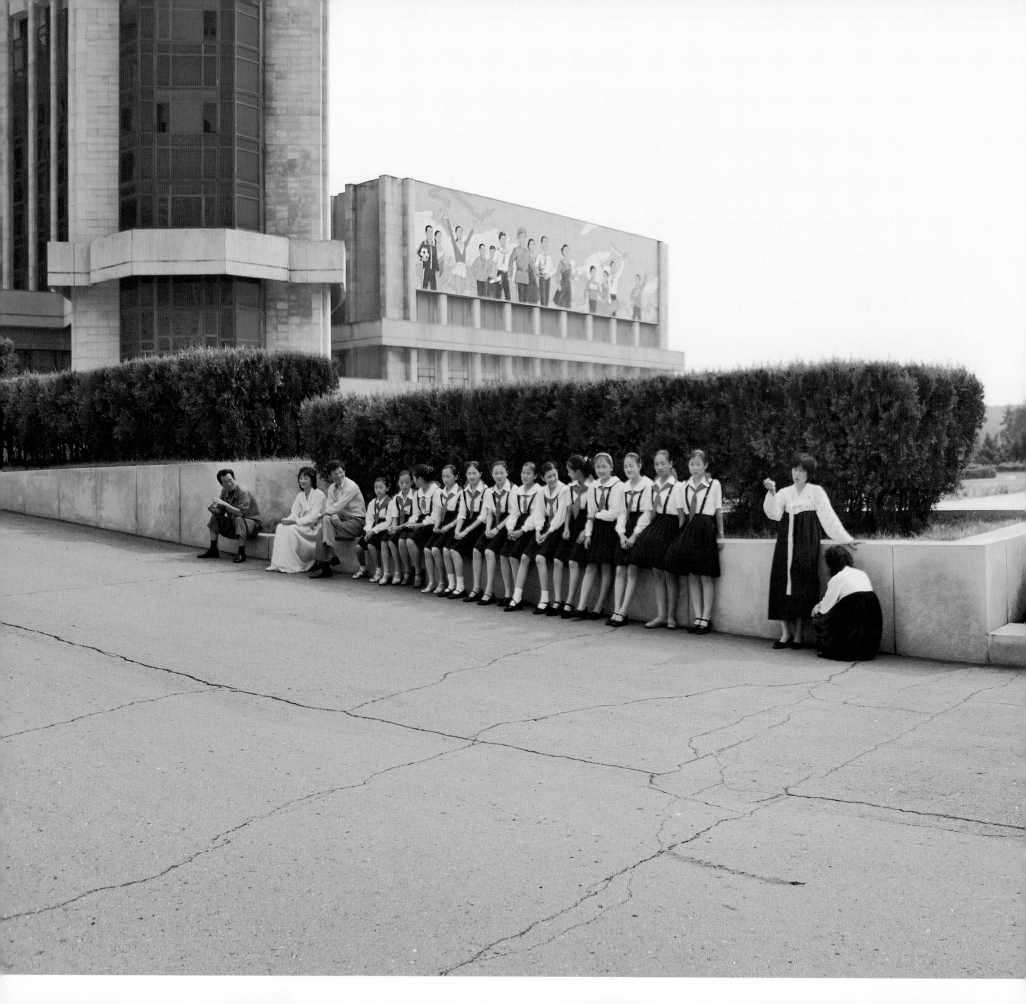

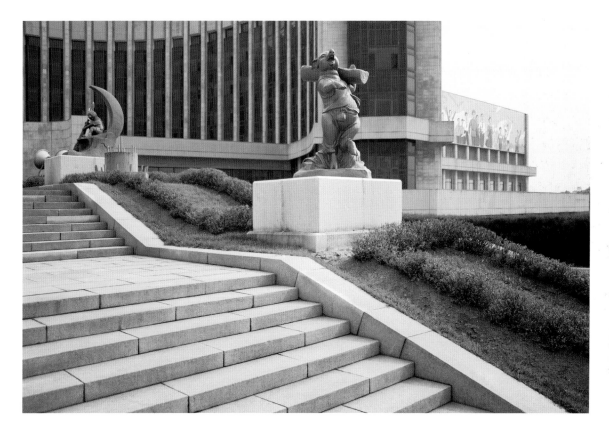

The main staircase to the Children's Palace

Students outside the Children's Palace

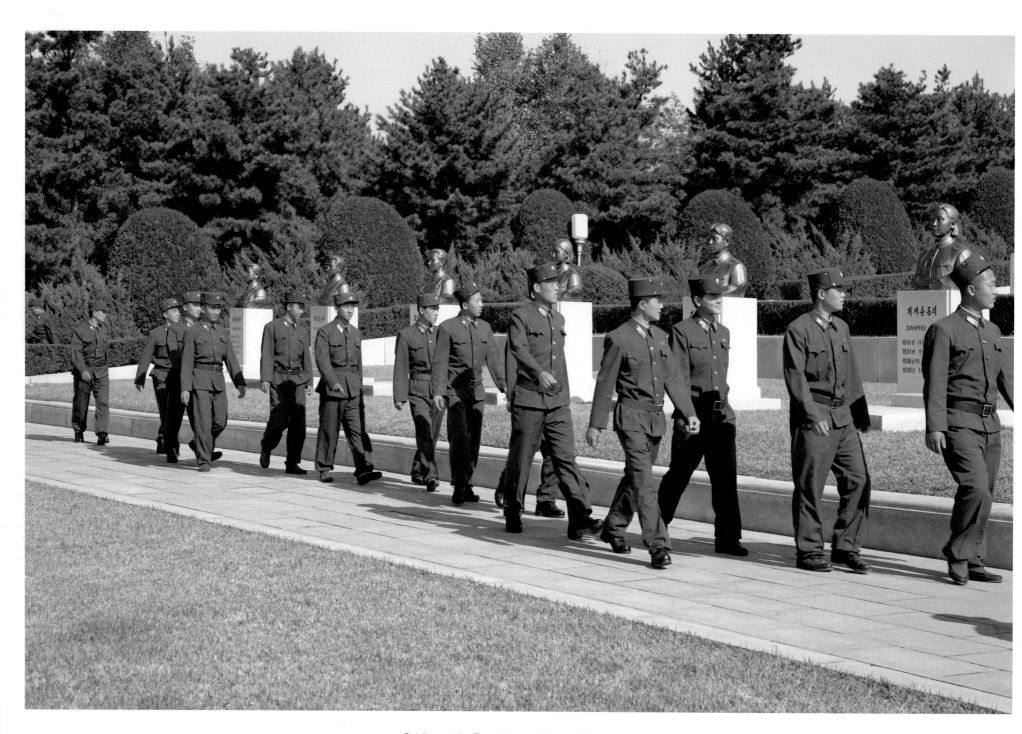

Soldiers at the Revolutionary Martyrs' Cemetery

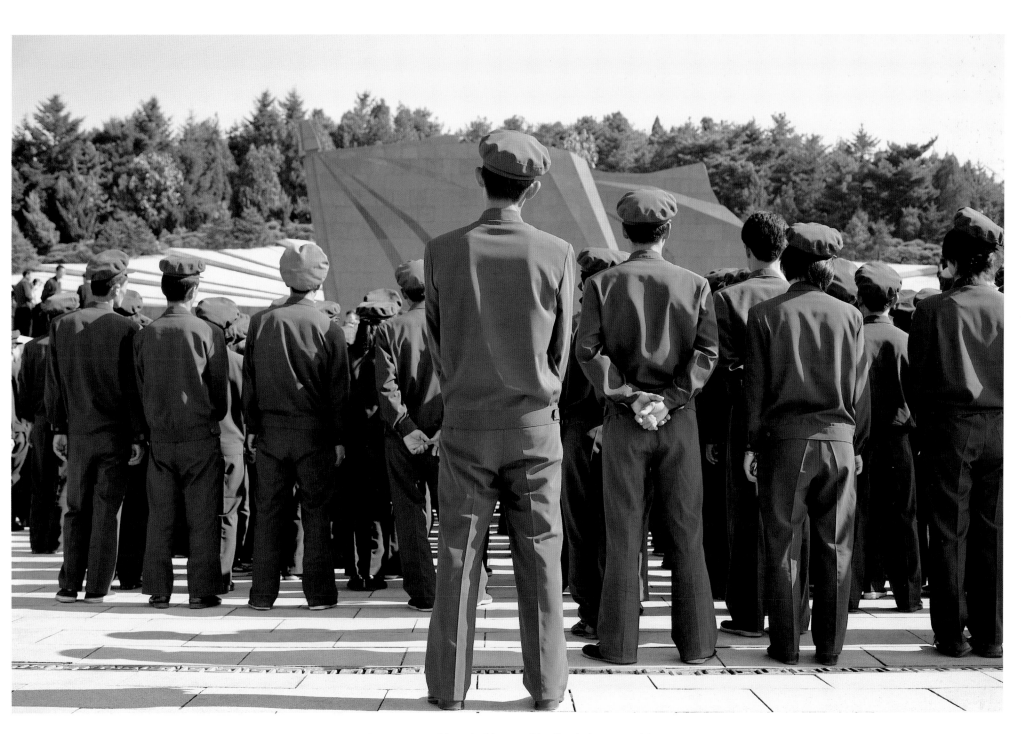

Soldiers assemble at the Martyrs of the Revolution memorial

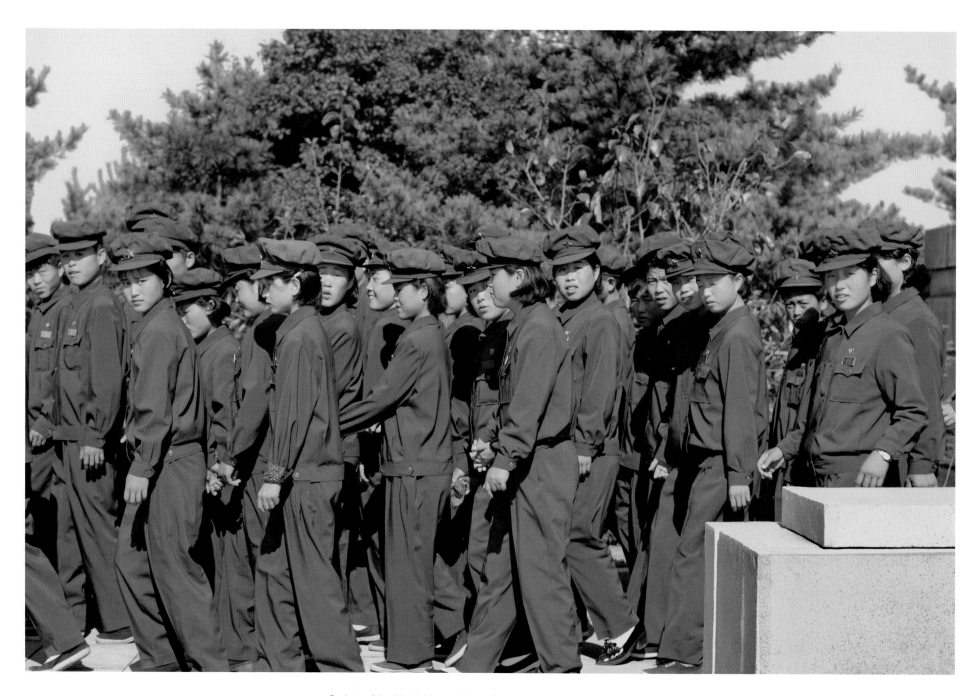

Cadets of the North Korean Army, Revolutionary Martyrs' Cemetery

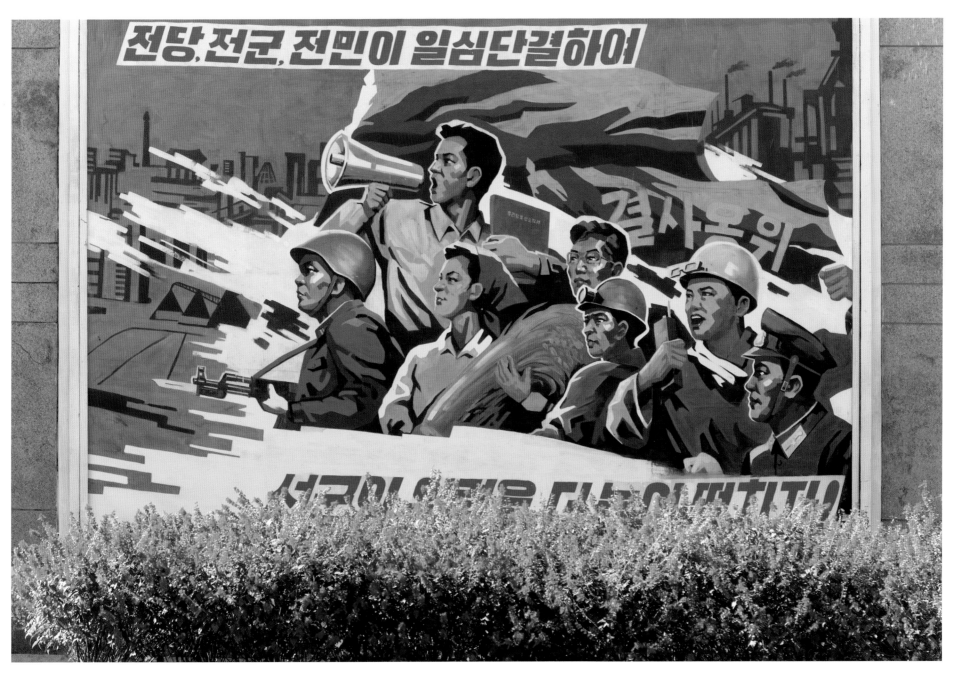

'We demonstrate to prove the power of Songun thanks to the enduring unity of the Party of the People's Army'

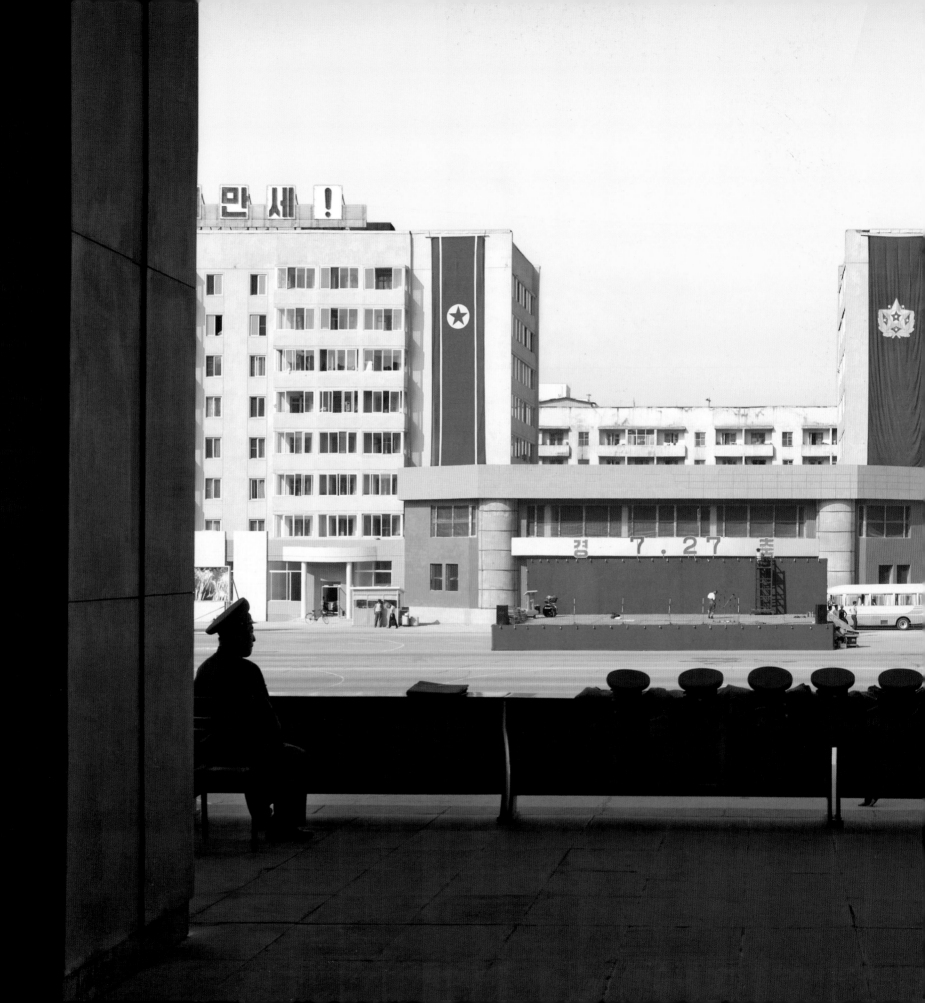

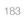

Commemorating the end of the Korean War (27 July 1953) 183

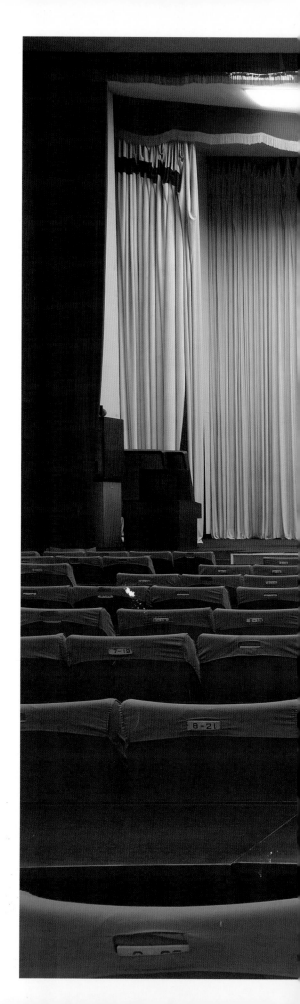

184 Main auditorium, Grand People's Study House

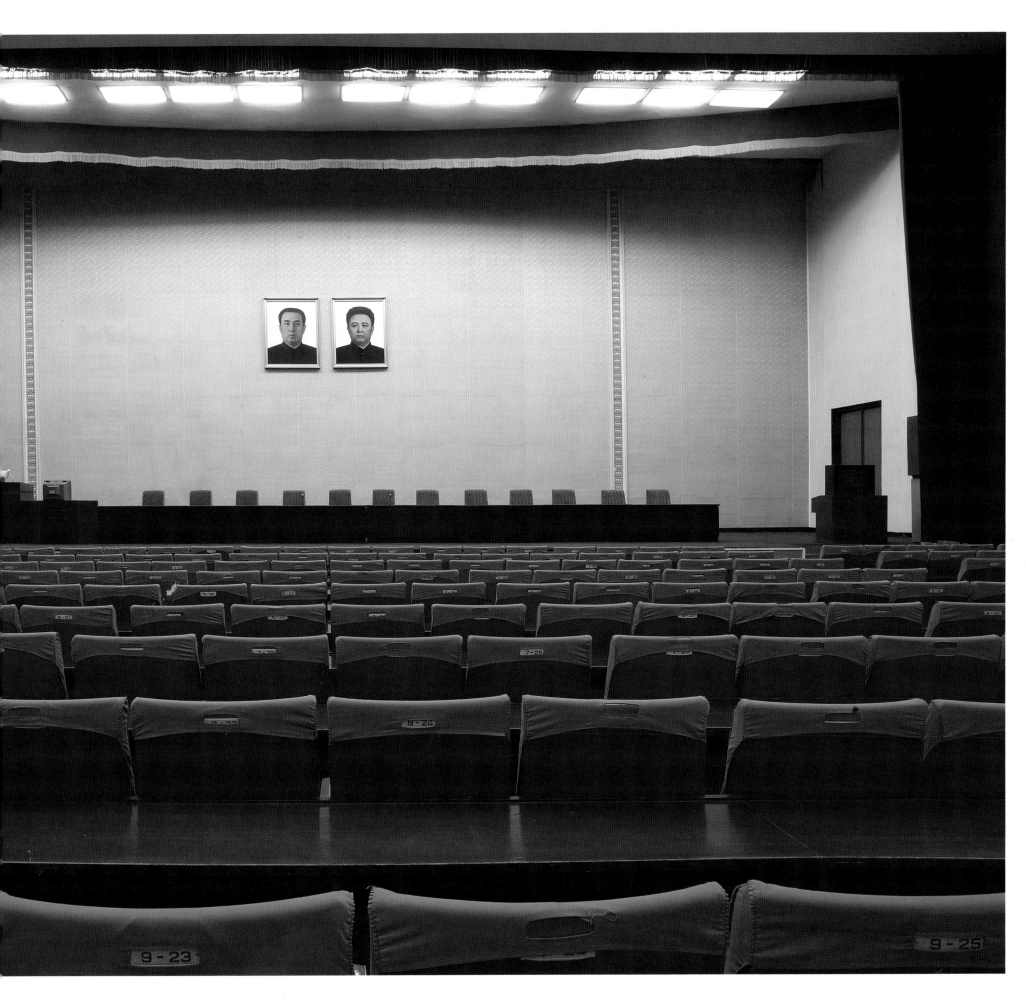

186 Sound library, Grand People's Study House

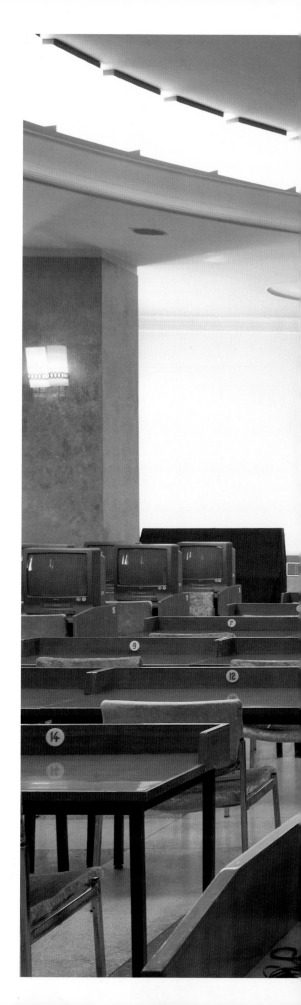

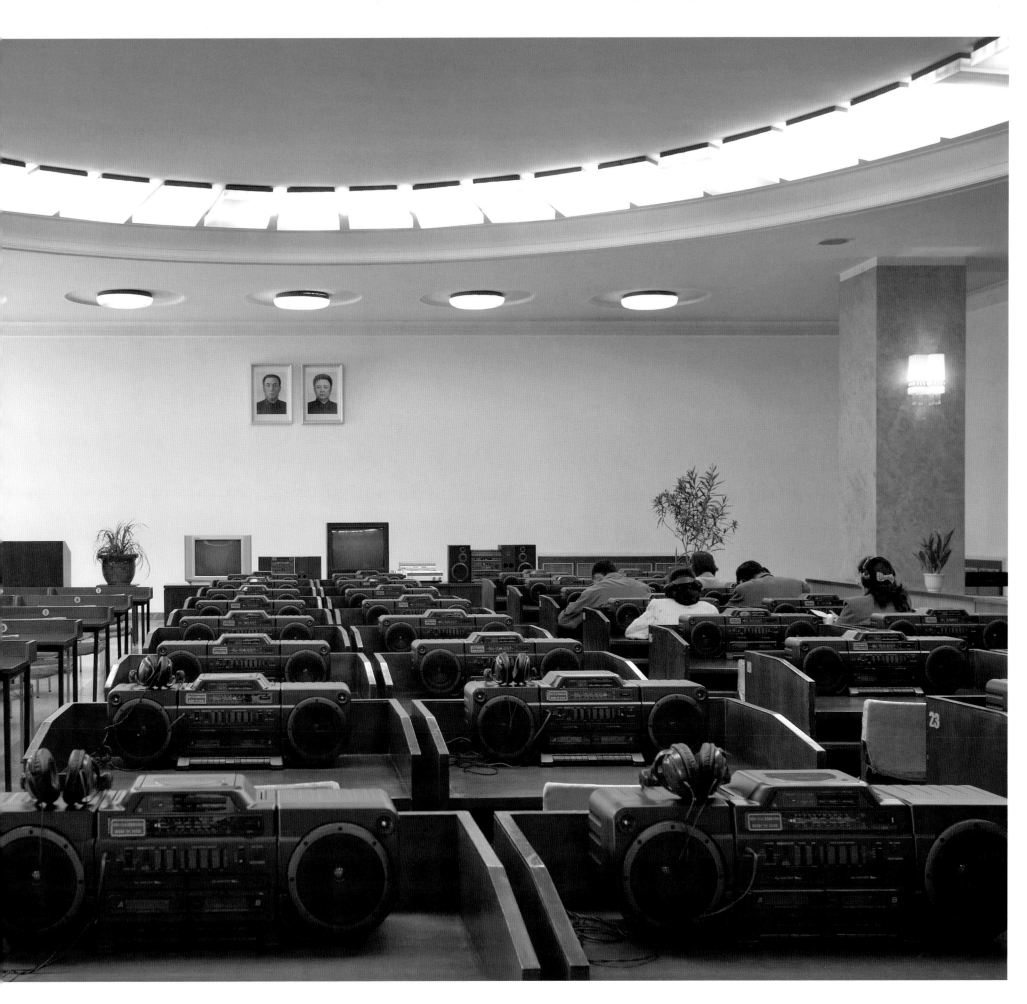

188 Computer room, Children's Palace

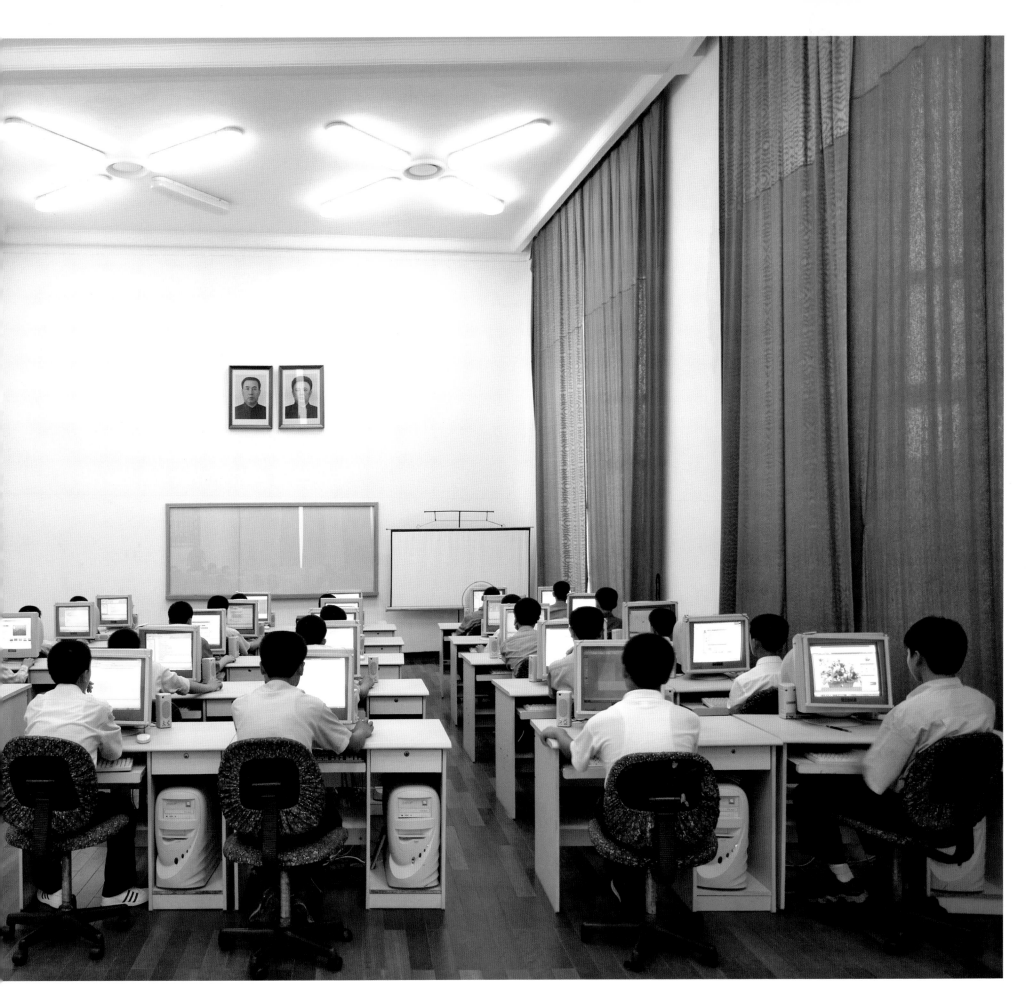

190 Reading room, Grand People's Study House

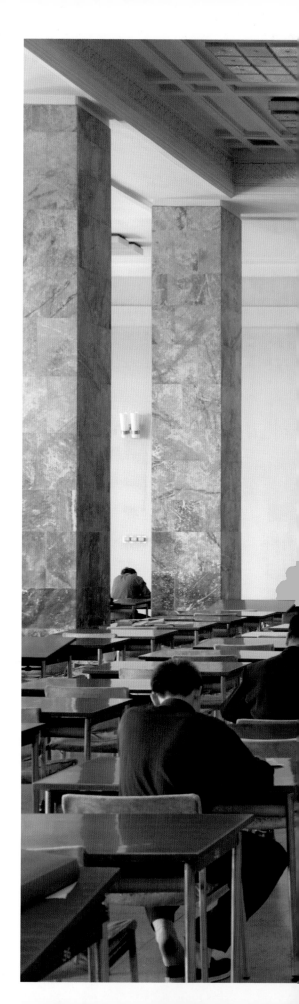

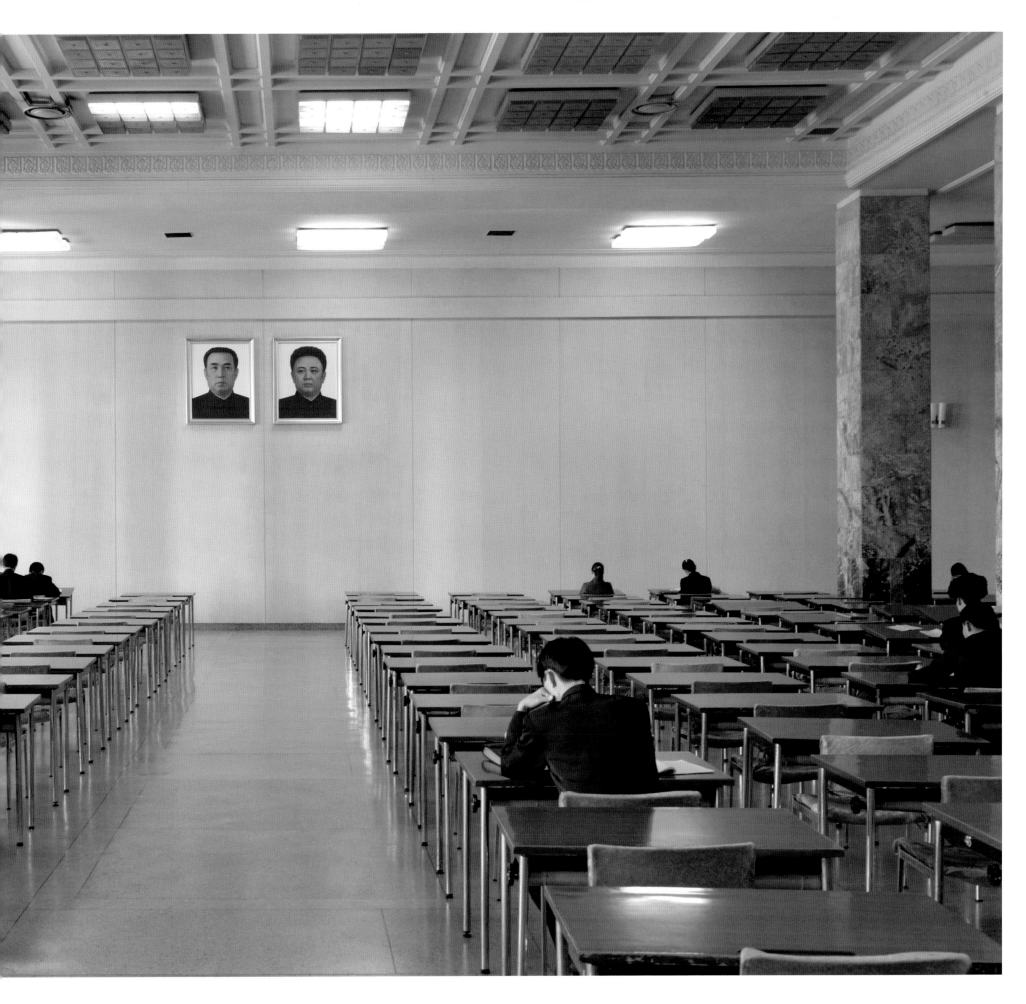

192 Kim Jong-il's desk, Kim Il-sung University

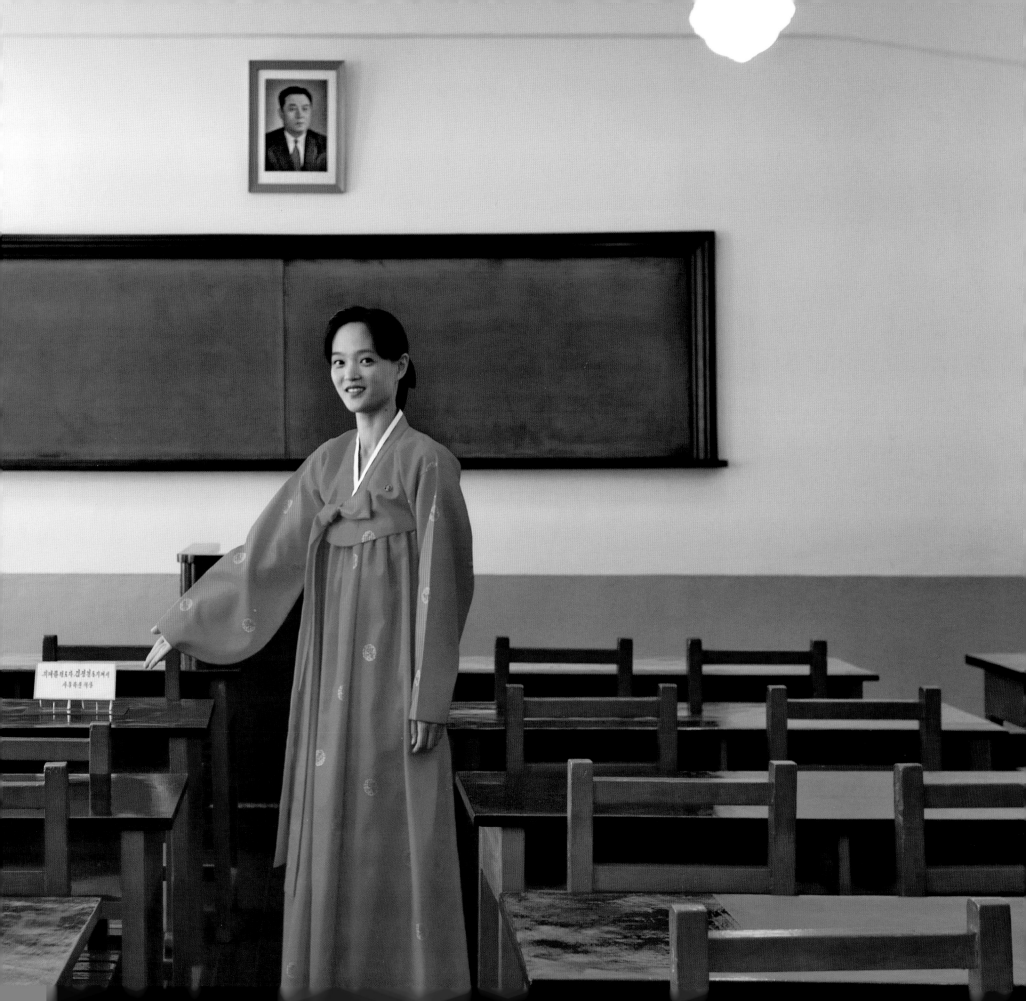

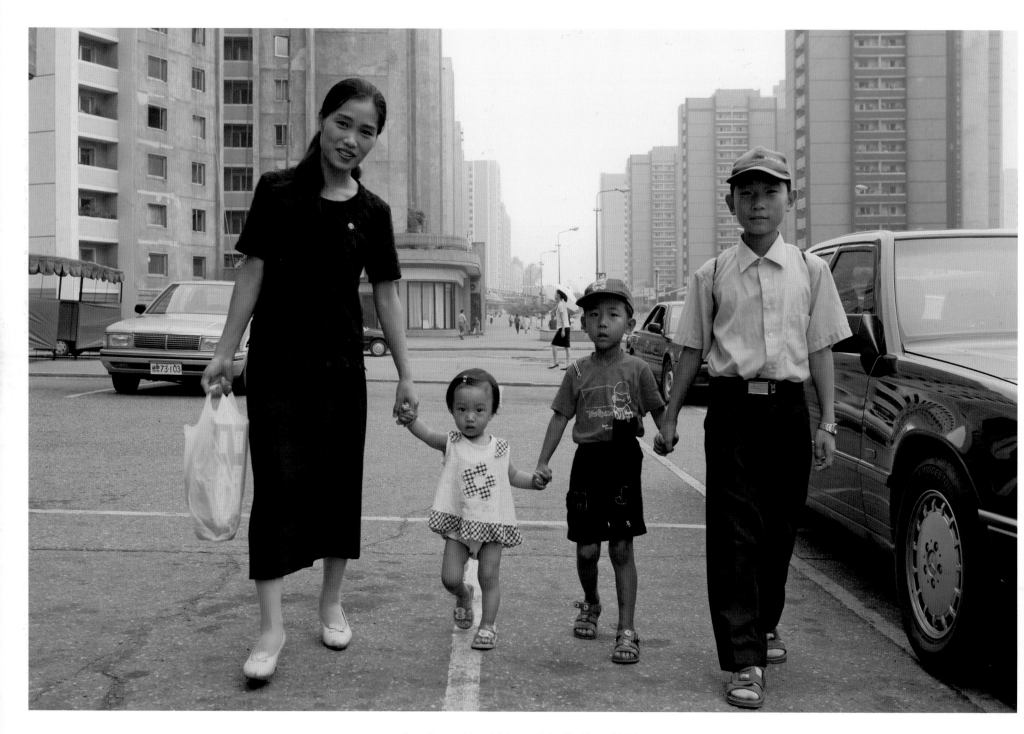

A mother and her children outside the Koryo Hotel

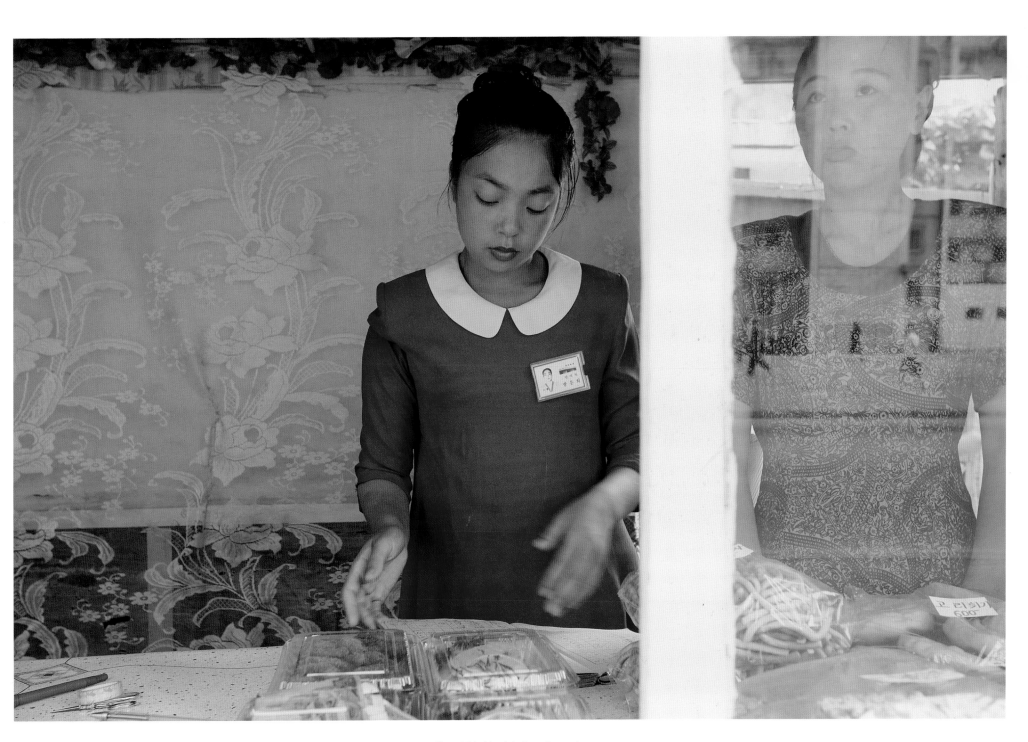

Roadside kiosk in the city centre

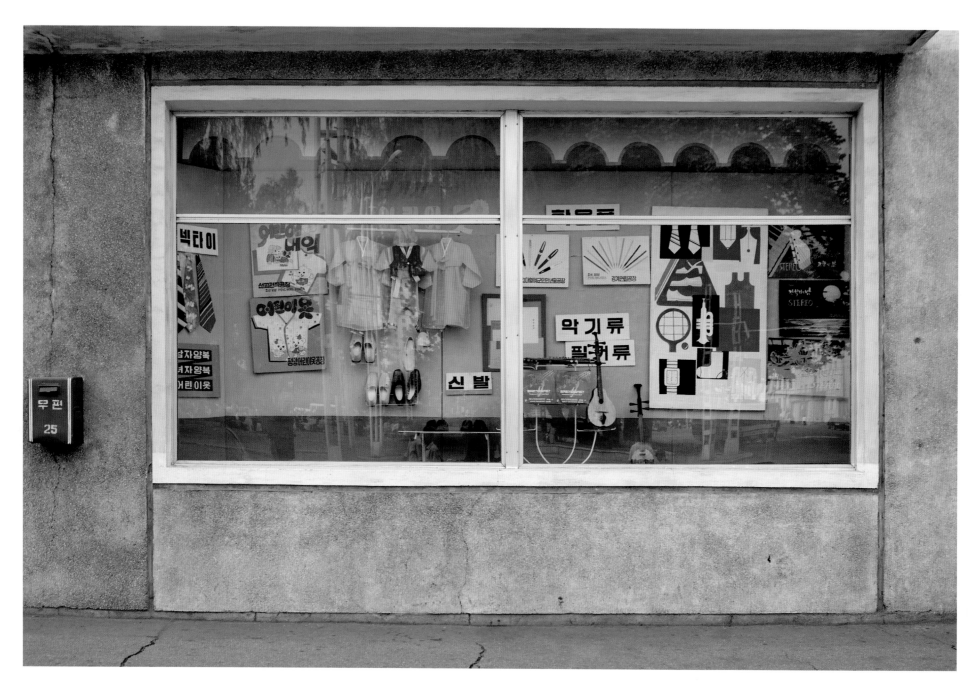

Shop window near Pyongyang Station

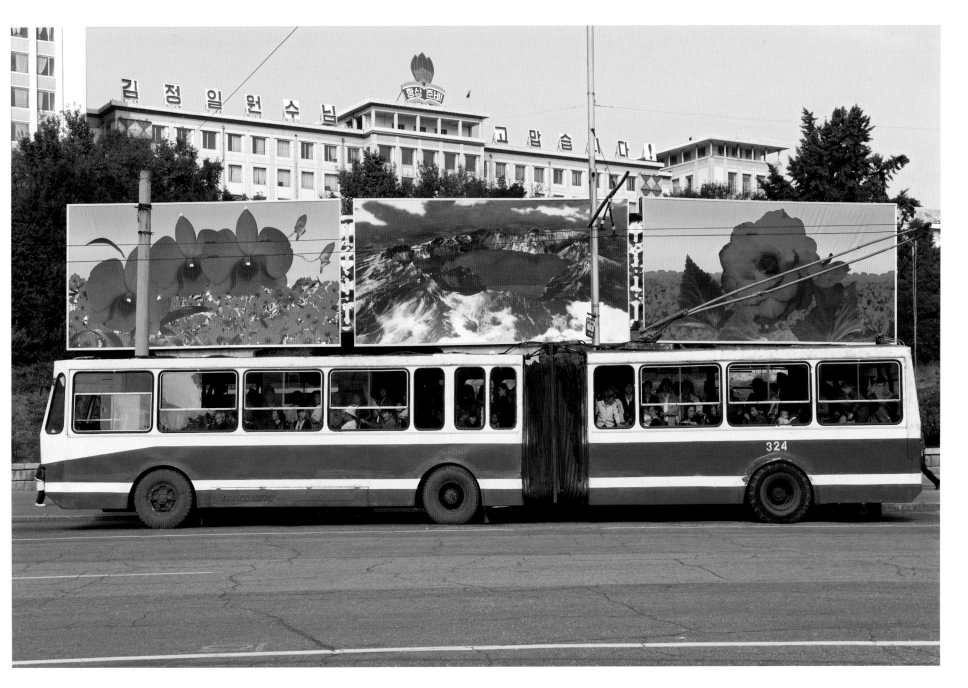

Three hoardings, representing from left to right: the Kimilsungia flower, Mount Paektu and the Kimjongilia flower

Erecting scaffolding in the city

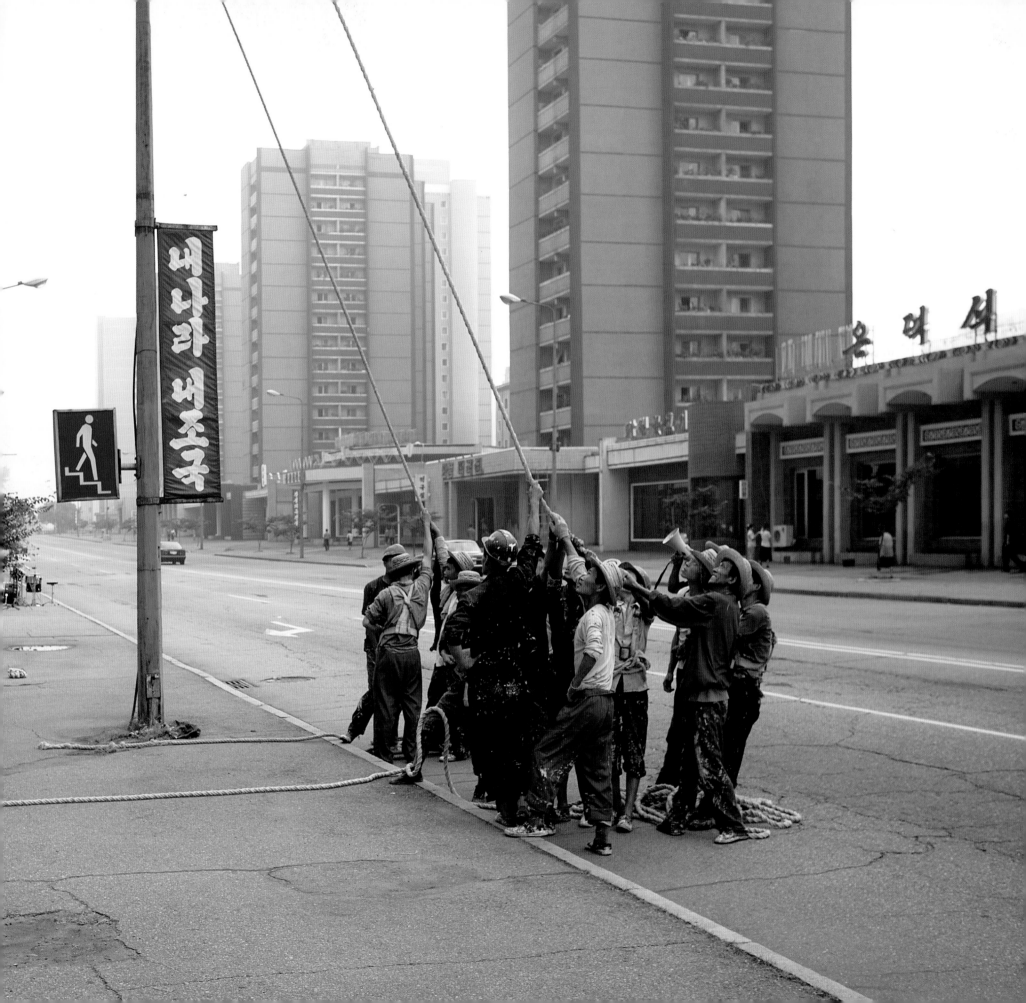

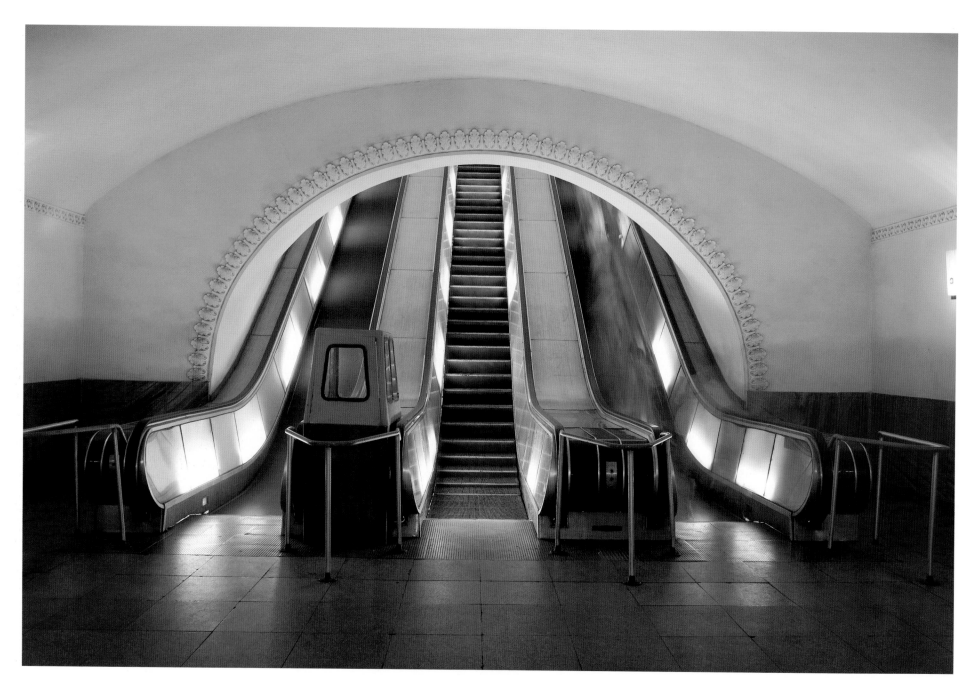

Escalator at Yongwang metro station, Pyongyang

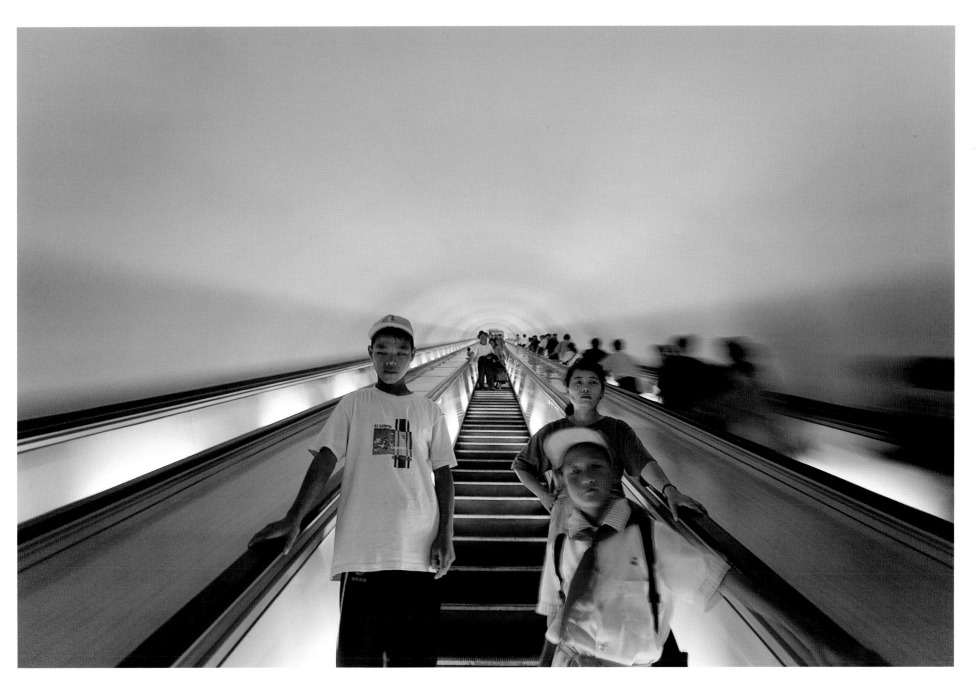

Entering the metro

202 On the metro

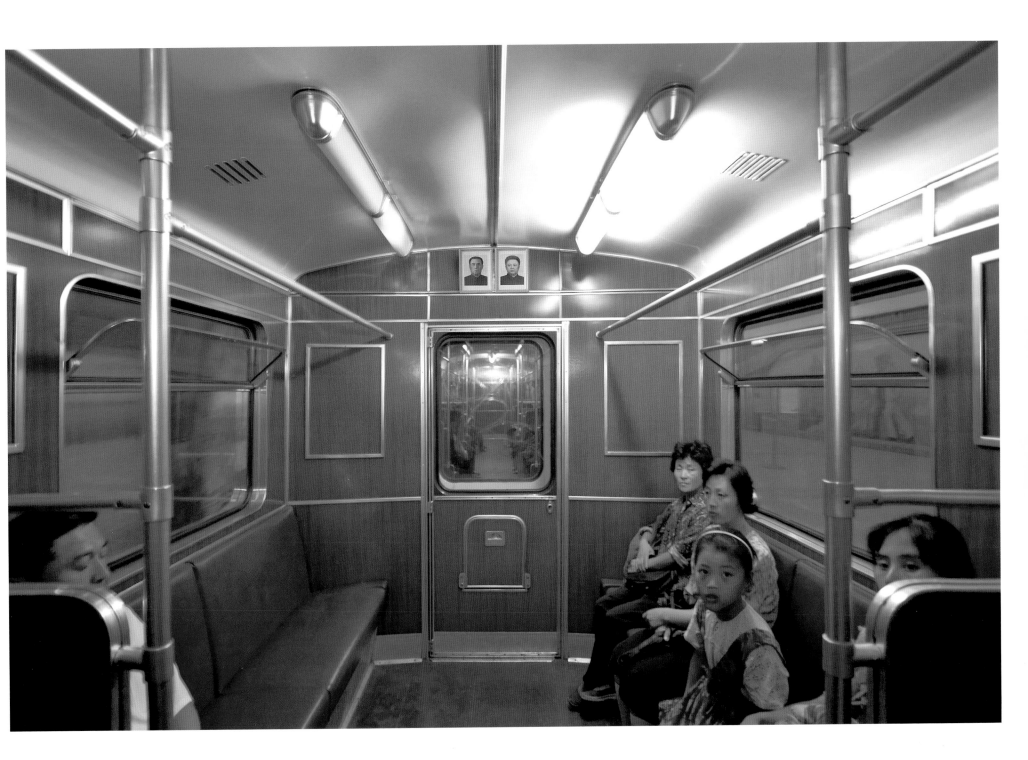

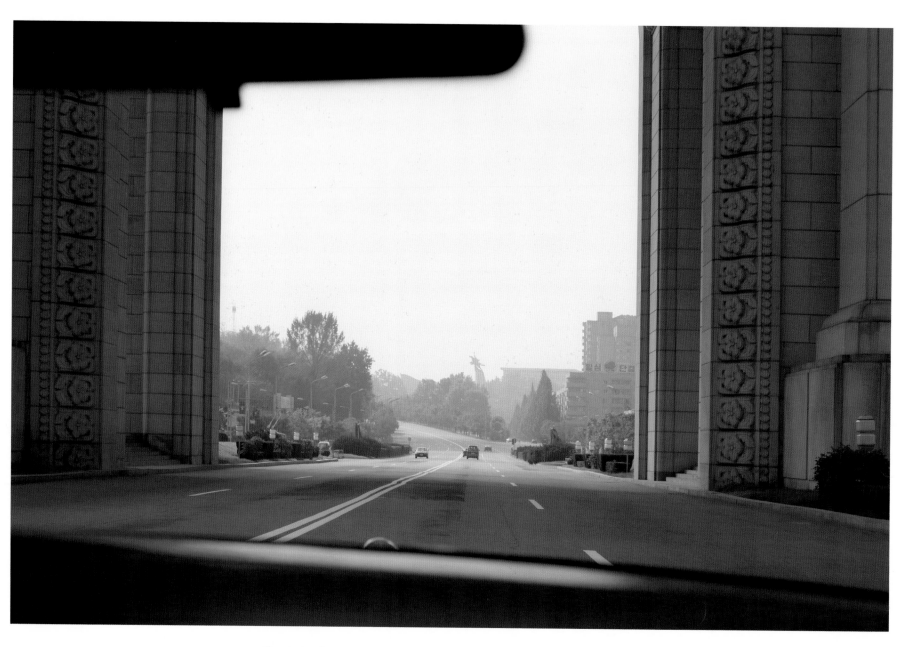

The Arch of Triumph commemorating Korean resistance to Japan, Pyongyang

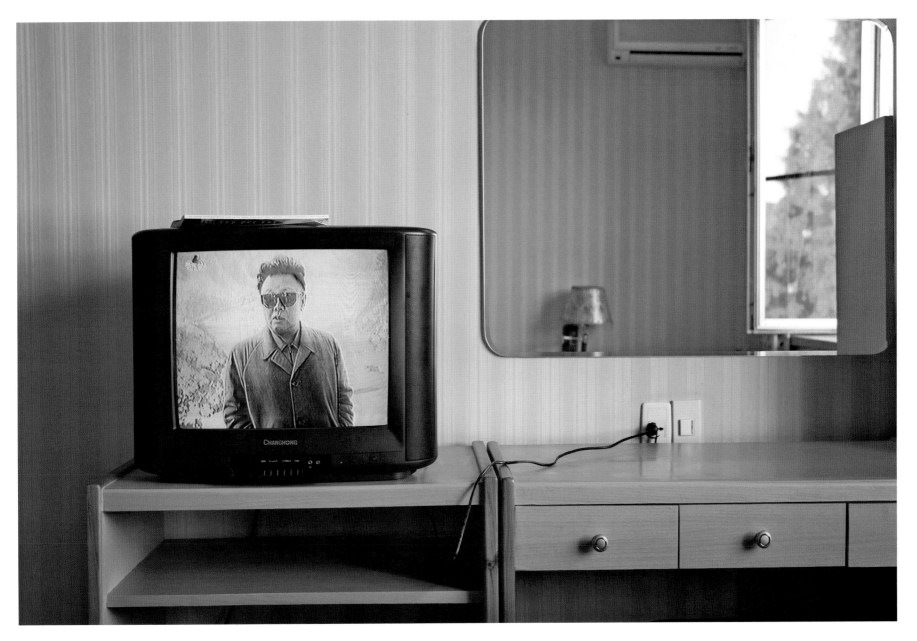

Documentary about Kim Il-sung, Pyongyang Hotel

206 On the way to work, Pyongyang

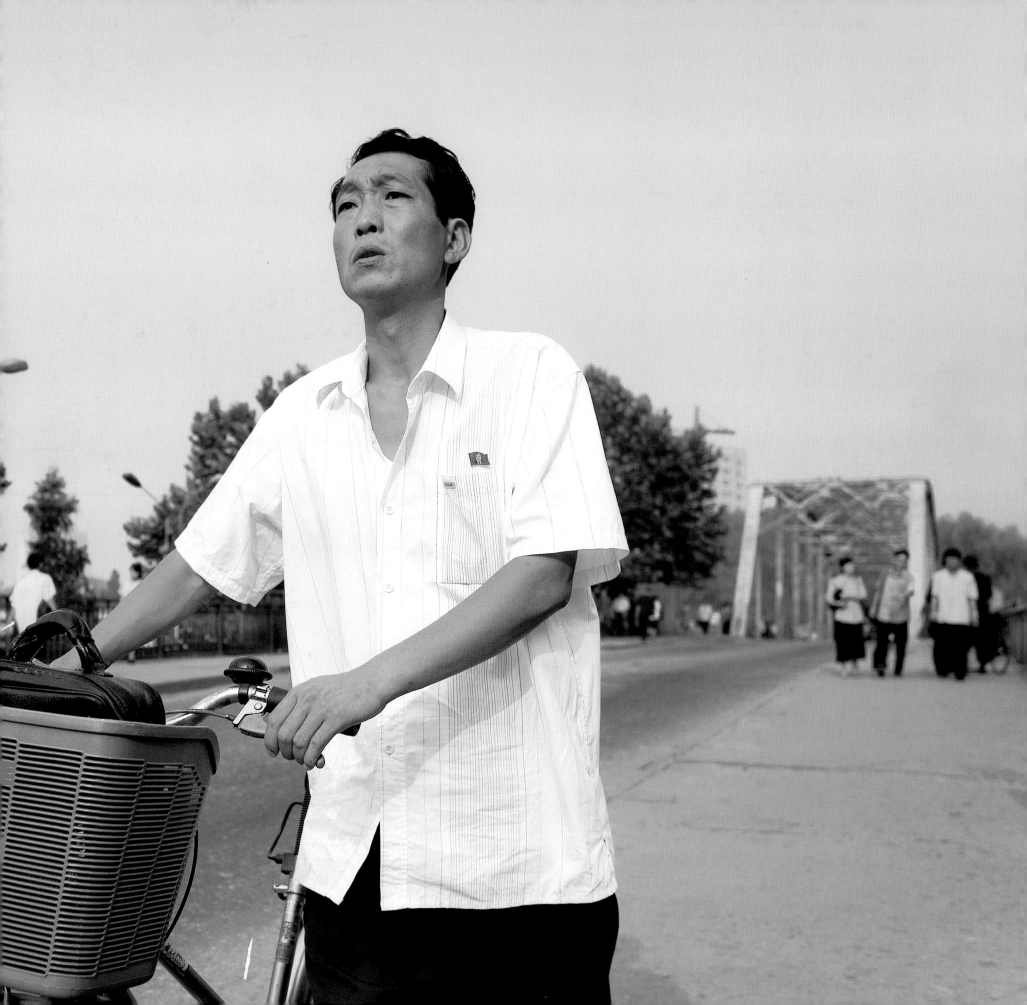

For Emma, Lucien and Valérie

Acknowledgments

I would like to thank everyone I have not been able to acknowledge
here by name, for reasons that are well understood, and one person
in particular who trusted me and without whom this book would never
have materialized.

My sincere thanks and warm gratitude go to Laurence Bertrand Dorléac,
Sylvain Bourmeau, Philippe de Chabaud Latour, Hervé Chandès,
Bénédicte Colpin, Philippe Dabasse, Philippe Dagen, Raymond
Depardon, Jonathan Fenby, Adrien Gardère, Emmanuel Kriegel,
Michel Poivert, Jean-Pierre Raynaud, Evariste Richer, Damien Sausset
and Valerie Weill, who have directly or indirectly contributed to this work.

Thank you also to Hélène Borraz and Frédérique Popet for their informed
and unfailing support.

'Appearances' translated from the French by David H. Wilson

Photographs © 2006 Philippe Chancel
Text © 2006 Thames & Hudson Ltd, London

First published in 2007 in hardcover in the United States of America by
Thames & Hudson Inc., 500 Fifth Avenue, New York, New York 10110

thamesandhudsonusa.com

Library of Congress Catalog Card Number 2006904269

ISBN-13: 978-0-500-54329-0
ISBN-10: 0-500-54329-1

Printed and bound in Hong Kong by Sing Cheong

Faint text in bottom right corner, mostly illegible.